Women in the Holocaust
Volume II

WOMEN IN THE HOLOCAUST

A COLLECTION OF TESTIMONIES
VOLUME II

Compiled and Translated by
Jehoshua Eibeshitz
and
Anna Eilenberg-Eibeshitz

R REMEMBER

WOMEN IN THE HOLOCAUST II
Edited by Fayge Silverman

FIRST EDITION
First Impression — September 1994

Published by
REMEMBER
705 Foster Avenue
Brooklyn, N.Y. 11230
(718) 692-3900

Copyright © 1994 by REMEMBER
ALL RIGHTS RESERVED

This book, or parts thereof, may not be reproduced, stored, or copied in any form without written permission from the copyright holder, except by a reviewer who wishes to quote brief passages in connection with a review written for inclusion in magazines or newspapers.
THE RIGHTS OF THE COPYRIGHT HOLDER
WILL BE STRICTLY ENFORCED.

ISBN 0—932351—46-8 (Casebound Edition)
SBN 0—932351—47-6 (Softcover Edition)

Printed in the U.S.A.

TABLE OF CONTENTS

❖

Preface	8
A Note on the Translation	12

In The Ghettos

1. Stolen Years / *Sara Plager-Zyskind*	17

On The Aryan Side

2. Search for a Child / *Ryvka Rosenberg-Waserman*	71

In The Camps

3. Hela / *Halina Birenbaum*	99
4. Images from the Depths / *Berta Fredreber*	137
5. The Golden Coin / *Flora Rom-Eiseman*	150
6. A Bittersweet Laughter / *Mussia Deiches*	164
7. A Bundle of Poems / *Ryvka Bosman*	182
8. Thirteen / *Drora Eisner*	186
9. A Different Planet / *Sara Selver-Urbach*	198
10. A Miracle in Auschwitz / *Esther Weiss*	206

Glossary	226

CORRECTION

In *Women in the Holocaust*, Vol. I, the biography on page 212 mistakenly states that Jonah Emanuel and two brothers were the only survivors among a family of eight children. A sister also survived.

❖

I feel fortunate to be able to present the second volume in this anthology, which contains ten more authentic testimonies of women who survived the Nazi horror. Each one provides a yet deeper glimpse into the minds and souls of the women who struggled so heroically to keep alive the spirits of those around them against the most crushing odds. It is my continued hope that in each of these stories the character of my dear wife Hedva, of blessed memory, will be preserved, and that the anthology will stand as a collective tribute to our Jewish sisters, who clung to their G-d and their humanity in an abyss of evil.

Jehoshua Eibeshitz

PREFACE

❖

Gathered in the second volume of this anthology are the testimonies of ten more women who survived the darkest period in Jewish history. Their experiences and observations enlarge the tableau of enormous suffering, unwavering strength, and remarkable perseverance that characterized the woman's experience during the Nazi era.

The woman's role in the Holocaust is particularly poignant. Many historians and witnesses have testified to the fact that her bravery during the war surpassed the man's and that she endured suffering better. The woman's work load was greater, especially in the ghettos, for she was subject to the same forced labor as the man, and yet she was still responsible for her home and family. Women often performed their duties in great peril because of the decrees imposed by the Germans on pregnancies and birth. Many of them became the sole family providers if their husbands or brothers wore beards and sidelocks and could not afford to be seen in the streets; and they also played an important part in the underground resistance.

The heroism of these women is intensified by the fact that most of them were young girls at the time of the war, and one who bears this in mind will read the stories in an entirely different light. The Holocaust

precluded any semblance of a normal childhood. It created adults who were adolescent only in terms of chronology, children of twelve and fourteen who found themselves in positions of responsibility unimaginable to their teenage counterparts of today, unthinkable to the average citizen of any peacetime society. They stood guard outside ghetto homes where organized prayer was taking place; they cared for younger siblings and ailing parents; they ran life-saving errands on roads patrolled by German soldiers; they worked in the underground as couriers and relief agents. Although their testimonies have been given with adult hindsight, the wise judgment, courageous endurance, and emotional maturity they exhibited under duress are an awesome tribute to a group of children-women whose insight and abilities far exceeded their years.

The striking authenticity of the twenty testimonies in Volume One is borne out by this second collection. Each story is different, yet there are common threads running through all of them that highlight the shared destiny of Jewish women in the Holocaust. The dovetailing of many of their descriptions, including everything from emotional impressions to the details of entry procedures in the concentration camps, provides a sense of immediacy that is fascinating and powerful.

The testimonies assume some knowledge of the Holocaust on the part of the reader. Those who are not familiar with the history or general conditions during the war are referred to the introduction in Volume I, which provides a brief background on the Final Solution. It is important to realize that the lethal German "conveyor belt," which methodically transported the Jews from their homes to the enclosed ghettos and finally to the death camps, left little room for any physical resistance. It did, however, spawn a profound spiritual resistance, and it is in this arena that the woman's experience is so valuable. The stories that follow create a moving profile of the spiritual struggle kept alive by women under the Nazi shadow — women of vastly different social strata and divergent educational and religious backgrounds, who were nevertheless united in their fight to retain their Jewish and humanitarian values. In the most dire circumstances they transcended their own needs in order to care for others, and they were ever alert to the danger of the moral degeneration that could result from hopelessness.

Especially prominent in this second series of stories is the recurrent theme of family bonds. Women such as Sara Zyskind ("Stolen Years") and Halina Birenbaum ("Hela") exhibited intense devotion to relatives, protecting them in every way possible, clinging to them until the last breath. Some of these episodes end happily, lifting the blanket of desolation from the chronicle of the Holocaust. Ryvka Rosenberg ("Search for a Child"), one of the more fortunate survivors, recounts the year-long search which enabled her to retrieve her young daughter from a gentile home after the war; and Esther Weiss ("Children of a Miracle") tells of her survival in Auschwitz with two children.

Sacrifice and devotion, however, were not limited to families. The testimonies offer a glance at the wide spectrum of techniques utilized by women and girls to uplift the sagging spirits of their fellow prisoners. Particularly inventive is the episode of the Dolls' Theater told by Flora Rom-Eiseman ("The Golden Coin") and Mussia Deiches ("A Bittersweet Laughter"), in which the women in a labor camp in Riga managed to stage a complete musical puppet show in their barracks, under the noses of the overseers. They also held "cultural evenings" and even wrote poetry (Ryvka Bosman, "A Bundle of Poems") in an attempt to strengthen and preserve the one treasure they possessed which was completely out of the Germans' reach — their own souls.

The precious resource of friendship threads its way through all the stories. Drora Eisner ("Thirteen"), an inmate in an unusually small labor camp, tells of the treasured correspondence she maintained with a friend in a nearby camp, whose wise advice kept her from sinking into depression. Sara Selver-Urbach ("A Different Planet") continues the saga she began in Volume One, writing of the four friends who became her family in Auschwitz and of how they insulated each other against the rampant brutality that surrounded them.

No historian can pinpoint the value of these testimonies better than the women themselves. Flora Eiseman perfectly encapsulates the survivors' legacy:

"Perhaps my story, as well as those of my friends, will serve as a truthful picture of life in the women's concentration camps. Authentic eyewitness reports, in spite of their limitations, may become more

valuable than books by professional writers, especially for our children. It is true, of course, that this kind of literature is subjective, for each of us saw with her own eyes and her own understanding; and when one is encaged, she often cannot comprehend what is happening around her. And yet, a mother's true experience of the Holocaust is more real and comprehensible to a daughter or son than a thousand fictions written by the best writer.

"To me, these testimonies are also very unique in that they portray the prisoner's paradox: the way he continued to go through the daily routines of life while death hovered over his head. And perhaps most importantly, they show the prisoners' triumph; for side by side with the unrelenting fear of death, there existed a friendly relationship among the inmates, for whom the struggle to maintain a healthy spirit was just as important as the struggle to stay alive."

The pages that follow provide a continued and breathtaking saga of the unbroken moral heroism of women in the Holocaust.

Fayge Silverman
EDITOR

A NOTE ON THE TRANSLATION

❖

All of the testimonies in *Women in the Holocaust* have been translated from the Hebrew original. The problem of maintaining the integrity of an original language in translation is well-known, and very often it is virtually impossible to find literal equivalents for words or expressions. An attempt has been made to adhere as closely as possible to the Hebrew version and to maintain the authenticity of the emotional tone of the testimonies. Adjustments in syntax and description have been made for the needs of the English-speaking public and, where necessary, historical background information has been added.

A glossary is provided to explain several foreign words and expressions which appear frequently in the testimonies. It is interesting to note that many of these words were used by the Jews of the Nazi era not in their literal sense, but rather as part of a unique jargon which grew up around the horrors of the regime. The prisoners in the concentration camps in particular had a special and often cynical argot. One example would be the word "organize," which meant to obtain — always at great risk — a needed item, whether it was a bit of medication or an extra piece of bread for a sick inmate. The word "steal" was not used by the prisoners, for to steal what the Nazis had already stolen from them was blatantly illogical.

Such usage has been left intact to as great an extent as possible in the narratives.

Women in the Holocaust is intended mainly to be a collection of deeds and not a collection of biographies, and therefore the length and depth of the testimonies vary considerably. This is due partly to the survivors' differing levels of memory and attention to detail, but mostly to the sensitive emotional issue of gleaning information from people who have survived unspeakable atrocities. Many of them were initially reluctant to talk during interviews and responded in a highly emotional and erratic manner. These were people who could not be asked for objective facts in any kind of systematic way, but who must be allowed to talk with the flow of their own memories and feelings and to emphasize what had been most important to them.

Because of the subjective nature of the testimonies, the information is not always complete; a few of them were originally given many years ago to Holocaust research institutes, making it difficult to trace the missing pieces. The chronology in some narratives is occasionally unclear, and sometimes people mentioned in the beginning of a story do not appear again. The reader will excuse these occasional lapses of information, for the testimonies are not meant as historical documents but as documents of the soul, and as such they fulfill their purpose admirably.

IN THE GHETTO

STOLEN YEARS
❖
Sarah Plager-Zyskind
Lodz, Poland

A New Home

The war had broken out half a year earlier, and hunger was now stalking the ghetto. The evidence could be seen everywhere: in pale faces with hollow cheeks, in the clothes that dangled loosely from emaciated bodies, in the frequent cases of utter exhaustion. Mother and I didn't feel the shortage of food so strongly, for even in good times we had eaten sparingly, but Father had a healthy appetite and suffered badly from hunger pangs. Mother tried to supplement our rations, saving every grain of barley and crumb of bread she could find. To disguise the terrible taste of the rotten potatoes we were now receiving, she grated them finely and made fritters out of them. When Father discovered her hidden culinary talents, he responded with good-humored praise.

I too did what I could to supplement Father's ration of food. Over the long summer vacation our school continued to schedule daily activities, during which we received two slices of bread for breakfast and another two with soup for lunch. In spite of the strict injunctions against taking bread outside of the building, I often managed to slip away with two slices of my own and two more given me by my friend Lilka, whose father worked in the central store in the Baluty market and was able to give her extra food.

That summer of 1940 was a very happy time. My friends and I spent the vacation playing volleyball, basketball, and other games. No less happy were the hours I spent with my mother, who, despite our difficult circumstances, did everything in her power to make our home a cheerful place. Only later was I able to appreciate how very precious these moments had been for me.

The vacation came to an end all too soon, and the new school year began. There was still no sign of an end to the war. The winter of 1940-41 arrived, a fierce Polish winter with its howling winds and heavy snowfalls, and the three measures of coal now allotted to us were nowhere near enough to keep our room warm for even a short time. Father was out of work, and his chances of finding a job were very slim. I so longed to do something for him that I stifled my pride and turned once again to my friend Lilka; perhaps she could ask her father to find him some kind of job in the food supply center. Expecting only a positive response, I daydreamed about telling my parents the happy news, but several days passed and Lilka made no further mention of the subject. I was reluctant to open up the conversation again, but finally I had to ask her point-blank if her father could help mine. Her reply — that all vacancies had long since been snatched up and that there was nothing whatsoever available — was a painful surprise.

That winter, food became even more scarce. The potatoes we received were so frozen that they looked like lumps of ice. Though Mother wore thick woolen mittens while peeling them, her small, delicate fingers were always red and swollen. I once overheard her mumbling to herself: "It can't go on like this much longer!"

One morning as I was leaving for school, I saw Mother drawing something on a large piece of cardboard. Amused, I asked her if she were about to take up a new hobby here in the ghetto, of all places. Instead of answering me, she quickly rolled up the sheet and put it away. But when I returned from school that afternoon, I found the piece of cardboard nailed to our door with the words "HOT COFFEE SOLD HERE" printed on it in large block letters. When Father came home after another futile day of job hunting, he noticed the sign and laughed — but he didn't laugh for long. Mother's idea turned out to be an excellent one. People who

were rushing to work in the ghetto usually had no time to get a fire going so early in the morning and to wait for their kettles to boil, and they seized the chance to warm up over a cup of steaming coffee — for the price of only five *pfennigs*.

Selling coffee wasn't a very profitable business, but it did enable us to buy an additional ration of bread for Father on the black market, plus an adequate supply of coal. Now our room was well-heated, and our fear of the coming winter abated somewhat. The sense of shame I had initially felt about Mother's enterprise soon turned into admiration as I watched her coping bravely with the new circumstances of our lives. It never occurred to this gentle and intelligent woman to turn up her nose at the most menial of tasks, as long as she was able to help her family.

Mother marveled frequently at the fact that she was able to live on barley and potato fritters and still feel well. "The Almighty is surely watching over me," she used to say.

But her good fortune did not last. One day I came home to find my mother lying in bed, with her sisters, Tsesia and Hanushka, sitting beside her. The doctor had diagnosed a severe inflammation of the gall bladder. Her sisters watched over her anxiously as the daylight faded and night came on. The last thing I heard before I fell asleep was Mother's voice calling out her affectionate nickname for me: "Salusia, cover yourself well. It's so cold in here!"

My aunts' screams roused me from my sleep. I leaped up and rushed to Mother's bedside. Her body was still warm, but she was no longer breathing. I called out to her, I wept and begged her not to leave me, reminding her of how she had always pitied Father because he was an orphan. "I don't want to be an orphan, Mother!" I cried. "I'm only thirteen years old!"

I recalled having read somewhere that if one massaged a person's feet, the blood would start circulating again, so I bent down and began rubbing Mother's feet frantically, but it was too late. By the time the doctor came rushing in, there was nothing left for him to do but fill out a certificate testifying to Mother's death at the age of thirty-six.

As I followed the black carriage carrying my mother's coffin to the cemetery, I prayed — as I had prayed at my cousin Moniek's funeral —

that the door of the hearse would fly open and my beloved one would step out alive... but the sad journey continued uninterrupted. When the coffin was lowered into the grave, my father, who was usually so strong and restrained, wept like a child. This sight shocked me. I resolved to pull myself together, to be strong and do all in my power to stand by my father and live solely for him — but I didn't keep my resolve for long. On the very first night after the burial, I was awakened by the storm raging outside, and I began to sob and scream that Mother was lying out there in the snow, freezing. Father took me into his arms and told me that her soul did not feel the cold, that she was in heaven, united with the souls of her parents and of my cousin Moniek. Lulled by his soothing voice, I fell asleep once more.

During the seven days of mourning, many people came to visit us. Some of my classmates came, among them my friend Lilka, who brought news from her father: through connections, he had finally found a job for my father. Thinking that she was acting out of pity, I was about to decline, but Father had overheard the discussion and accepted the offer at once.

Now that Father would be at work all day long, the problem arose as to who would look after me. Aunt Tsesia insisted on taking me into her home. "What do you mean, overcrowded?" she said to my father. "I've got five children, and now I'll have six!" I personally would have preferred to live with Aunt Hanushka, and under normal circumstances I knew that she would have been overjoyed to have me; but the war had badly affected her husband's nerves, and his behavior had become so unpredictable that this was out of the question. I begged to be allowed to remain at home with my father, but he refused, reminding me that our room would be extremely cold now that we no longer had Mother's coal ration or the extra fuel we had been able to buy with her coffee money. He said it was very important that I be able to concentrate on my studies and finish high school, as Mother would have wished. The very thought of Mother not attending my graduation brought on another outburst of tears; but a glance at Father, who stood there helpless and depressed, had a sobering effect on me.

Aunt Tsesia and Uncle Shimshon treated me with the same loving care they gave their other children. I shared a bed with my cousin Temcha,

and every morning before school Aunt Tsesia would tenderly brush and braid my hair, the way my mother had always done. Aunt Hanushka and Uncle Hersh dropped in daily to see how I was doing. I was surrounded by my family's love . . .

My school had been relocated several times, and we were now occupying a number of small huts in the fields of Maryshin, which had formerly been used by the Zionist agricultural groups.* I was delighted at this transfer from a closed-in building to the open spaces of Maryshin. Moreover, the area was near the cemetery where Mother was buried, and I could now visit her grave each day after school. I would sit on the ground and talk to her as I had in the past, telling her of life at Aunt Tsesia's house and at school, and of Father's new job, compressing coal dust into briquets. I kept these daily visits a secret from everyone, including Father. On my way to school in the mornings and again on my way back, I would also make a detour past our apartment house on Marinarski Street and peep through the window into the small room that had once been my home. Though I knew that nobody would be there, I was irresistibly drawn to that cold, dark room . . .

When Father came to see me each evening after work, Aunt Tsesia always had something ready for him to eat. I awaited his arrival with great impatience and was distressed when it came time for him to leave. I would accompany him part way home, and then he would walk me back again; and this would continue until we had retraced our steps several times. There was so much we had to tell each other, and when we talked of Mother, a deep longing for her would overcome both of us.

Once, in a fit of sheer frustration, I accused Father of intending to remarry after the war and forcing me to live with a stepmother. As soon as I said it, I could have bitten my tongue off. Father did not become angry. Instead he turned to me and said softly: "You're all I have left, my darling. So long as I live, I won't allow anything or anyone to harm you. I won't get married again unless you want me to . . ."

*For a short time in the ghetto, members of various youth movements operated a "farm" in a section of the ghetto called Maryshin, where they grew produce on plots of land allocated to them by the Judenrat. Eventually the youth farm was disbanded because the authorities feared excessive levels of organization among the young people.

Each time we parted, my heart grew heavy at the thought of Father entering that empty, cold room whose walls were sheeted with ice. He had lost weight at an alarming rate, and his cheeks were sunken; his walk, formerly so light and energetic, was now heavy and slack. The suffering of the last few weeks had taken its toll on his health and spirit.

Aunt Tsesia Departs

As the snow of that winter melted slowly into a muddy slush, new sources of income began to appear in the ghetto. Taking advantage of a cheap, captive labor supply, the Germans were now setting up workshops to manufacture all kinds of goods. Although the salaries were barely adequate to pay for the meager monthly *ratzia* (food ration), employees in the workshops were entitled to an extra slice of bread each day.

At first most of the workshops made uniforms for the soldiers of the Third Reich, but others were soon established to manufacture luxury goods like carpets and lingerie. Uncle Abraham — my mother's brother, and a brother to Tsesia and Hanushka — was able to obtain a job in the supply department of a corset factory. Genia, one of my cousins, was put in charge of a workshop which produced metal products. Her managerial position, like those of other privileged supervisors and high-ranking police officers in the ghetto, entitled her to a greater food ration. She had been elevated into the sphere of the ghetto elite — the "millionaires" who were able to acquire whatever they needed by trading their surplus food. The principal of our school, Mrs. Rein, was also entitled to extra rations, but she refused them, maintaining that as long as her pupils went hungry she could not accept such favored treatment for herself.

While my relatives were all busy at their new jobs, I was occupied with school. In addition to German and Latin, I was also taking classes in Yiddish and Hebrew this year, and studying took up most of my spare time. One day our school received an important visitor: Chaim Rumkowski, the Judenelteste of the Lodz ghetto. Rumkowski was an elderly man, close to seventy, but of tall and upright bearing, with gray hair and bronzed features which gave him a look of eminence. Because of the authority granted him by the Germans, he had become the virtual "king" of the ghetto and even issued his own currency for internal circulation.

During the general assembly Rumkowski gave a speech expressing his great admiration for us. We high-school students were the future of the Jewish people, he told us, and he would see to it that our schooling would not be discontinued and that none of us would go hungry. In the near future, he informed us, a field kitchen would be set up in the school compound so that we could receive some soup and a little meat.

Rumkowski kept his promise, and a few days later students began coming to school with tin bowls and spoons dangling from their knapsacks. When we discovered that the patties we were eating were made of horse meat, we were nauseated at first, but we soon overcame our revulsion and were glad to fill our stomachs.

The listing of the monthly *ratzia* for ghetto residents, which was pasted periodically on the front windows of the grocery stores, kept shrinking visibly. The coarse barley and the murky black cooking oil that at one time had aroused our disgust had disappeared long ago, and now seemed almost like delicacies. The supply of pickled cabbage and kohlrabi was cut drastically. The only commodity in ample supply was soap — a green substance smelling of fish oil, with the letters R.J.F.* imprinted on each bar. If only we had known the meaning of those initials!

Under the worsening conditions, people changed so much in appearance that many of them were no longer recognizable. Their faces became bloated, puffy bags developed beneath their eyes, and in some cases their legs became so swollen that they could not walk. Such people, whose symptoms of starvation were so evident, we called *mussulmen,* and we knew that their days were numbered.

During the past winter the Germans had initiated their systematic deportation of Jews from the ghetto. Hundreds of people received official notices that they would be transferred from Lodz to special labor camps in the countryside. The notices were accompanied by detailed lists of the possessions they could take along. At the assembly point in the courtyard of the Czarnieckiego Street prison, each deportee would be given a loaf of bread for the journey. Many of those who received deportation orders were already employed in the ghetto, but they easily found "volunteers"

Rein Jüdisches Fett, meaning clean Jewish fat.

to take their places in the deportation line, most often half-starved people who jumped at the opportunity to receive a whole loaf of bread on the spot. For many, the prospect of working in a village was a virtual escape from the near certainty of a lingering death in the ghetto.

News of the imminent deportation of Aunt Tsesia and her entire family fell upon us like a thunderclap. Father, so weakened that he could barely hold on to his job, would gladly have joined them. That was what I wanted too, more than anything else, for the thought of parting from those who had given me such a loving home was unbearable; and, like everyone else, I was longing for the chance to get out of the ghetto. The prospect of living and working in the countryside excited our imaginations.

Aunt Tsesia and Uncle Shimshon weren't unduly concerned about the deportation order, and their children looked forward to the change most of all. In preparation for the departure, they exchanged all of their household goods and kitchen utensils for strong boots and warm clothing. Aunt Hanushka, Uncle Abraham, and I accompanied them to the assembly point in the prison courtyard. As soon as they passed through the gate, Aunt Hanushka burst into uncontrollable sobbing, unnerved at the thought of having to part with her second sister after she had already lost one. Uncle Abraham reproached her, insisting that we'd all be together again as soon as the war was over, but Aunt Hanushka was inconsolable. She couldn't rid herself of the haunting feeling that she might never see her relatives again.

We watched Aunt Tsesia and her family as they walked away from us, each carrying a heavy knapsack. My eyes followed my cousin Temcha, whose auburn hair, parted into two thick braids, stood out in the crowd. I was suddenly aware of how tall Temcha had grown. Though only a year younger than I, my twelve-year-old cousin had outgrown me by a head. As I watched her, I was reminded of a comical incident that had occurred while we were in elementary school, and I burst out laughing. When Uncle Abraham turned on me with a look of disapproval, I realized that this was hardly an appropriate moment for laughter; but on our way back home, I told him what had made me giggle.

When Temcha was in the third grade and I was in the fourth, our

classrooms were on the same floor. Our mothers loved to dress us up in the same clothes, and one day Temcha and I came to school wearing identical green coats with collars of gray rabbit fur. We hung our coats on the rack in the hallway along with all the others. After school we were in a hurry to get to Sienkiewicza Park and stake out our hopscotch squares. I hurriedly put on my coat and was astonished to find that the buttons didn't reach the buttonholes and that the sleeves were too short. Was it possible, I wondered, that I had grown so much in half a day that the coat which had fit me perfectly in the morning was now too small?

My classmates were calling, and I had no more time to think about this puzzle, but when I got home, my mother burst into hysterical laughter. With tears streaming down her face, she tried to explain to me that I was wearing my cousin's coat. Temcha, meanwhile, had put on mine, and couldn't understand why it was so roomy, with sleeves so long that her hands were lost inside them. Our mothers met halfway between our two houses with the coats in their hands, laughing so hard that people in the street stopped and stared at them.

I had hoped that my tale would cheer my listeners a little, but instead Aunt Hanushka broke into tears again, and Uncle Abraham busied himself polishing his eyeglasses.

The days that followed were particularly trying for me. I moved in with Aunt Hanushka and Uncle Hersh, where I had my own bed and plenty of space; but now I had to cope with my uncle's volatile moods. His nature had changed so greatly in the past year that I could hardly remember the elegant, good-humored gentleman he had been, the jolly uncle who never came to visit without a surprise hidden in one of his pockets. Now he was extremely jealous of me, grumbling whenever he saw Aunt Hanushka doing my hair, begrudging every bit of bread she put into my lunch box, and complaining about everything I did.

Sick of it all, I begged to be allowed to move out and live with my father again, but Aunt Hanushka and Uncle Abraham pleaded with me to ignore Uncle Hersh's behavior and to concentrate on my studies instead. I knew they meant well, and I realized that there was nothing I could do about my situation except to suffer it in silence; but I did this only with great difficulty.

I didn't tell my father about my troubles, for I did not want to worry him more than necessary. Instead, I hurried to the cemetery as soon as school was over each day and poured my heart out over Mother's grave. I told her of the deportation of Aunt Tsesia and her family, reminded her of the episode of the two coats, and complained about Uncle Hersh's erratic conduct. Unburdening my heart at Mother's grave brought me great relief. In fact, those moments were the only bright spots in my life now, but I was not permitted to enjoy them for long.

Father's Illness

My father's health continued to deteriorate, and he eventually came down with a severe case of dysentery. Because of his condition, he lost his job and along with it his extra bread ration. Aunt Hanushka tried to compensate for the loss by sneaking an occasional slice of bread for Father into my lunch box.

Father's illness put me in a spot. I couldn't leave school to look after him, for then I too would forfeit my additional food ration, which I had always shared with him. I racked my brain to come up with a solution to this dilemma and finally decided to call once again on my friend Lilka, whose father worked in the food supply department. She could easily do without her extra school ration, so I offered to buy it for the sum of five *pfennigs*, and she agreed to the deal. My routine now changed; I would set out to Father's apartment each morning before school started, leave him half my bread ration, and rush back right after school with the soup and meat patty I had bought from Lilka. In the evenings I returned again, bringing him another portion of bread and some coffee which Aunt Hanushka had prepared for him. All of these deliveries kept me so busy that I had no time left now to visit Mother's grave.

In order to prevent any of the children from smuggling food outside the school grounds, a guard was always on duty at the gate. One day when I was passing the sentinel's box, a policeman stepped into the path and barred my way. Looking up, I recognized Mietek, an old acquaintance. Overjoyed, I was on the verge of greeting him when I was checked by the scowl on his face. I understood quickly that he was determined to draw the line between us.

Mietek was the son-in-law of the Shor family, our former neighbors and my parents' closest friends from the old days, before the move to the ghetto. For years their apartment had been like a second home to me, and I had looked upon their daughter Sabcia — Mietek's wife — almost like an older sister. Mother and I had visited the Shors several times during our first days in the ghetto. They had obtained a two-room cottage with a plot of land next to it, and Mrs. Shor raised vegetables there, which she proudly showed off to us whenever we called. During our last visit I had been struck by the change in Mrs. Shor's appearance. She and Mother had gone off to the other room for a whispered talk, and when they emerged, Mrs. Shor's eyes were swollen from weeping. I had caught snatches of the conversation and heard her say that she and her husband would have been much better off if Sabcia and Mietek had gone to live elsewhere. When Mother reported the story to Father later on, she added, "Mietek has sold his soul to the devil."

Not long after Mother died, I had run into Sabcia and accompanied her to her parents' home, where I found Mrs. Shor sick in bed. She burst into tears upon hearing of Mother's death and kept repeating, "*Ach*, so young, so young . . ." She told me then that Sabcia and Mietek had separated and that their daughter had become their sole means of support. Several weeks later Mrs. Shor had died.

And now here was Mietek, standing in the gateway of the school and treating me like a complete stranger. He demanded curtly to know what I was carrying, and when he saw the soup and meat patty, he reminded me sharply that it was forbidden to take food out of the school. I managed to stammer out something about an upset stomach, telling him that I wanted to save the food until I felt better; I did not dare reveal my true intentions. Mietek miraculously let me off, but not without a warning that the consequences would be severe if he caught me at it again. He never had to carry out his threat, for I discovered another exit from the school grounds where I could slip out unobserved, though it took me much longer to reach home by this route.

Despite the extra food, Father's condition continued to deteriorate, and his face assumed an unnatural pallor. Dr. Kshepitzki, our family physician, came to see him and prescribed a strict diet to stop his diarrhea.

He told us that only hospitalization would give Father a fair chance of recovery and added that he could count himself lucky because of his strong constitution; a weaker person would have succumbed long ago.

Dr. Kshepitzki's advice put us all in a quandary, for there was no chance of getting Father admitted into the already overcrowded hospital. We knew of many sick people who had died long before their names reached the top of the waiting list. The doctor was unable to help us personally but thought that it might be effective if I made the request myself. "The pleading of a girl your age might arouse someone's pity and speed up the process," he told me. He left us a letter recommending hospitalization and went away.

After that I began to stand in line at the hospital reception desk every day, but my sad story didn't impress anyone — least of all the stern-faced reception clerk, who kept turning me away with the invariable refrain: "No beds available. Your father's turn hasn't come up yet."

Though I attended school as usual, my heart wasn't in my studies. My mind was continually occupied with strategies for bringing Father the extra food from school, and I was haunted by the dread of going to the apartment one day and finding him dead. I would run from the field of Maryshin right up to the door and then stop short in front of it with a pounding heart, not daring to enter. An unspeakable terror would take hold of me. Was he still alive? I'd peep in fearfully through the window until I caught a glimpse of him, lying with his eyes closed and his face so white that it almost blended with the pillowcase. I would rap softly on the pane, wait a moment, and then give a much louder rap. Panic-stricken at the lack of response, I'd shout at the top of my voice, "Daddy, Daddy!" Only after seeing him open his eyes and smile weakly would I dare to enter his room.

Dr. Lieder

Finally we reached the summer of 1941. I now had two years of high school behind me, thanks to the determination of our teachers to keep the school going against overwhelming odds. For the first time in my life, however, I had received two low marks on my report card, in Hebrew and in Latin. The time that I would have invested in language drill I now spent

standing in line every day at the hospital reception desk or in ration lines. All of my homework had to be done hastily between one break and another at school.

On the last day of the school year I went to visit Mother's grave and poured out all my troubles, large and small; I begged her to intercede in heaven for Father's sake and told her about the low marks I had received. I told Father, too, about my bad grades, but he dismissed my concern with words of praise.

The closing of the term brought upon me a new worry that nearly drove me crazy; I could no longer bring Father my ration of food from school. Each day I prayed that a miracle would happen and he would be admitted to the hospital, but each day I was turned away with the same terse refrain: No beds available.

The first day of vacation was disastrous. When I went to Father's apartment to prepare his meal, I had trouble getting the fire started. I had never learned to perform this simple household chore, and I wasted countless matches in the process. Finally Father had to get out of bed and light the fire for me. I hadn't seen him standing up for some time, and the sight of his frail body and stick-thin legs shocked me deeply. It took all the strength I could muster not to burst into tears. After the fire was lit, I quickly peeled the turnips — the only food that had been distributed lately — and put them into the boiling water. But the fire went out after a short time, and all I could offer Father was a soup consisting of salted water and half-cooked turnips, when he could barely digest anything!

The rest of the morning did not progress much better. After leaving the apartment, I went to get our monthly coal ration. There weren't many people in line that day, and I was soon on my way home, doubled up under a load of thirty kilograms of coal. The trip had never been short, but now it seemed endless. When I was halfway home my sack ripped open, and small pieces of coal began to tumble out in all directions. Somehow I managed to gather them all up and lug the load to Father's apartment.

I was in a downcast mood when I reached Aunt Hanushka's house that evening. Uncle Abraham was there, waiting impatiently to tell me of an idea that had occurred to him. He wanted me to appeal to our neighbor, Dr. Lieder, who lived across the landing, and ask him to use his influence

on Father's behalf. He had meant to take the matter up himself but thought that a young girl pleading for her own father might make a better case.

Dr. Lieder was a veterinary surgeon whom the Germans frequently called outside the ghetto to treat their horses and dogs. With the exception of Chaim Rumkowski, he was the only person who had the use of his own carriage and a personal driver to take him in and out of the ghetto whenever he pleased. My acquaintance with Dr. Lieder and his wife and son was most casual and had never gone beyond the exchange of polite greetings on the staircase.

My fervent wish to save Father's life overshadowed my shyness, and that very evening I stood outside the Lieders' door with a thumping heart. Mrs. Lieder answered my knock. She listened to my stammered request, led me to the dining room, and invited me to share their evening meal. I halted for a second on the threshold, dazzled by the scene that greeted me. In front of me stood a table spread with a white cloth and heaped with food — a whole loaf of bread, chunks of various cheeses, fish, butter, jam, a bowl of sugar, and a pot of coffee!

Before I had time to collect myself, I was seated at the table, and a plate with several slices of bread was placed before me. "Go on," I heard voices urging, "butter them and help yourself to anything else you'd like." I buttered the bread with a trembling hand but didn't dare to reach out for any of the other foods. Mrs. Lieder helped me to some slices of cheese, whose pungent aroma set my head spinning. But when I remembered my mission, the food stuck in my throat. I felt my chin begin to quiver uncontrollably and was on the verge of tears when Dr. Lieder came to my aid by inquiring how things were going at home. He encouraged me to talk about myself and the reason for my visit.

I repeated word for word what Dr. Kshepitzki had told me about my father's condition. The coffee was served, and the spoonful of powdered milk that was dunked into my cup brought back a smell and taste I had forgotten. Suddenly I found myself talking about my life before the war, something I hadn't done since my mother's death. The sugar bowl was pushed toward me. Hoping that no one would notice, I put two sugar cubes in my cup and kept a third for Father. When I finally took my leave, Dr. Lieder assured me that he would arrange for Father to be admitted to

the hospital at once. Completely overcome with gratitude, I burst into tears and could not even gather myself together to thank him.

I raced home to Father with the wonderful news. I told him over and over about everything that had happened in the Lieders' apartment, describing in minute detail the room, the meal, and the conversation. As he sucked on the sugar cube, Father smiled wearily. "And to think that less than two years ago," he said, "your mother had to force you to eat an apple or a buttered roll."

An apple! A buttered roll! Only two years ago — two summers, two winters. It seemed as though centuries had passed . . .

Dr. Lieder kept his promise. The following morning I was walking toward Father's apartment, thinking with a heavy heart of all the chores to be done and trembling for fear that I wouldn't find him alive. Suddenly a horse-drawn Red Cross ambulance overtook me, heading in the direction of our apartment building. My heart missed a beat. Was it possible? I broke into a run and managed to get there ahead of the wagon. Bursting into the room, I shouted, "Daddy, Daddy! They're coming to take you to the hospital!" I had scarcely finished my sentence when two men entered with a stretcher.

Father's face was radiant. "G-d hasn't forsaken us yet," he murmured. "I'd given up all hope of ever leaving this bed alive."

Too happy for words, I hugged Father and followed the stretcher bearers outside. As soon as the ambulance was out of sight, I ran to the cemetery to tell Mother what had happened. There was no doubt in my mind that the miracle had taken place thanks to her intervention with the Divine Powers. For days afterward I was aware of a sense of relief, as though I had been released from a heavy burden; my mind was at ease now, knowing that Father was receiving proper medical care. I recalled what Dr. Kshepitzki had said about his strong constitution, and I was convinced he'd recover.

The Bread of Life

My joy over Father's admittance into the hospital was so great that it made me forget my own unhappy situation — but not for long. The summer vacation had left me with no school ration and too much time on

my hands, and hunger was beginning to torment me again. Released from anxiety about my father and from the burdensome household chores, my days were empty. Reading had always been a favorite pastime, but the gnawing and rumbling of my stomach kept me from concentrating on my books. My cousin Salek, Uncle Abraham's son, suffered a similar lot, for he too had been dependent on the rations we received at school.

Salek and I looked forward eagerly to the beginning of the new school year, when we would again have enough to eat. But when the summer ended, classes did not start. Rumkowski's solemn promise to the high-school students had been broken. Our school would never open again.

Of course, we young people were not the only ones suffering from hunger. The number of ghetto residents dragging themselves about on swollen legs was increasing daily. Particularly affected were the unemployed, who had only their weekly ration to depend on — one loaf of bread. Many of these people were unable to make the bread last more than three or four days and were compelled to live out the rest of the week without any nourishment whatsoever. They became so weak that they died of tuberculosis and other diseases for which a malnourished body is easy prey.

So numerous were the ghetto deaths that instead of taking them for burial one by one, the funeral wagons were now heaped with corpses. Very soon there were not enough wagons to cart all the dead away.

As the death rate rose and deportations increased, the ghetto was rapidly refilled by Jews from Czechoslovakia and Germany. We were mystified by this development; thousands had just been deported from the ghetto, and now thousands of others were being brought in. But the Germans seemed to know what they were doing. Their goal was to replace those who were too weak to turn out the production quotas with healthy, strong workers who were as yet unaffected by the diseases rampaging in the ghetto.

We gazed in awe at the newcomers in their well-tailored suits and well-padded coats. They looked down upon us at first and shrugged off our advice; instead of dividing their weekly loaves of bread into equal daily portions, they rashly went through their rations within a few days. Before long, they began selling off their clothes and valuables to the

ghetto "millionaires" in return for more bread to fill their empty stomachs, but even this extra food did not prevent them from falling victim to starvation. Unlike the original ghetto inhabitants, who had been exposed to malnutrition over a period of years, these newcomers had had no time to develop defenses against the condition, and the death toll among them soon reached inordinate proportions.

Bread had now become so coveted a commodity in the ghetto that brother stole from brother and children stole from parents in the dead of the night. Of course there were exceptions. My uncle Abraham couldn't bear to see Salek and me go hungry, and he always divided his daily ration from work between the two of us. Though greatly tempted, I didn't want to accept the food at first, arguing that I had no right to deprive him of his share, that he was working and needed the bread more than I did. I had barely finished my protest when my usually good-humored and kindly uncle flew into a towering rage and yelled at me, "You little upstart! Who's asking your opinion? It's still *mine* that counts around here!"

Subdued, I took the bread with a trembling hand and a murmur of thanks. Aunt Hanushka watched this exchange silently, dabbing the tears from her eyes.

One chilly fall day, Salek and I were sent to the butcher's shop to get the one hundred grams of horse meat that were occasionally allotted to each individual. A closed wagon passed us on the street, and we got a whiff of freshly baked bread! So intoxicated were we that we changed direction and followed the bread van, our mouths watering. In a flight of fantasy, I imagined a stray loaf falling from the van and saw Salek racing to pick it up. I envisioned us sitting down in some dark corner and devouring chunks of the still-warm and crunchy bread, experiencing — just for once — the gratifying sense of being full.

The vision dissolved, and the memory of a long-forgotten scene from childhood took its place. During the summer months, which we had always spent at Uncle Abraham's estate in the country, Salek and I had often been sent out early in the morning to fetch milk and bread from the peasants in the village. The forest pathway was pristine at that hour, the dew still pearly on the grass, shafts of sunlight filtering through the hazel

trees and berry bushes. My cousin and I would stroll along the road with the empty milk cans swinging loosely at our sides, listening to the chirping of birds and the echo of our own voices in the morning stillness. There was an orchard that we always passed as we came closer to the town, and the aroma of the ripe apples that enveloped us was mingled with the fragrance of pine trees and baking bread.

After we had bought our loaves of warm bread, we would go to the home of the peasant who supplied us with milk. He would lead us into his cowshed, seat himself on a low stool, and begin milking the cow. We stood near him and watched in fascination as the jets of milk spurted from the udder into the pail. With our cans brimming and the basket full of bread, Salek and I would soon be on our way back to our house at the edge of the forest.

And now, years later, we were walking together again, lured on by the aroma of fresh bread. We were still ensconced in our fantasy when the bread van drove into a courtyard and the gate clanged shut behind it. My cousin and I exchanged looks of profound sadness.

Other than running errands, I now had little to occupy my time. I was not able to see my father due to the strict prohibition against visiting patients in the hospital. Instead I received progress reports from the receptionist, who told me that his condition was steadily improving. Although I longed to see him, my mind was at ease knowing that he was on the road to recovery. I resumed my visits to Mother's grave, but time hung heavily on my hands, and each day seemed to crawl by more slowly than the one before.

Salek, in a similar limbo, suggested that we use the time to pursue our studies. Since he was one class ahead of me, he would teach me the subjects he had studied the previous year, while he himself would try to obtain textbooks and meet the requirements for those subjects normally covered in the last year of high school. If nothing else, Salek argued, the work would take our minds off our hunger.

Salek had always been the studious type, but somehow I lacked the enthusiasm for such a pursuit at a time like this. In the midst of hunger, poverty, and death, the study of Latin and algebra or the sayings of Socrates and Aristotle seemed utterly absurd. What would these great

thinkers say if they could see us starving in a ghetto for no other reason than that we had been born Jewish? But Salek applied himself stubbornly to his self-imposed task, spurred on by the conviction that when the war was over he'd be able to take up his studies formally again.

My cousin's fervor finally infected me, and we both became absorbed in our new occupation. Salek tutored me in the morning and devoted the rest of the day to his own studies. In my eyes he was a genius. He excelled in both the sciences and the humanities, and was a gifted linguist. He also wrote poems, some of which became well-known in the ghetto.

One of Salek's poems affected me very deeply. Though I never learned it by heart, the essence of it remains in my memory even now. The poem was about a small boy lying awake beside his mother, father, and little sister, the pain of hunger gnawing at his stomach. In the corner of the room stood the bread box containing the small piece of bread that was to last the family for the rest of the week. The boy couldn't take his mind off the bread, and he fought hard against the temptation to sneak over and cut off a slice so thin that no one would be able to tell the difference. Why not? an inner voice kept prompting. Hadn't the bread already been whittled down to an almost insignificant portion? It wouldn't last the week in any case. So why not? Why not?

His conscience tried feebly to remind him of his hungry parents and sibling, but to no avail. Overcome, the boy stole past his sleeping family to the bread box and took a slice. Then he got back into bed, pulled the blanket over his head, and nibbled at the bread, now seasoned with the salt of his tears.

Salek's own hunger was eased somewhat when he found a job in a machine repair shop which carried the bonus of a ration supplement. Now Uncle Abraham had to share his work ration only with me.

In the Workshop

It was not long before I joined Salek in the work force. Uncle Abraham found me a job in his own workshop, which manufactured lingerie for German women. His eyes shone with happiness as he described how he had managed this feat; he had simply walked up to the

supervisor and told her about his eighteen-year-old niece who had worked in a lingerie factory before the war.

"But Uncle, I'm only fourteen!"

"Don't interrupt!" he said sharply. "I know exactly how old you are! Guess what happened then? She hired you on the spot. She was even annoyed that I hadn't mentioned you before."

"But I haven't the slightest idea how to make such things," I protested, shaking all over. "I've never even touched a sewing machine! They're sure to find me out!"

"Take it easy," my uncle said. "Don't you think I've considered that myself? You don't have to know much. I've been watching the sewing machine operators for a long time. All you do is put your feet on the treadle, turn the wheel with your hand, and the machine goes by itself. The rest is done mechanically. Besides, no one makes a garment from start to finish — you will be only one part of an assembly line. All you need to know is how to sew a straight seam. Tomorrow you'll come to work with me."

"Oh, no, I'm not. I won't tell a lie. It's hard enough to convince people of my real age!"

"You have to lie, my child," Aunt Hanushka interceded quietly. "And you'll do it convincingly. After all, it won't harm anybody. Having a job might be the only thing that will enable you to see the war through. You need the extra ration of food. And you know that the jobless people are constantly being deported. Look at Tsesia and her family! No one has a clue where they've gone to . . ."

They were right, of course; I had no other choice but to fib my way into the workshop. I consoled myself with the thought that if I succeeded, at least Uncle Abraham would no longer have to share his daily bread ration with me.

Early the next morning, Aunt Hanushka labored to change my hair style so that I would look older. She undid my long braids, cut my hair shorter, and with the aid of numerous hairpins built it into something resembling a tower. On our way to work, Uncle Abraham explained once again how easy it was to operate a sewing machine, but the more he talked the more nervous I became.

When we arrived at the workshop, he introduced me to the supervisor, who sized me up from head to toe. Standing stiffly erect to add to my height, I stammered out my uncle's story about my age and the trade I had supposedly acquired before the war. Without further ado, the supervisor led me to a seat between two women who were very busy pedaling away at their machines and did not give me so much as a glance. She handed me two pieces of satiny material and showed me how to stitch them together. Then she told me to repeat the process until the entire pile of cuttings was done, and went away with Uncle Abraham.

I began to work, pairing the two pieces as she'd shown me, setting the wheel in motion, and pushing the treadle up and down. Wonder of wonders! The machine started turning. It purred pleasantly, and the pieces of material glided forward. I reached out for the next pair and the next. A thrill of satisfaction ran through me. Uncle Abraham was right; I could handle a sewing machine without a hitch. If only Father could see me now!

But what was this? No sooner had I moved the completed batch aside than all the pieces fell apart as though they'd never been stitched together. I was baffled and threw furtive glances at my neighbors, both of whom were doing exactly the same work, but could gain no clue to my error. Maybe I hadn't pushed the treadle down as hard or as fast as I should have. I started the pile all over again, but after several attempts I had not made any progress; the pieces collapsed as soon as I set them aside.

Just then the door to the workroom opened, and Uncle Abraham peeped inside. I sighed with relief; surely he would get me out of this fix! But when he saw me bent over my machine, he assumed that everything was running smoothly, and with a wave of his hand he disappeared again. After several more tries I gave up. It was useless; my happiness had been premature. I found out later that while Uncle Abraham had been telling me about the wheel and the treadle, he had neglected to mention that the machine also had to be threaded!

Just then the supervisor passed by. She came to a sudden halt when she saw the mess next to my machine. I stood up quickly.

"Listen," I said desperately, feeling the hot blood rush into my face, "I can't do it. The truth is I don't know anything about this work. I've

never touched a sewing machine in my life! I told you a lie, but I'm not a liar, and I didn't mean to cheat you. It's work and bread I want." I tried hard to keep my composure, but despite my best efforts I burst into tears. Most of the machines had stopped running by now, and the women were all looking in my direction. Overcome with shame, I tearfully continued my confession. "I'm not eighteen at all! I'm only fourteen . . ."

I bowed my head, expecting the supervisor's wrath, but instead I felt a hand softly stroking my hair. "Stop crying, child," she said. "I could tell at once that you weren't eighteen. Never mind about that; you can stay on. We need youngsters your age, and we'll find something you can do. In time you'll also learn how to work a sewing machine."

I smiled through my tears, unable to believe my good fortune. A few minutes later I was seated at another table where I learned how to fasten buckles on corsets. When I had been at the job a few weeks, the supervisor kept her word and taught me herself how to operate a sewing machine. I took my place again between the two women in the sewing room. I had found a job and a skill I could use.

The winter of 1941-42 was upon us — the third winter since the war had begun — but I felt contented and warm. Father was still in the hospital, receiving the care that he needed. I had a job and a daily ration of bread, which meant that Uncle Abraham could now keep his entire ration for himself. I was happy at work; the supervisor treated me with affection despite my earlier deception, and my fellow workers were kind. Eventually I got to know most of these women well, but two in particular stand out in my memory.

Mrs. Frankel, who sat opposite me, was about twenty-six years old. Despite her pallor and hollow cheeks, her face was remarkably lovely, with large, haunting green eyes; but the most beautiful thing about her was her voice. She often sang Polish and Yiddish songs while she worked, songs about trees and birds, about hills and forests, about inner longing; and as the machines purred and her voice filled the room, we would forget our hunger and our suffering for a while.

Mrs. Frankel frequently brought family snapshots to show us, and I listened in fascination whenever she talked about her life. The only child

of well-to-do parents, she had married the son of a wealthy industrialist soon after graduating from high school. She had lived a happy life with her husband; her photographs showed the young couple on various vacations in the mountains and at the seashore. There were also many shots of their chubby baby boy, who had inherited his mother's radiant coloring.

Their son was three years old when they moved to the ghetto, along with Mrs. Frankel's mother. Mrs. Frankel had been the first to get a job, and thanks to her iron will had never once touched the bread she received at work, but took it home to share with her family. In time her husband had also obtained work, but — she told us sadly — he did not have the same self-control.

As time went on, Mrs. Frankel's songs were heard less often in the workshop. She began to tell her fellow workers about the terrible problems caused by her husband's behavior. Her family had always shared the weekly allotment of bread equally, finishing the first loaf before breaking into the second. But her husband, in total disregard of the others, kept sneaking pieces of bread whenever he felt hungry. Things became so bad that two days before the next rations were due, the family was often without a crumb of bread.

Finally Mrs. Frankel and her mother decided that her husband had to manage his own loaf and make ends meet by himself. Far from solving the problem, this only made matters worse; for Mr. Frankel went through his loaf in four days and then took a share of his son's ration, arguing that a child didn't need an entire loaf. The boy was now constantly hungry, having nothing to eat but the leftover morsels which his grandmother fed him, soaked in soup. This ordeal left its mark on Mrs. Frankel, and before long her appearance changed drastically. Her singing ceased, and along with it the stories of her glamorous past. Finally she stopped talking altogether and sank into an embittered silence, withdrawing completely into herself.

My neighbor on the right was Rochelka, a girl of about eighteen. Rochelka's large black eyes shone with a peculiar gleam, and she gave off an odor that grew more offensive from day to day. I asked her if she was ill but she answered evasively, and from hints dropped by Mrs.

Frankel I understood that I shouldn't say anything more. Rochelka, she told me, was suffering from galloping consumption — a severe case of tuberculosis.

Setting aside my strong aversion to Rochelka's physical symptoms, I befriended her and learned more about her life. She had been born into a very wealthy family and was in high school when the war broke out. Her father was drafted into the Polish army and was never heard from again. Rochelka, her mother, and her little brother Chaim moved to the ghetto, where her mother suffered a nervous breakdown. Sunk in a deep depression, she would sit by the window for hours with a glassy stare in her eyes, responding to nothing, not even to her own children. Finally she refused to eat. The entire burden of the family now fell upon Rochelka, who had to look after both her little brother and her sick mother. One day she found her mother dead in the chair by the window. Rochelka and her brother were now alone.

Each day when we received our bread rations at work, I couldn't help noticing Rochelka's inner struggle not to eat her entire portion. She would place the bread beside her and take tiny bites from it every now and then. It was obvious that she intended to leave some of it for her little brother, but she rarely succeeded. When there was nothing left of the bread, I often saw her weeping softly to herself, and I would think of Salek's poem about the little boy and the bread box.

Rochelka was full of praise for her brother, who kept the house clean and stood for hours in the long ration lines. She invited me several times to her house, and one day I finally went to visit her. As soon as I reached the floor where she lived, I was aware of the familiar foul odor, and it hit me squarely in the face when her brother opened the door. I stepped back involuntarily at the sight of this child. Chaimke was seven, but he looked no more than four or five; his shape was monstrous, with a large head and a tiny, feeble trunk. His round black eyes shone with the same peculiar luster I had observed in his sister's eyes. Only much later did I learn that this sheen was characteristic of all consumptives.

Rochelka brought me a chair, and I sat down to talk with her brother. In a thick voice that made him sound much older than he looked, Chaimke told me about a rumor going around that the next monthly ration would

include a hundred grams of marmalade. He was very excited about the prospect of receiving this sweet. When I left their place soon afterward, I felt a great relief.

For several days after my visit Rochelka failed to show up at work, and finally I went back to her apartment. When she opened the door, the stench from within all but overwhelmed me. I noticed a small heap on the floor, covered with a blanket. In a very dry voice Rochelka informed me, "My little brother died yesterday afternoon."

"Why didn't you tell them to take him away?" I cried, staring in fear at the lump on the floor. "Why are you keeping him here like that?"

"Look here, Salusia," she replied hoarsely. "He's dead, and there's nothing I can do about it. But tomorrow the weekly ration is due. If I had reported his death yesterday, they'd have taken away his coupons. At least this way I'll get an extra loaf of bread."

"And you're going to keep him here until tomorrow?" I asked in horror.

"What else should I do? Forfeit the bread?"

My stomach turned. I broke into a mad scramble and ran away as fast as I could.

The Notice

One day I stopped at Father's apartment and found two envelopes shoved beneath the door. Who could possibly be sending us mail? I wondered. Perhaps this was a sign of life from Aunt Tsesia? But that was unlikely, since any contact between the ghetto and the outside world had been completely cut off. I opened the envelopes with trembling hands and was riveted to the spot. Inside were orders of deportation from the ghetto for Father and myself! In two days he and I were to report at the prison on Czarnieckiego Street.

I was shaking all over — but not because I feared leaving the ghetto. Far from it! I was only too eager to get out to the countryside; perhaps we'd see Aunt Tsesia and her family again. But we couldn't leave now. Only yesterday the clerk at the hospital had told me that Father had just gotten out of bed for the first time and was now learning to use his legs again, like a baby.

With the deportation orders in my hand, I rushed to the hospital. The receptionist set my mind at ease by assuring me that Father would get a letter from the doctor recommending a temporary exemption, and that I would be exempted as well. It was inconceivable, he said, that they would send a child away all on her own.

The next day I reported at the office of the Sonderkommando, the special ghetto police force, with the doctor's letter. Father's deportation was put off on the spot, but mine was not. In tears, I tried to explain that I wasn't asking for a cancellation but only for a delay. I assured them that Father's health was improving and that he'd be fit to travel by the time the next transport was due. Surely the policemen could understand that I was my father's only child and that he would not be able to manage without me when he returned from the hospital. But nothing would make them change their minds. I could fill in a form requesting a delay, they told me, but if the reply did not come in time, I would have to report for deportation as ordered. There was nothing else they could do; now would I please move aside to make way for the next applicant in line?

My knees were buckling under me as I made my way to Aunt Hanushka's house. I won't go, I said to myself. I won't leave Father behind! I'll skip this transport, and they'll have to let me take the next one ... Father would be quite well by then, and we'd go together. I knew that I'd be forfeiting my ration coupons in the process, since all prospective deportees were immediately struck off the list. But I wouldn't let that stop me; I was determined not to budge without Father.

When I told Aunt Hanushka and Uncle Abraham of my plan, they agreed. "As long as we're around, you won't starve," Uncle Abraham said.

I knew that searches were conducted for all the deportees who didn't show up at the appointed time, but I wasn't afraid. They wouldn't be able to trace me so easily, I reasoned, since I was hardly ever at our apartment. The next morning, the day I was to report to the Czarnieckiego Street prison, I passed by our house and found the entrance sealed with a strip of white paper, affixed at the ends with two red blotches of sealing wax. I went to the police station to inquire about my application for a delay, but no answer had come. The policemen warned me to report to Czarnieckiego

without delay. Of course I had no intention of doing so, but I was unaware of how organized and thorough these procedures were.

The next day I went to the workshop and learned that a policeman had come there looking for me after I had failed to respond to the notice. My fellow workers had tried to explain to him that I was only a youngster and that my father was sick in the hospital, but he said he was under strict orders to track me down and bring me to the assembly point. They tried to put him off the scent by pretending ignorance of my whereabouts, all the time in constant dread that I would suddenly turn up. They now urged me to run and hide somewhere, and promised to take my daily food ration to Aunt Hanushka's house.

I followed their advice and left quickly, feeling like a hunted animal. Father's place was out of bounds for me, the workshop was forbidden territory, and I didn't dare approach the hospital. There was danger everywhere. Finally I went to my cousin Genia's attic, where I spent most of the time playing with her little daughter Rishia, who was now four years old. Uncle Abraham asked at the police station for news about my application, but there was still no answer.

A few days later I stopped at Aunt Hanushka's, certain that the danger had now passed, and the door was opened — by a Jewish policeman.* I was so stunned that I didn't immediately connect his presence with my own predicament, nor did I heed Aunt Hanushka's desperate signals. When the policeman asked for my name, I unwittingly gave it. Only when I saw his eyes widen did the truth dawn on me, but by then it was too late. The policeman could barely hide his own confusion; it had never entered his mind that he'd been sent after a child.

Aunt Hanushka sank on her knees before the man, telling him in a tear-choked voice that I was an orphan whose father was mortally ill in the hospital, and that she was responsible to her dead sister for my well-being. I too pleaded with him to tell his superiors that he had been unable to trace me. The policeman was obviously flustered, but said he had no choice. He was deaf to our appeals; he simply repeated his story that he'd

*The Jewish police force, called the *Ordnungsdienst,* was appointed by the Germans to keep order in the ghetto. Its members had to comply with German dictates and were forced to conduct and assist in deportation roundups.

been ordered to track me down at all costs, even if it meant lying in wait for me throughout the night. These last words sent a shudder through me, bringing to mind criminals whom the police were determined to trap by any means. But what had all that to do with me? Of what was I guilty? Suddenly a horrible fear came over me.

The policeman told my aunt to gather my belongings together but to take her time so that she would not forget anything, and he sat down to wait. When my friends from the workshop came in to bring my soup ration, he was genuinely moved, but only repeated again that it was beyond his power to help me.

Weeping silently, Aunt Hanushka shoved into a knapsack whatever she could find, even the bread that happened to be in the house — her own and Uncle Hersh's. She said she didn't care what he'd do when he found out about it. With trembling hands she braided my hair for the last time and helped me into my coat. She wanted to tie a woolen kerchief around my head for protection against the cold winds, but I refused it, donning instead my old high-school beret, from which the emblem had been removed long ago. Aunt Hanushka was crying bitterly as she took leave of me.

People in the street were startled to see a policeman escorting a child who carried a knapsack. They all knew what it meant; they were accustomed to seeing people led away, often entire families — but a child alone was a rare sight. When we neared the hospital, I begged the policeman to let me ask the receptionist about my father's health and to leave word that I was about to be deported, and he agreed. We entered the hospital, and the receptionist stared at us as if unable to believe his eyes. He recognized me and understood now why I hadn't come by lately. He told the officer that he hadn't the heart to send me away without letting me take leave of my father, even though it was against the rules and might even endanger his own job.

The policeman and I entered a large men's ward. All eyes were focused on us. Father's bed was vacant; he'd just gone out to the lavatory, someone informed us. The other patients knew at once who I was, for Father had often talked about me, his only child. I saw fear and sympathy in their eyes.

Father entered soon afterward, supported by a nurse; he was still unable to walk by himself. When he saw me standing in the middle of the aisle with my knapsack on my back and a policeman at my side, his face turned white. He began to sway and would have fallen to the floor if the nurse had not held him up.

I ran forward and hugged him tightly. "Daddy! They're going to send me off all by myself. I don't want to go without you. Don't let them send me away!"

Groans and weeping could be heard from all sides of the room. Father ordered the nurse to bring him his clothing at once and insisted that he was going away with me. The nurse dragged him to his bed and forced him to sit down. She explained the obvious to him: that he was incapable of taking even a single step by himself. But my father wouldn't listen. He said that if his clothes weren't brought to him immediately he would leave the hospital in his pajamas.

A doctor was quickly called in. He told Father that if he tried to leave now, the diarrhea was bound to return and might even cause his death. I was only being sent to a labor camp, he pointed out; I was healthy, and we were sure to meet again at the end of the war . . .

By this time I had stopped crying. I could see how weak my father was, and I tried to calm him down. "They're right, Daddy. You can't walk yet. I'm healthy and can look after myself. We'll meet . . . after the war. Try to get well quickly for my sake. Go and see Aunt Hanushka often and talk with her about me."

But Father refused to listen. He struggled with the nurse and the doctor until they finally forced him down on the bed and gave him a sedative. I left the hospital with shaking knees, the tears drying on my face. When we arrived at the gate of the prison courtyard, the policeman handed over the search warrant together with his "delivery," and the gate closed behind us. The courtyard was teeming with men, women, and children, huddled together in family groups and sitting on their baggage. I stood apart, watching the scene. Soon I saw several policemen enter the courtyard. One of them stood out because of his smart uniform and star-studded epaulets. He moved about energetically, barking out orders that were obeyed with curt salutes. Suddenly, out of the more than five

thousand people who were gathered there, the policeman's eyes came to rest on me. Once more his gaze swept the entire courtyard again — and once more settled on me.

"What's your name?"

"Sarah Plager."

"How old are you?"

"Fourteen."

"Whom are you with?"

"No one," I said. I told him about my situation, and the policeman who had brought me confirmed the fact that my father was unable to travel. The officer gave his subordinate a tongue-lashing for not having told him of the circumstances. Then he led me from the courtyard and took me into a large office, where he sat down behind a desk littered with paperwork. After scribbling something on a sheet of paper, he stamped and signed the document and handed it to me, saying: "You're released. Display this form at the exit. There you'll receive new bread coupons and two months' *ratzia*. May G-d restore your father's health."

In a daze, I thanked the policeman. I should have gone down on my knees and kissed his feet, for I learned later that he was the chief of the ghetto Sonderkommando.

With the precious piece of paper in my hand, I walked toward the courtyard gate. Its bolts were withdrawn, and I stepped into freedom — freedom within the ghetto! Oblivious of the weight of my knapsack, I ran straight to the hospital again. The receptionist looked up in shock, and his eyes quickly filled with tears.

"Go on! Run to the ward, but don't cause a disturbance; enter quietly," he instructed me.

I ignored his warning and burst into the ward like a whirlwind. "Daddy! They released me! Daddy, I'm free!"

My father sat up in bed, as did most of the other patients, and cried out, "Salusia, my child!" He rose and ran toward me — unassisted! We hugged and kissed and wept tears of happiness.

From the hospital I ran straight to Aunt Hanushka's. I found my aunt lying in bed, her face pale and her eyes closed. She had caught a glimpse of me through the window but had feared that it was merely an halluci-

nation. Only when I was standing before her in the flesh did she believe that I was real. She began to laugh and cry alternately, and in her excitement and confusion she kept calling me by my mother's name: "Mini'le, my little sister Mini'le."

Uncle Abraham and his wife Faiga shared in the joy of my escape, and when I reappeared at the workshop the next day, I was greeted with shouts of delight and affectionate hugs. It was as though I had returned from another world.

Potato Peels

Finally the joyous day arrived when Father was able to come home from the hospital. Although he was still not completely healthy, at least he was strong enough to resume his job. I was overjoyed to have my father returned to me, but our troubles were far from over.

Hunger continued to ravage the ghetto. Immediately after the *Sperre** no more *mussulmen* had been seen in the streets; they had either died or been deported. But it was not long before new ones began to appear, with their puffy faces and enormously swollen legs.

We soon learned to prepare two new kinds of food, which we dubbed *babka*. Babka in its ideal form was coffee cake, but in the ghetto it referred to cake made from whatever scraps were available. The first kind consisted of something resembling coffee grounds, which were really blackened wheat chaff—and the only foodstuff in plentiful supply at that time. The "grounds" were boiled in a small quantity of water until they solidified. The resulting substance was so bitter and had such an acrid smell that it took a certain amount of determination to swallow it. This babka, sweetened with some sugar or marmalade, was our standard food at the beginning of each month, when our rations came.

The second kind of babka consisted of the peels of rotten or frozen potatoes. After being washed thoroughly, the peels were brought to a boil in salted water, which was then strained. After a second boiling they were mashed or minced into a mush. This concoction, too, had a pungency that

*The *Sperre* was an embargo on all movement in the Lodz ghetto, which took place from September 5-12, 1942. During this week all of the children, elderly, and sick people in the ghetto were deported to Chelmno, the primitive first death camp. None of them survived.

left a smarting sensation in the throat and a musty taste in the mouth; but it stilled our hunger for a while.

Potato peels became a coveted commodity in the ghetto. People could be seen rummaging for them in the garbage cans outside the big workshop kitchens, where the daily soup ration was cooked for the employees. When the demand for potato peels increased, the kitchen workers stopped throwing them out and gave them instead to anyone who asked for them. This resulted in the formation of long lines outside the many workshop kitchens.

After a short time, the lines vanished as quickly as they had appeared. The kitchen workers had decided to keep the peels for their own families and friends — and unfortunately we didn't have any connections among this privileged group. But soon the kitchen workers lost their advantage. The ghetto doctors, aware of the peels' nutritional value, hoped that their vitamin content might reduce the swelling caused by malnutrition, and ordered them reserved for medical purposes. Henceforth, those rotten, rank-smelling potato peels could be obtained only by prescription.

My father was soon in need of this repulsive medicine, for his health had taken an alarming turn for the worse. Every day he'd get up earlier in order to reach work on time, and he would return home later in the evening. His walk had become sluggish, and his legs began to swell badly. He also began to complain of a constant pain in his back. Dr. Kshepitzki found that his body contained too much water and drained several syringes full of fluid from his back. Water in the back, the doctor explained, was a result of malnutrition, and the only cure for it was more food. He forbade Father to soak his bread in water and told him to avoid other fluids. He also prescribed two kilograms of potato peels.

Armed with the prescription, I took my place in line at the kitchen the following morning, but failed to obtain any potato peels; they had run out long before my turn came. The next morning I got up at dawn, even before Father left to work, and this time I succeeded in procuring the two kilograms of peels. The babka I prepared from them had so vile a taste that I couldn't get it down my throat, but Father ate uncomplainingly.

The "medicine" did not help him. The swelling in his legs increased, and walking became even more difficult for him. When he set out in the

mornings on the long walk to work, I was full of apprehension for him.

Father struggled bravely against his weakness and refused to give in to it. He tried to carry on as best he could, often remarking wryly that instead of his legs carrying him along, it was now *he* who dragged *them*. If he sat down, he couldn't get up again without my help, so he avoided sitting unnecessarily. He seemed to be fading away like a flickering candle.

One day his legs failed him altogether. He was only thirty-nine years old. The look in his eyes that day was one of sorrow and deep despair; I will never forget it.

Since Father was now bedridden, he lost the soup ration he had received at work. I was desperate, for unlike the time of his first illness, I now had no extra food to give him. I could only bring him half of my own soup ration from work. At lunch hour I was so hungry that the aroma of the soup would set my head spinning. Before starting to eat I would count the potato cubes in the soup and divide them into two equal portions. I'd eat very slowly, but before I knew it I had finished my share. I'd take another spoonful, just a last drop, and was shocked to see how little was left. Good heavens! I had hardly tasted the soup, and now the bowl was nearly empty! There was scarcely anything left to take home to Father . . .

I recalled Rochelka and her daily contest with hunger. Now that I was in the same plight, I no longer thought ill of her. I too wept because I couldn't resist the temptation to take another drop of soup, and yet another. This battle nearly drove me crazy. Each morning I vowed anew not to exceed my share. The days on which I managed to keep my vow were happy ones, but whenever I failed I would invariably burst into tears.

Father never uttered a word in complaint.

A Medicine Called Wigantol

The next time Dr. Kshepitzki came to see Father, he made an additional diagnosis: a lack of calcium in the bones, which was another disease common in the ghetto. There was a cure for this condition, a tonic called *Wigantol,* which was purported to contain a high concentration of vitamins. The doctor assured us that one bottle of this powerful medicine

would put Father back on his feet again. The trouble was that it could only be obtained at the dispensary, which was under the control of the Sonderkommando. The dispensary opened daily at eight-thirty a.m., and despite the long lines no more than twenty-five bottles were handed out each day. Dr. Kshepitzki prescribed this tonic for Father, but his outlook was bleak. "Who knows if you'll manage to get it," he sighed. "People begin lining up at five in the morning."

Father tried to persuade me not to attempt to get the medicine. "You heard what the doctor said — long lines for only twenty-five bottles. What chance have you got? You're too young — and so small!" His voice was full of despair.

I didn't reply, for I had already made up my mind to obtain the Wigantol. The following day I was up before dawn, determined to come home with my treasure in spite of the snowstorm raging outside in the darkness. In order to reach the office of the Sonderkommando I had to pass the gate on Zgierska Street. The road to get there, which connected two sections of the ghetto, was itself considered outside the ghetto boundaries and was patrolled by German soldiers. Both sides of this road were fenced off with barbed wire, and in order to cross from one side to the other, one had to pass through gates which were guarded by Jewish policemen. There was a bridge spanning the road that could be crossed freely, but it was much too far away from our apartment. This left me no other choice but to try to get through the gates — and I knew they were locked at this hour.

I put on my coat and Father's fur cap with the ear flaps, which completely covered my head. Outside, the stormy wind almost swept me off my feet. I groped my way along the dark streets until I reached Zgierska Street. A lamp was burning at the gate, but it was still locked, as I had expected. The freezing wind whipped about me, and I had to hold on firmly to the grille in order to keep my feet on the ground. The Jewish guard and the German soldier who were on patrol cast wondering glances at me through the driving snow. I explained to the guard that I had to get to the Sonderkommando dispensary, but he told me to go back home and return when they opened the gate. The German came to a halt in front of the gate and asked the guard what "that boy" was doing here in the middle

of the night. When the guard repeated my story, he ignored it and resumed his beat; but strangely enough, he returned to the gate after a moment and ordered the guard to let me pass through.

When I reached the dispensary, I discovered that I wasn't the only one with such foresight. In the murky darkness I saw several forms huddled together on the landing at the top of the stairs. There were only five of them and I sighed with relief, knowing that I would be the sixth in line to receive one of the twenty-five bottles of Wigantol.

It was now 4:30 a.m. The snowstorm roared relentlessly. My teeth were chattering, and the frost bit at my fingers and toes. I considered myself lucky, though, because my new shoes had kept my feet dry in spite of all the deep snow I had waded through. Time crawled by at a snail's pace . . . Every now and then a new snow-covered form popped up out of the darkness. One of these newcomers pushed himself into the line in front of me, claiming to have been there before I was. A second man backed up his claim and added that he was keeping another place for a woman who had also been here earlier. I wasn't very upset since I would still hold the eighth place. The line behind me grew longer, and then the woman who had been mentioned arrived and pushed herself in front of me, forcing me down two steps. Another two people claimed to have "been here earlier" and pressed ahead of me. I objected vehemently, but they shoved me down. Never mind, I consoled myself; I was still tenth in line.

The man in front of me took out a piece of bread and began to eat. The sight tormented me. It was only six a.m. now; two and a half hours to go before the dispensary opened. My feet were frozen, and I was shivering all over. What could I do to make the time pass faster? Perhaps I could entertain myself with thoughts of the past. A memory floated close to the surface of my consciousness . . . a memory of a time when my feet had been as cold as they were today. Now, what was it? Of course! . . .

One winter day a hundred years ago, Uncle Hersh had presented me with a pair of skates. I also received special leather boots to which the skates could be attached, and a skating outfit. Father took me to the skating rink in Poniatovski Park for my first lesson. He pushed over the ice on a sled with runners, and I held onto the sled for support.

Skating was a great deal more difficult than I had expected. The blades of my skates were extremely sharp, and I had the feeling that I was walking on knives. The moment I entered the rink my feet skidded in opposite directions, and I fell down. I had scarcely managed to stand up when I was down again! I was insulted when Father laughed at my predicament, but he urged me to keep trying and even talked about the day when I'd be dancing on ice like a ballerina. By the end of the first lesson I had improved enough to manage without the sled, and Father was full of praise for me. I was pleased with my progress, but I was also in tears because my feet were sore and frozen. At home Mother rubbed them with snow, and a tingling warmth began to spread through my body. After tucking me into bed, she brought me a cup of hot cocoa and sat near me for a while, kissing and caressing me. How pleasant it was . . .

Absorbed in my reverie, I had paid no attention to the people who were pushing ahead of me. I now held the thirteenth place. As the morning advanced, more and more people crowded in and several wedged in alongside me on the stairs, while others pressed forward from behind. Before long a double line had formed. At eight o'clock two policemen armed with clubs turned up and began to introduce order.

"What's going on here? A double line? Get off the steps, everyone! Hey, you, boy!" one of them shouted at me. "Down you go!"

"But sir, it's my place. I've been here since four in the morning! I was sixth in line!"

It was useless trying to make myself heard above the tumult and jostling that filled the hallway. I was constantly thrust downward until finally I found myself at the bottom of the stairs. There was an uproar further along, and the policemen swung their clubs. "Stop pushing!" they bellowed.

The door of the dispensary opened, and the lucky ones were already descending, each carrying a bottle of Wigantol. I looked after them enviously. By now it had quieted down and the distribution was proceeding in an orderly fashion. The line continued to move up, step by step; but at the very moment I reached the door, it was banged shut in my face. The policeman announced the end of the distribution and ordered us all to disperse and come back tomorrow.

At that point I threw a fit. I lunged at the door, thumping against it with my fists and kicking at it with my shoes. I howled and screamed: "I won't budge without the medicine! I was sixth in line and people kept shoving me down!" The policeman grappled with me at first, then tried to persuade me to go home and return the next morning. But I grabbed hold of the door handle and shouted, *"I'm not coming back tomorrow! The same thing will happen all over again! My father's terribly ill — he's stopped walking altogether. Only the Wigantol can save him!"*

Never in my life had I bawled like that! I didn't know I had it in me.

Just then the door to the dispensary opened and another policeman came out. "Stop that racket, once and for all!" he shouted, shoving me backward. "Get out of here, or else —"

His push knocked me off my feet, but I managed to thrust a leg through the open door, and they were unable to close it again. As they tried to pull me away, I grabbed the doorpost and held onto it for dear life, yelling at the top of my voice, *"It won't help you! I won't move without the medicine, even if I have to stay here until doomsday! I was sixth in line! The German soldier himself opened the gate for me at four in the morning!"*

Though my voice was getting hoarse, I kept shrieking and struggling. At length a man in a white gown emerged from the dispensary with a bottle in his hand. He walked up to me and asked for my prescription. My hand trembled as I held it out, and I almost snatched the bottle away from him. Mad with joy, I ran down the stairs and raced all the way home.

Father was astonished when he saw the bottle in my hand. Not wishing to upset him, I didn't tell him about the manner in which I had obtained it; but my efforts proved worthwhile, for the Wigantol did indeed turn out to be a wonder drug. Four days later Father himself opened the door when I returned from work. He was fully dressed and radiant with happiness.

"Look at me! I'm walking again and will even be able to run soon. I feel strong as never before!" he said, laughing and crying alternately like a happy little boy.

Everybody — Uncle Abraham, Aunt Faiga, and several of my cousins — gathered about us at the sight of this miracle. Father marched

back and forth before them, already full of plans. In another two days he'd finish the medicine and return to work. Now, he said, he would no longer have to deprive me of my soup ration . . .

The "King"

But Father did not return to work as soon as he had planned. Although he left the apartment, he still felt too weak to undertake the long walk and returned home almost immediately. If only his job were not so far away! I tried to think of a way to ease his situation, and suddenly I had an idea. I would ask Chaim Rumkowski for assistance! Surely he could get Father a job closer to the house — in a kitchen, perhaps, or a bakery. I decided to keep watch for Rumkowski's carriage and beg for his help.

Before I had a chance to implement my plan, the miracle wrought by the little bottle of Wigantol vanished like a mirage. Father's legs gave out, and when he sat down he was unable to rise again. Dr. Kshepitzki prescribed another bottle of the medicine, as well as two kilograms of potato peels. Once more I got up at the crack of dawn and was the first to pass through the gates at Zgierska Street. This time I didn't indulge in any idle fantasies but fought furiously for my rightful place in the line, and I got my bottle without a fuss. But the wonder drug was completely ineffective this time. Father did not leave his bed again.

I began loitering about in the streets of the ghetto, hoping to catch sight of Rumkowski's coach. This time I intended to beg for an increase in Father's food ration. "G-d," I prayed fervently, "give me the courage to stop his coach. Please take away my sense of shame and fear . . ." Of course, even if I did find the courage to speak to Rumkowski, I knew there was no guarantee that he would listen. The capriciousness of our "king" had become common knowledge in the ghetto; he responded to some of those who appealed to him for help, but drove off others with blows and insults. Rumkowski had decreed that Yiddish was to be the official language of the ghetto, and he forbade anyone to address him in Polish. So intense was his dislike of the Polish tongue that he would allegedly slap the face of anyone who dared to use it in his presence.

I didn't speak Yiddish well. I had heard my grandparents speak it when I was a small child, but everyone else had always spoken to me in

Polish. Now, as I roamed the streets where Rumkowski was likely to turn up, I kept rehearsing in Yiddish the few phrases I meant to address to him. Suddenly I heard the beat of horses' hooves, and I stepped out into the road — but the coach that came by was Dr. Lieder's.

The next day Rumkowski's coach finally did appear, but when I saw it I was paralyzed. I wanted to step out in front of it, but something held me back. Before I could gather my wits together, the coach was gone from sight . . . The third day came, and again I couldn't muster up enough courage to take any action. On the fourth day the coach passed again, but Rumkowski was not inside. I drew a sigh of relief; at least this time I didn't have to reproach myself for my cowardice.

This pattern continued for several days, but I was simply unable to quell my aversion to the act of begging. I knew this was mere vanity on my part, and my failing haunted me for many nights as I continued to rehearse my speech to Rumkowski. Yet each time a new chance presented itself, I faltered and put it off again for the next day . . .

Avramek, a neighbor of ours, unexpectedly came to my assistance. He worked as a messenger for Rumkowski's secretary, and he arranged for me to have an interview with her. I was very grateful to him; despite the suffering in the ghetto, the feeling of compassion for one's fellows apparently had not yet vanished altogether — although it sometimes seemed to me that those who could best afford to help others were so engrossed in their own welfare that they were insensible to the distress and squalor around them.

Avramek accompanied me to Rumkowski's office and encouraged me to beg very boldly for an increased food ration for my father. I walked beside him with a thumping heart, praying to G-d to give me strength. When my turn came to see the secretary, I entered the office on shaking legs. A young woman with a severe frown on her face was sitting behind the table opposite me, scribbling away on a piece of paper. I opened my mouth to tell her about my mother's death and my father's illness, but her stern appearance made the words stick in my throat. My chin started to quiver, and once again I burst into tears. Startled, she finally raised her head from her work and asked, "What is it you want, girl? Why are you crying?"

But I was choked by my tears and unable to speak. The secretary called in Avramek to ask him what was going on. Avramek did his best to describe our family situation, but he did not say all the things I had intended to say. The woman handed me a coupon for an additional soup ration, valid for only seven days. This was far too little! The week would be up in no time, and what would we do then?

I was still sitting in the office; I could still beg for a month's rations. If I didn't seize this chance, I would never have another — but I couldn't do it. The same paralysis that had frozen me so many times in front of Rumkowski's coach now seized me again. Someone else was already standing in the doorway, and my interview was over.

The secretary's impatient gaze swept past me to the next person in line. "What's this girl still doing here?" she asked. "She got what she came for, didn't she?"

I walked out of the office and cried bitterly all the way home. I had failed again . . .

The following week was a good one for us, even though it was all too short. After work I hurried to the public kitchen on Dworska Street, where my pan was filled with three-quarters of a liter of hot soup for Father and myself. For seven whole days I didn't have to count each spoonful of soup that I ate; for seven days I could finish my own ration down to the last drop without having to battle the guilt of dipping into Father's share. But the days went by quickly, and with each one the fear in my heart increased. Before I knew it, the seventh day had come and gone. That night I hardly closed my eyes, and with the arrival of the morning my torments were renewed. Should I go back to Rumkowski's office and ask for more coupons? What if I should burst into tears again and stand there struck dumb, as I had before? What could I do?

Then suddenly I thought of a way out.

Earrings and a Lottery Ticket

I owned two pairs of diamond-studded earrings that had belonged to my maternal grandmother. One pair had been among the valuables hidden in the safe in Genia's garden, but the safe had been confiscated by the Kripo. The second pair was kept with several other pieces of jewelry

at the bottom of the linen basket in our room. It now occurred to me that I might be able to trade my earrings for an additional day's soup ration for Father.

Taking care not to arouse his suspicion, I removed the earrings from the basket. The following day during my lunch break at the workshop, I finished all of my soup and then hurried with my pot and the earrings to Dworska Street. The public kitchen here not only dispensed rations, but also served as the hub of the ghetto's bartering trade, and it was already swarming with people making offers: soup in return for bread, bread in return for sugar, sugar for whatever else happened to be in demand.

I stood in the entrance to the courtyard, and people began to approach me to ask what I had to exchange. Most of them turned away indifferently on seeing the earrings; diamonds were a worthless commodity in the ghetto. I was beginning to despair. My lunch break was drawing to an end, and I had met with no luck. I was about to leave when a man came up to me.

"Show me those earrings again. You're sure they're genuine diamonds?" he asked.

"Of course they are," I answered eagerly. "They're heirlooms handed down to me by my grandmother. We've been keeping them for an emergency."

"Keep your pot steady," said the man, and he poured the soup from his own pot into mine. I hurried home, delighted with my success. When Father looked dubiously at the soup, I told him that there had been such an uproar in the kitchen the day before that I had gotten my soup without handing in the last coupon. I couldn't tell him the truth, but I was bursting to tell someone about this successful venture of mine and chose Salek. "You did the right thing in getting the soup for your father," he told me, "but we'll have to find some way to retrieve the earrings after the war, even if we have to offer a price far in excess of their value."

Of course the earrings had only bought one day's ration of soup, and the sleepless nights quickly returned as I racked my brains over other strategies for getting food. One morning I was so immersed in my thoughts that when I got to work I was at first unaware of the hubbub around me. Talking all at once in their excitement, several girls told me

about the lottery that was about to begin in our workroom. The lucky winner would be entitled to an entire month's work in a bakery!

I held my breath. For some inexplicable reason I was deeply convinced that G-d would help me draw the lucky ticket — maybe because all our soup coupons had run out, maybe because I had bartered away my precious earrings for one last pot. Trembling all over, I sat down at my machine, but was unable to do any work. I raised my eyes to heaven and entered into a silent parley with G-d, trading away ten years of my life in return for one month's work in the bakery, and promising solemnly to observe all of His commandments for the rest of my life. I tried to convince Him that my case merited His special favor. True, I argued, everyone in the workshop was equally hungry, but most of the others still had their families; I had only a father who was critically ill.

So absorbed was I in my communion that I already imagined myself the lucky winner. While my imagination was running riot, Shula, our supervisor, entered. She wasn't going to participate in the lottery, but her face was flushed with excitement. Shula tore up several sheets of paper, made thirty-six tickets, and wrote the word "Bakery" on one of them. After folding the tickets carefully and placing them inside a hat, she called on one of the girls to shake up its contents, and the drawing began.

Deep silence reigned in the room. Beginning at the far end, Shula passed from one girl to the next, and our eyes were glued to each person in turn as she unfolded her paper. There were four rows of benches with nine machines to each. Neither the first, nor the second, nor the third row had come up with the prize. With clenched and trembling fists, I watched each girl take her pick, and sighed with relief when she drew a blank.

Thirty-two girls had drawn blanks; the coveted prize still lay at the bottom of the hat. It was now Tola's turn. She took her time unfolding her slip of paper — and it was blank. Now it was my turn. "Dear G-d," I prayed, "please guide my hand. Father's life depends on it." With closed eyes and a pounding heart, I fumbled for a ticket inside the hat, conscious of all eyes on me. I unfolded it very, very slowly. And then . . . my heart missed a beat.

I had drawn a blank! I sank heavily into my seat and wept inside. "Oh, G-d, why did You do this to me? Why did You let me down?"

Before I had time to collect myself, a shriek split the air. *"Bakery!* I won it!" Rosie shouted. She fell on my neck, laughing and crying at the same time. It never occurred to her how utterly miserable I was. But her delight was so infectious that I couldn't help smiling, and for a moment I even forgot my own wretchedness.

That day I made up my mind to take the plunge and stop Rumkowski's coach. I loitered in the streets of the Baluty market for many hours, but, as if to spite me, he didn't appear anywhere that day. I saw him drive past the next day and on several days afterward, but my sudden burst of courage had dissolved in the interim, and I could not muster the nerve to step into the road.

Rosie's machine stood idle for an entire month. Each day while I ate my soup, I kept thinking of her and of the many loaves of bread she was now able to take home to her family. I was bursting with envy.

It was Rosie who eventually told Father about the lottery. She dropped in two weeks later with a loaf of fresh bread whose delicious fragrance filled our little room. Father, scarcely able to believe his eyes, didn't want to accept it at first, telling her that she ought to save it for her own family, but Rosie insisted that he take it; her relatives had plenty of food, thanks to her job.

Father realized now why I hadn't breathed a word to him about the lottery. He understood the distress I had felt, having been so close to such a prize and then losing it all in a moment.

A Bitter Passover

After the second bottle of Wigantol failed to put Father back on his feet, he despaired of ever recovering from his illness. He made a great effort to conceal his feelings and pretended to believe me when I talked about the war coming to an end soon and the things we would do when he was well. Each day when I came home from work, he would greet me with a smile and his usual quips, but his dull, sorrowful eyes belied him. The only thing I could do now was to supply him with plenty of books to make him forget his hunger for a while; but though he read a great deal, the books could not ease his agonizing pangs.

One day Father gave up reading altogether and no longer attempted

to conceal his deep despondency. He spoke openly to me, telling me that he had given up all hope of leaving his bed alive. I burst into tears and tried desperately to convince him that his weakness was only due to hunger.

"No, my child," he said. "It's no use fooling ourselves. I won't hold out much longer. Even if this war ends soon, I won't be here to see it. My only consolation is that you might survive — and somehow I'm sure you will. You're young and have the staying power of youth. I remember how it was when I was a youngster during World War I . . . The thought that you will be happy and whole one day is my only hope. As for myself, all I want is to eat my fill one time before I die."

I buried my face on Father's chest and cried bitterly for a while; but as my tears dried, a new thought occurred to me. "Daddy! I'll get you back into the hospital. There you'll get food and all the Wigantol you need. Why didn't I think of it before? Why didn't Dr. Kshepitzki think of it?"

I did my best to talk Father into agreeing with me. I reminded him of the time he had had dysentery, when he was in an even worse state than now. In the hospital, I assured him, he would have a chance of recovery. He was silent for a while; obviously he wasn't enthusiastic about the idea, but he did nothing to oppose it. "Perhaps you're right," was all he said.

When I made the proposal to Dr. Kshepitzki, he didn't seem very hopeful either. In fact, his response was rather evasive. "Well, if that's what you want, there's no harm in trying," he finally said.

As soon as he left, I hurried to the hospital with his letter of recommendation. The receptionist informed me that the wait at this point was not very long and that they'd have Father admitted within a day or two. I was overjoyed.

It was springtime, only four days before Passover. The arrival of the holiday would coincide with the next bread allotment, and this time each person would receive eight *matzos,* the unleavened bread eaten on Passover, in place of the usual weekly loaf. I managed to collect Father's matzos and his monthly *ratzia* before he was taken to the hospital. Pleased with this stroke of luck, I told him that I would be able to bring him portions of the extra food, in addition to the three meals a day he'd receive in the hospital. Father did not respond, and I couldn't understand why he was so apathetic.

Before leaving for work I fixed him something special — coffee mixed with a heaping spoonful of the marmalade we sometimes received. Father took a sip but was unable to swallow it. I suggested that he eat some bread first and wash it down with coffee, but he couldn't swallow the bread either. He tried to set my mind at ease by saying that the sweetness of the coffee had probably deprived him of his appetite, and he promised to eat it all in a little while. When I looked in on him an hour later, he still hadn't touched the food.

I had barely settled down at my sewing machine again when the shop manager came to tell me that she had seen the Red Cross wagon in front of our building. I raced down the street and reached the wagon just after the two attendants had lifted the stretcher onto it. I told them that it was my father they were taking away and asked them to let me kiss him goodbye, but they thrust me rudely aside, grumbling that they had no time to wait until everyone had done with kissing and leave-taking. I caught a glimpse of Father inside the ambulance, smiling feebly and waving his hand . . . then the door banged shut, and the ambulance moved away. I stood in the street for a while, looking after the white wagon until it disappeared from view.

Knowing that Father was in good hands and would even reach the hospital in time for the midday meal put me in a better mood. When I returned to work, I felt so happy that I began humming to myself, something I hadn't done since Father had fallen ill. I started a song, and the girls smiled at me as they picked up the tune and joined in.

After work that day I put together a parcel of my own and Father's rations and hurried to the hospital. The receptionist was like an old friend to me, and I chatted with him for quite a while. I told him how lucky I was to have collected Father's weekly and monthly rations before handing in all his food coupons, and remarked with a teasing smile, "I'll be here to pester you day after day . . . I'll be coming back to bring Father his matzoh ration every day of Passover."

The receptionist listened patiently to my excited chatter and promised to hand the food parcel to Father in person. He was not the only kind person there. Several other members of the staff who knew me were extremely sympathetic when I said goodbye to them that evening, and it

seemed to make up for the rudeness of the stretcher-bearers, who had refused to let me kiss my father that morning.

It was a beautiful spring day, and the warm breeze that was blowing convinced me that everything would work out all right after all. I went to the cemetery to share the happy events of the day with Mother. I sat on her tombstone and watched a little cloud floating across the sky . . . A sense of lightness filled my whole being, as if I had been released from a heavy burden. There was such peace and beauty around me. Surrounded by the fresh green of spring, I offered a prayer of thanksgiving to G-d for the favors He had shown me.

The following day the hospital receptionist told me that Father was fine and no longer felt hungry. When I came on the third day, however, he was not so friendly. I waved and smiled at him as I entered, but he only nodded briefly and busied himself once more with his work. He's probably in a bad mood today, I thought.

"Sir," I said timidly, "I've brought my father's last portion of bread. Tomorrow I'll be back with some matzoh . . ."

Without saying a word, the man bent down, took two parcels from beneath the counter, and placed them on the table. Something trembled inside me. These were the two portions of bread I had left for Father yesterday and the day before. Why hadn't the receptionist delivered them as he'd promised? Hadn't he told me only yesterday that Father was well, that he was no longer hungry? He had told me a lie!

"Why didn't you give the bread to my father?" I shouted in anguish. "He must have been waiting for it all this time! He'll wonder what's happened to me. Why did you lie to me? Why?"

The man kept his eyes fixed on the counter and said quietly, "Listen, child, I know I did wrong to tell you a lie. I did it because I hadn't the heart to tell you the truth. Your father died the day he was admitted. I couldn't bear to tell you the truth when you came in looking so cheerful and full of hope . . . I just couldn't bring myself to spoil your happiness."

For a few moments the receptionist's words failed to register. I kept thinking that Father was still hungry, for he hadn't received the packages I had brought for him. Then the realization cut through me like a blade. My father was gone. I would never see him again . . . never.

The receptionist was still talking. "Forgive me for not telling you right away. I thought it would do no harm if you went on thinking for another day that everything was all right . . . but I couldn't keep it from you any longer. Tomorrow morning at nine they are coming to take him for burial.* You should go and wait outside the cemetery then . . ."

I stood motionless at the desk. My feet seemed to be nailed to the ground. The thought that Father was dead, that I would never see him again, that all my hopes had gone up in smoke, kept pounding inside my head. As if from a far distance, I heard the clerk say, "Sit down, child. Here, take a sip . . ." Just then something snapped inside me, and I was able to move again. I took several steps backward and then broke into a run, heading for the doors, heedless of the man's shouts: "You forgot the bread, little girl! The bread!"

The bread had no meaning for me now. One purpose drove me on, chasing at my heels like a demon. Before long I reached the far end of the ghetto, where the barbed-wire fence separated it from the outside world. Two German sentinels with rifles on their shoulders were marching to and fro in opposite directions. One of them caught sight of me. He halted abruptly, pointed his rifle at me, and yelled, "Don't move!"

The second soldier rushed to his side, and both stood with their guns aimed, shouting at me to stop where I was. I ran on, praying for a bullet to deliver me — but it did not come. Sounds of screaming and whistling arose on all sides. Then two Jewish policemen suddenly appeared beside me, as though they had just popped up out of the ground, and they chased me as I made an all-out dash for the fence. I had almost reached it when they caught up with me. I struggled and kicked and bit, but they soon overpowered me and dragged me back in the direction of the ghetto.

"You fool! What do you think you're doing? The Germans were trying to get you! They would have killed you!"

"Please let me be, I *wanted* them to kill me!" I screamed, trying to break loose. I told them that my father was dead, that he'd be buried the next day, and that I wanted to be buried with him . . .

"Calm down," one of the policemen said soothingly. "I'm sure your

*Because of the mass numbers of people who died in the ghetto, burial procedures were frequently delayed, and a deceased person was often not buried for several days.

father wouldn't want that — he would want you to live on. You're still so young, a mere child."

It took a while before I came to my senses. Gradually my strength waned, and with it the will to go on struggling. The policemen seated me on a stone.

"Whom have you got my left, my child?" one of them asked.

That question unleashed the tears which had refused to flow until now, and I wept and wept as I had never done before in my life.

"There's no one left of my family," I sobbed. "No one to live for. I wanted to be with my father. Why did you have to interfere?"

One of the men stroked my head. "Go ahead and cry, child; it will make you feel better. Taking one's life is a sin. Your father would not have wanted you to do that. You've got to go on living for his sake." He left me for a moment to bring me a cup of water. After I took a few sips, he poured the rest of the water into his hand and bathed my face. He remained with me while the other officer returned to his post.

I have no idea how long I sat on that stone, but it was beginning to get dark when the policeman finally asked where I lived and offered to walk me home. I told him there was no need for him to watch over me since I did not have the strength to try anything dangerous again.

"I believe you," he said, but insisted on taking me home all the same.

Uncle Abraham* opened the door of the apartment and stared at us in amazement. I rushed past him and headed straight for my room, where I fell, sobbing, on my bed. My uncle came in after a moment and sat down beside me; he patted my head and said softly, "My poor girl. How much trouble you have known! But as long as I'm alive I'll look after you. You'll be my second child . . ."

During that long night Uncle Abraham dozed in a chair beside my bed, starting up in alarm at the least movement I made. Finally the sky began to lighten, and I sat up, dry-eyed.

"I'll come to the cemetery with you," my uncle offered.

"No," I said firmly. "I want to be alone with my father. It's the last time. Don't worry about me anymore — I won't try anything . . ."

*Portions of the manuscript are omitted. At this point, Sarah's Uncle Hersh had passed away, and Aunt Hanushka had been deported; Sarah was now staying in Uncle Abraham's apartment.

Uncle Abraham nodded, then took Father's prayer shawl and detached its ornamental collar. Father had made this silver panel himself in the shop where he had worked before the war. My uncle now put it away in the linen basket where I had kept my diamond earrings. He said to me, "Take care of this collar. After the war, when you get married, give it to your husband. Tell him that your father cast it and sewed it onto his *tallis* with his own hands." His voice broke, and I wept with him, a fresh surge of tears. After some time he handed me the unadorned *tallis* and told me that I must ask the gravediggers to wrap it around Father's body.

It was still early when I got to the cemetery, and I had to wait a long time before the black wagon arrived. The first body taken down was my father's. A tin plate bearing the name *Anshel Kalman Plager* was tagged with a thin wire to his feet. His face had changed, and his eyes were wide open, as if frozen in the midst of a fearful question. The men pressed his eyelids shut. Then they took the *tallis* and wrapped it around him, but they didn't do it carefully, and his legs were left exposed.

I walked silently behind the stretcher. Even when his body was being lowered into the grave, I didn't cry. Something kept choking me, but I didn't cry. Perhaps I had no tears left in me . . .

One of the gravediggers took a pocketknife and cut the traditional *kriyah** into the lapel of my jacket. They flung a few shovelfuls of earth into the grave and turned to leave. I protested in horror, demanding that they finish their job; but they were in a hurry, for it was the eve of Passover, and they were working only half a day. Besides, there were many more bodies on the wagon waiting to be buried. They shrugged me off; Father was just another dead body to them.

The gravediggers left, and I stood there helpless and bewildered. I suddenly felt that my father needed me, that he was asking not to be left abandoned like this, partially exposed and shamed. The well in the bottom of my soul opened up again, and I burst into wrenching sobs. One of the workers returned and lent me his shovel, telling me that I could use it only until they needed it again.

I began to shovel dirt over Father's body. How horrible it was! "Dear G-d," I prayed, "give me strength, but take away my understanding so that

*A customary rip made by a mourner in his garment.

I won't know what I'm doing! . . ." Every additional crumb of dirt made our separation more final. Soon Father would disappear from my sight forever. Don't think . . . don't think . . . finish quickly, before the man returns for his shovel . . .

In the midst of my labor I suddenly remembered that today, the eve of Passover, was my birthday. What a bustle there had always been at home on that day — what presents and what feasting! . . . I mustn't think about such things now, I mustn't feel sorry for myself, I must go on living without my father . . .

After I had filled the grave, I formed a small mound of dirt at the head and pressed Father's nameplate into it.

That night it rained hard. I lay in bed weeping and thinking of the rain seeping through the earth into Father's grave. My mind raced back three years to the snowstorm that had raged on the night after my mother's funeral, and I remembered how I had awakened in terror at the thought of her lying out there all by herself. But then, Father had been beside me, soothing and kissing me. Now there was no one who could console me.

The next morning I heard the hushed voices of my aunt and cousin in the next room, but I didn't get out of bed. Uncle Abraham came in and tried to offer me something to eat, but I refused. Everyone left, and I remained all alone in the apartment . . .

The hours crawled by very slowly, and my loneliness began to oppress me. I longed to be near people. After a bout of restless pacing, I finally went out into the street, which was deserted at this midday hour. I was drawn toward my workshop, but for some reason I was ashamed to face my co-workers, many of whom had known my father. I walked past the workshop twice before I finally mastered my aversion and went inside. I mounted the staircase with downcast eyes, keenly conscious of the looks of pity in the eyes of the janitor and others who passed me on the stairs. Singing was coming from inside the workroom, and as I hesitated in the hallway, the door was suddenly flung open by one of the girls. "Sala!" she cried out.

The singing tapered off, and all eyes turned to me. It was an awful moment. My eyes were glued to the floor, but I felt looks of compassion boring through me, and I winced. I walked toward my machine, wishing

for the earth to open up and swallow me. Strange though it may sound, I was deeply ashamed at the death of my father. But why? Was it only me, I wondered, or did everyone feel this way after such a loss?

While I was concentrating on my work, Shula, our supervisor, came up to me from behind. I heard her swallow a sob as she bent down and kissed me quickly on the cheek. Next to me Rosie, the girl who had won the lottery, was crying softly. Another girl at the table started humming absently, but she abruptly caught herself. "Oh, sorry," she whispered. Being the focus of so much pity was unbearable, and a huge, threatening lump rose in my throat.

Then, for some reason, a bizarre impulse seized me, and I began to sing myself. Scarcely a day after Father had been buried — and I found myself singing! I sang softly at first, then more loudly, while a new rush of tears streamed down my face. Finally the others joined in, restoring the atmosphere in the room to a pretense of normalcy. Thus passed the first day after I had buried my father.

Even at home I couldn't rid myself of this inexplicable sense of shame, which was further aggravated by the furtive glances cast at me by my cousin Salek and the Milewski children, who lived in our building. But at least here I could escape into my room and pretend to be asleep.

Going to work the next day was much easier. I looked at no one, greeted no one, and passed along the benches with my eyes trained on the ground. The looks of the girls did not seem so terrible today, and my presence no longer seemed to disturb anyone; intent on their work, they sang and hummed as usual. I felt as if I were enclosed inside a shell, completely isolated from the others.

When the lunch break came, I no longer counted the potato cubes in my soup or the number of spoonfuls I swallowed, and I did not sing again for a long time afterward.

Sarah Plager-Zyskind was eventually deported to Auschwitz along with the remainder of the people in the Lodz ghetto, and she was liberated in Mittelsteine. She and her husband fought in Israel's War of Independence and now live in Tel Aviv. She is the author of two books, HaAtarah HaNe'evdah, *from which "Stolen Years" is excerpted, and* Maavako Shel Hanaar.

ON THE ARYAN SIDE
❖

SEARCH FOR A CHILD
❖
Ryvka Rosenberg-Waserman
Pilev, Poland

The Wandering Begins

I was born in 1912 in the town of Pilev, in the district of Lublin. Pilev was a characteristic European Jewish town; we had several synagogues, and one of our prominent residents, the grand Chassidic Rabbi, was a grandson of the Kotzker Rebbe. The Polish population was small but typically anti-Semitic. The town supported a few public elementary schools, as well as an agricultural high school, a common institution in those days.

My parents were considered middle-class, and they were G-d-fearing Jews. Our family consisted of eight children: six boys and two girls. Only three of my brothers and I survived the war.

In 1930 I married Shymon Waserman, an industrious and successful businessman who dealt in crops, grain, and fodder. His business flourished, and soon he became a partner in a transport company. Shortly before the German occupation, we were about to buy a house in Pilev. This was a considerable advancement, for in Poland a Jew who owned a house was considered a member of the upper class.

Signs of anti-Semitism were quite pronounced, and in fact the oncoming war was in the air; but even so, when it finally broke out in 1939, we were caught very much by surprise. At the time I was with my

two boys, Menashe and Yaakov, in Malinki, a country neighborhood near Pilev where we used to spend the summers. On Friday, September 1, 1939, my husband came out from the city to pick us up. In just a few hours it had already become impossible for us to return home, for the Germans had bombed our town. Their aim was to destroy the bridge over the Vistula River to prevent the Polish army from retreating eastward. As a result, all the roads leading to Pilev were immediately cluttered with tens of thousands of people fleeing the approaching German forces. The refugees were met with a hurricane of grenades and bombs, which were hurled from low-flying airplanes. The confusion and panic further increased the congestion on all the roads.

My husband, who was a practical and courageous man, quickly assessed the situation and decided to use side roads. Instead of going home we went to Miechow, a nearby small town in the district of Kielce, where we managed with difficulty to rent a dilapidated one-room apartment. However, we did not escape the terror and chaos of the new crisis that had been thrust on our country, for here, too, thousands of homeless refugees thronged the streets. The pandemonium was so intense that many parents were separated from their children and never found them again. Those people who could not find a place to live slept on the sidewalks and in the gutters, while others ran into hiding in the forests and fields. But ultimately, no place was safe. The long arm of the Nazis reached everywhere, and people fell dead like flies. After several days of bombardment, the Nazis secured the occupation of Miechow.

As soon as the terror had subsided somewhat, we returned to Pilev; but in a short time our hometown was occupied as well, and we found ourselves under the murderous thumb of the Nazis. One of their first orders was the formation of a Judenrat,* and Henrik Adler was appointed Judenelteste. Adler, a former officer in the Austrian army, was a very honest man who had been chief of the local public school system. One month after the occupation, the Germans confined all the Jews of the

*The formation of *Judenraten*, or Jewish councils, was one of the first of a systematic series of orders implemented by the Germans in each town they took over. The Judenrat, whose members were appointed by the Nazis, was a strategic and multi-purpose instrument; it managed internal Jewish administrative affairs in the sequestered ghettos, and it acted as a Nazi puppet, providing quotas under duress for forced labor and for eventual deportation to the death camps.

town in a cramped ghetto, where the houses were small and decrepit. All of the windows facing the Aryan side of the town had to be kept sealed and dark.

Our house had been totally destroyed during the bombing, so we had to move into my sister's apartment. She welcomed us with open arms, and although we were very crowded, we consoled ourselves with the thought that all the Jewish families were in the same predicament. Many other homes had been destroyed, and those whose houses were still livable had to make place for the others. The ghetto became congested beyond imagination. It was plagued in addition by a severe shortage of food.

The only way to obtain food was to smuggle it in from the Aryan side, an offense punishable by death; but if we did not want to die of hunger, we had no choice but to risk our lives. The smugglers were primarily women and children. They were hunted by the Germans, and those who were caught were tortured and sometimes shot.

The Germans appointed a Volksdeutsche named Matkowicz as mayor of Pilev. Known for his cruelty, he began a massive campaign of harassment, encouraging the robbery of Jewish possessions and the pillaging of property, and humiliating the Jews at every step. Then he ordered the boundaries of the ghetto to be narrowed even further.

The Judenrat leaders tried to reason with Matkowicz, explaining that the increased crowding would lead to the outbreak of epidemics. When their pleas yielded no results, they tried to bribe the German officials to annul the edict. The Germans refused the bribe, and so we were forced to crowd into smaller and more run-down rooms. But the worst was yet to come.

One day the Germans decided to expel us from the town altogether. The thought of leaving the town in which we had been born and raised caused us anguish enough; we were further terrified at the prospect of having to travel in the heart of the brutal Polish winter, a time when any movement was extremely hazardous. A delegation of Jewish women went to the authorities with a petition to revoke the edict, or at least to postpone it until spring. They explained that a journey in such cold would cause many deaths, but the German representatives were not swayed.

Suddenly, before the date of the expulsion, a detail of SS soldiers apprehended all the Jewish men of the town, stood them against the wall, and forced them to sing songs. While they were standing there, the murderers summoned all the members of the Judenrat, including Judenelteste Adler, and bludgeoned them with iron rods until they were beyond recognition.

Realizing the hopelessness of the situation, my husband and I decided to flee the town and look for refuge in a region under the Russian occupation. My husband smuggled himself out of the ghetto and traveled as far as Gniewiszow, where he intended to hire a horse-drawn wagon for our escape across the German-Russian border. However, we could not carry out our plan because the Germans abruptly initiated the planned expulsion of the Jews from Pilev. They cordoned off the town periphery and blocked all the surrounding roads. My husband could not return home.

When I saw that he wasn't coming back, I decided that I had to act on my own. I removed my yellow star, sneaked out of the ghetto, and went to the local market square to hire a wagon, hoping to take my two children and flee the town before it was too late. Gentiles were now officially prohibited from trading with Jews, but I prayed that I would not be identified.

That day was Friday, when all the peasants from the surrounding villages came to sell their wares. Among them I recognized an old acquaintance from Malinki, the country village where we had spent our summers. With his help I rented two wagons and smuggled out my mother, my sister and her children, and my youngest brother to a nearby town. Next, I left my two children temporarily with a Polish woman on the Aryan side of Pilev. I also managed to retrieve some of our most important household items, which I sent in the wagons to Malinki.

In the meantime I remained at home in the ghetto. When the situation had quieted down somewhat, I went to retrieve my two boys, and as soon as the blockade was over, the three of us started out on the road to Malinki. Along the way I managed to send a message through some Poles to my husband, who was still in Gniewiszow, telling him to join us in Malinki.

It was now January of 1940, and the weather was bitter. The distance

to Malinki was only seven kilometers, but traveling on foot with two small children on a road covered with a high blanket of snow was no simple task. The trip took us more than four hours.

When we finally arrived, we learned that all the Jewish property had been confiscated by the Germans. The Polish peasant from whom we had rented our summer home each year welcomed us cordially. He was an honest and compassionate Pole who empathized with the plight of the Jews. However, we knew that his family would be subject to harsh punishment if they were found giving shelter to us, so we remained in his house for a few days only and then traveled on to Konska-Wola. Here we could find no room to rent, so we traveled on again — this time to Wonwolice, a town in the area of Lublin, where we moved in with four other people in a tiny attic.

Even here we found no peace. There were eight of us altogether in this little room, including children, but this was not the greatest burden. The Nazi pattern of dominion had assumed a predictable pattern. In this town, too, the mayor was a Volksdeutsche, and the Jews under his command were maltreated and humiliated in a terribly brutal way. When the fear became unbearable for us, we moved yet again to Hodel, a small hamlet in the same district.

In spite of the severe restrictions imposed by the Germans on every aspect of Jewish life, the Jews during this precarious time did not hesitate to violate the edicts. Many were caught and killed on a daily basis for every type of real or alleged infraction, but their will to survive was stronger than any other force. My husband endangered himself by engaging illicitly in the flour trade. While still in Gniewiszow, he had secured false Aryan identification papers for himself and for me, and he traveled from town to town under the Polish name of Jan Winiecka, even going as far as Warsaw.

In spite of all our difficulties, we led a relatively quiet existence in Hodel during the next ten months. At the end of this hiatus, the terror began anew. The Germans began to round up Jews again, but this time it was not merely for the purpose of humiliating or beating them; now they were being sent to extermination camps. One of the camps was Belzec, which was known to be run by Germans with criminal records.

My husband was among those captured and sent off with that first transport, but he was not ready to comply with the decree. He organized a group of young people who escaped from the concentration camp one very black night, and he returned to Hodel. To this day I have no idea how he carried out such a bold plan. I knew that in the camp there were watchtowers manned by guards who carried machine guns and had giant attack dogs at their disposal. Searchlights flooded the entire area, and the camp was surrounded by triple wire fences, ditches, and road blocks. How the men passed all these obstacles unnoticed is a riddle to me.

Refugees

In February 1941, in the midst of a biting frost and temperatures ranging to twenty-five degrees below zero, refugees from Lublin began to arrive in Hodel. They had been expelled in a very cruel manner, and their plight was horrendous. Especially heartbreaking was the sight of the little children, who had been tossed out like garbage. At first the refugees were sheltered in an abandoned synagogue, but gradually they filtered into the town, which did not even have room to house its own inhabitants.

Even before the arrival of the Lubliners, news had reached us of a wave of refugees who had been expelled from Vienna and had come to Opole. When we heard this, my husband and I decided to visit them. It was very dangerous to walk on foot from Hodel to Opole, in deep snow and stormy winds, knowing that the Germans would kill us on the spot if they found us. But we felt urgently that we must go. Even if we had known beforehand that we would not be able to do much to help, we felt a strong need to identify with our fellow Jews in their misery.

The Viennese Jews were living much like the Lubliners, sleeping in synagogues and *shtiblech* (small prayer houses), in wooden shacks and huts, and even in abandoned market stands. They used blankets to divide the space in those rotting rooms and to create compartments for each family. The blankets also served as shields against the cold, powerful winds that seeped in through the cracks in the walls and windows.

The Viennese Jews were very different from us. They were better dressed and better educated, but they were much more confused and frightened. They told us that their exile had been sudden and malicious;

they had had only fifteen minutes to pack their most necessary belongings and were pushed into train wagons before they even had a chance to finish. Among them were patients, doctors, nurses, and other staff members of the well-known Rothschild hospital in Vienna. These were people accustomed to lives of comfort and luxury, who had suddenly been thrust out of their homes into a poor, remote east European village. And this was only the beginning of their troubles.

The Judenrat of Opole did its utmost to alleviate the refugees' plight and to provide them with food and other vital services. They established a public kitchen and distributed hot meals, free of charge. The community, however, was a poor one, and its resources were very limited. The Jews of Pilev had also been exiled to Opole, and the crowding became literally intolerable. I am still in wonderment to this day as to how the people there were able to carry on any kind of routine existence under such fearful conditions.

When we returned to Hodel, we discovered that our own situation had changed from unpleasant to treacherous. On *Taanis Esther*, the Fast of Esther, when I was kneading *challos* for the feast of Purim, a Nazi burst into our room and demanded to know where I had obtained my flour.

"I bought it at the market," I replied, hoping desperately that he would not ask me any further questions. My husband had brought me the flour, and it was forbidden for Jews to engage in such trade.

Without answering, the German began beating me viciously, in spite of the fact that I was in the last months of my pregnancy. He only let go of me when I was lying unconscious in my own blood. I was sick from the wounds for more than a month, but thank G-d my pregnancy continued normally.

As a result of this German's "discovery," the authorities organized a hunt for all Jews in the area involved in illegal trade. They were understandably interested in my appearing as a key witness at the trial, or even as a defendant. On top of this, we found out that a non-Jewish smuggler who had been arrested had disclosed my husband's name. We had no time to weigh or plan. We grabbed a few bundles, and in the thick of the night stole through the ghetto fence to resume our seemingly endless migration. We trudged along dirt roads with our two little

children by our sides. We walked until we came upon a wagon, and we asked the driver to take us as far as the Vistula River, hoping to reach Gniewiszow on the other side, the town where my husband had been stranded at the outbreak of the war. I had some distant relatives there, and we had heard that the news from Gniewiszow was not too terrible.

My children were frozen to the bone by the time we reached the river, but they did not cry. Somehow they felt and understood our bitter predicament. As I pressed them against my body to warm them up a bit, my five-year-old son Yaakov said: "Mama, it's better to die than to suffer so much."

Yehudis

When I knew that I would soon go into labor, my husband advised me to go to Warsaw. Here in the remote village of Gniewiszow there wasn't even a single Jewish doctor and no chance of getting any kind of adequate medical help. In spite of my fear, I disguised myself as a Polish peasant woman, using the Aryan papers my husband had acquired for me some time ago, and reached Warsaw without complications on July 15, 1942. There I found a room with a Polish woman with whom I had had a friendly acquaintance before the war. However, immediately after I returned from the hospital I was forced to leave her house, for friends of my hostess had warned her that someone was spreading the word that she was "in contact" with Jews. I took my infant in my arms and returned to Gniewiszow, using the same illegal means by which I had come. We named our baby daughter Yehudis.

Earning a living in an isolated town like Gniewiszow was very difficult. We worried constantly about our children, especially about Yehudis, for whom we could not get milk. My husband and I never ate our fill, for whatever we had we gave to our hungry children. As though they understood our plight, they never complained and never asked for anything; they accepted all of the anguish and discomfort with an unusual and precocious understanding.

As time progressed, our lot worsened. We sold whatever we still possessed that wasn't absolutely necessary for survival, but soon we had no options left. The Germans had made food almost impossible to obtain.

When there was no other choice, I smuggled myself out of the ghetto to get some food for my three children. Constantly I was plagued by one thought: "If I am caught, how will my little birds survive without a mother?"

There seemed to be no end to our troubles. Wherever we ran, the Nazis caught up. We became pieces tossed about in a game, batted back and forth from one place to the next with no chance of resting.

On August 20, 1942, the Gestapo in Radom proclaimed an expulsion of all Jews of Gniewiszow and the surrounding vicinity. We were to leave our homes within twenty-four hours and travel to a designated area in Zwolin. We had heard that Zwolin served as a concentration point for the deportation of Jews to the death camp Treblinka. We had little time to contemplate; we decided quickly to flee to Demblin, but this time not together. We separated into three groups, so that if something happened to one of us, G-d forbid, the others would have a chance to escape and our family would not be wiped out.

I disguised myself in my peasant clothing, took Yehudis in my arms, and told my five-year-old Yankele to follow closely after me. Together we stole out of the ghetto and walked in silence along narrow paths through the fields, guided by a seventeen-year-old Jewish girl who was also disguised as a peasant *shiksa* (gentile woman). We were trembling with fear, for a Jew caught on the road could expect only a bullet. We had no packages; all our small possessions had been left behind in the urgency of the moment. My husband left the ghetto separately, also in Aryan disguise, and our older boy we hid for the time being in the house of a gentile coachman. However, luck was with us, and our family was reunited in Demblin. My husband had relatives here, and they welcomed us wholeheartedly into their single narrow room.

We heard that the Germans were about to establish factories in Demblin and to use Jews as slave laborers. If work was available, the prospects for survival here would be a bit better. My husband succeeded through bribery in getting a working position that appeared secure, and with tremendous difficulty we also managed to rent a quiet corner in another house so that we no longer had to burden our relatives. The new

place was equally crammed; my three children and I shared one narrow bed, and the room was infested with vermin and mold. To obtain food or a sip of water was nearly impossible. Food was distributed in Demblin — as in all the ghettos — only to those who held German coupons, but we were living here illegally without coupons and were literally starving. To make matters worse, Herbert Winkart, the Demblin Judenelteste, had received strict orders, on the threat of punishment, to deny entry to refugees. It often happened that when the police were conducting a hunt for the "illegals," we had to run from our "corner" and hide in some other shelter or in the fields outside the ghetto.

The struggle to sustain and protect my young children now rested totally on my shoulders. My husband couldn't help me because he was working in a German factory, and any movement outside the factory grounds during working hours was restricted. My mother and sisters were in a different town and were unable to come to my aid. In addition, my infant fell ill and required immediate medical attention, and once again I had to smuggle myself out of the ghetto to find help. The life of misery I had endured for three years now turned into a hell on earth.

In September 1942, the liquidation of the Demblin ghetto began. My husband decided that as soon as anything serious happened, we would smuggle our two boys into the camp where he was working and hide them in the factory. He even took them to the grounds on one occasion to familiarize them with the route, in case of emergency.

On October 15 the *Aktion* began, unleashing an uproar and confusion so overwhelming that it paralyzed all the people in the ghetto. I sent my boys out to the factory, but to my great distress I had waited too long, and they had to return. The roads leading to the camp had suddenly been cordoned off and were swarming with Germans. The boys tried once more to break through the blockade and reach their father, but they were caught and put aboard the transport going to the Treblinka death camp.

I pulled myself together, put on my peasant costume, and with my baby in my arms turned toward the outskirts of the town, where only gentiles lived. My disguise seemed effective, and the German soldiers paid no attention to me. I walked aimlessly; the area was totally unfamil-

iar to me, and I did not know anybody there. Then I saw a wooden shack and knocked at the door. The people let me in but only for a short time, not wanting to endanger themselves on my account. I left, finding myself once more on a strange road in a strange neighborhood. Shots pierced the air around me. I heard that the Germans were killing Jews, particularly the old and the feeble.

Night fell. I was confused and despondent, not knowing where to turn. I continued to wander with the baby, not knowing what to do or what path to take. A sudden indifference to my fate suffused me; only one request to G-d was in my mouth — that He should have mercy on my baby, who did not yet know the meaning of sin . . .

As I was walking in the darkness of the night, two SS men carrying machine guns appeared nearby. It was too late to run, for they had already seen me. I had no choice but to continue walking peacefully, as though I were heading home to the nearest village. My casual walk must have convinced them of my "innocence," for they did not stop me.

After a while the shooting finally stopped, and the transport to Treblinka departed. The Poles, who had taken refuge in their homes during the *Aktion*, were now emerging into the streets. A group of young gentiles ran after me, shouting, "Look! Look, a Jewish woman still remains!" I quickened my pace.

As I ran along, I stumbled on several dead bodies, victims of the shooting of moments ago. I saw that not only the sick but also many young and healthy men had been killed that day.

A strange sensation engulfed me, a wave of the apathy I had felt earlier in the evening. I walked as if moonstruck, as if my life and the life of my little one were not at stake, detached and indifferent toward everything. My baby did not cry, though she must have been very hungry. I passed the town like a thief, being very careful to avoid contact with anyone, and made my way to the factory where my husband worked.

There I found my older boy, Menashe! By the greatest good fortune, my husband had managed to rescue him. When he saw that the children were not coming to him in the factory as planned, he surmised that they had been caught and perhaps even put on the transport. He asked a guard at the factory to escort him to the town, a distance of several kilometers,

and for a substantial price the soldier agreed. As they were coming into Demblin, they bumped right into the transport. Menashe noticed my husband and jumped from the wagon. Yankele, the younger one, tried to follow him, but was caught and dragged back to the train.

I can hardly explain my feelings at that moment. I had lost my little son — but at the same time I was overcome with happiness at the miraculous rescue of my older boy. It is too difficult to explain . . .

The fact that we were inside the factory gates did not mean that my baby and I were finally on safe territory. On the contrary: the German commandant discovered that many Jewish women and children who had escaped the shooting spree in the town were hiding on the factory grounds. He issued a harsh order to the Demblin Judenelteste, Mr. Wankort, to find and expel all of them. I didn't wait to be caught, but immediately fled with my baby and returned again to town. There were rumors that those who had survived the initial roundups would be allowed to return home safely. Even the sworn pessimists clung to these rumors, preferring to live under the illusion that for the moment, at least, they were safe. "And later," they said, "whatever has been decreed upon us from above will happen anyway . . ."

In the meantime dead bodies were being removed from the streets of Demblin, but the traces of the massacre could not be completely erased. Gigantic blotches of blood and piles of spilled brains were scattered in many places . . . It was an unspeakable experience to walk the streets where Jews had once lived, to see signs of the slaughter on every step. By the side of the house where we lived, two young girls lay on the floor, murdered in cold blood. It was a grisly sight . . .

We were not allowed a moment's rest. Amidst all this horror, an inner voice told me that the crisis was not yet over. I felt intuitively that another *Aktion* might follow this one, and indeed, on October 27, twelve days after the massacre, the Germans once more surrounded our town to finish the slaughter of those who had escaped the first round.

That evening I donned my peasant dress once more and left the house with my baby, literally under the noses of the SS gendarmes. I ran again to the factory. As I stood in front of the locked gates, I saw a Jew in the compound who happened to be walking in my direction, and begged him

to let my husband know that I was waiting at the gate. A few minutes later my husband came out to me. We decided to leave immediately and make our way to the nearest village. There was no time to retrieve our son Menashe from his hiding place, and in any case it was too dangerous, for guards were everywhere. It was a horrible feeling to leave him there; but for the time being he would probably be safer where he was, and we planned to come back for him as soon as we could.

Feeling like animals surrounded on all sides by hunters, we set out, crawling most of the way on our hands and knees, not daring to raise our heads for long periods of time. Finally we reached a shack in the next village where an acquaintance of my husband lived. She opened the door and let me feed my baby, but refused to let us stay overnight. No offer of money moved her; all our cries and pleas fell on deaf ears.

We spent that entire stormy night under the trees in a nearby copse. Torrential rains poured down upon us without respite, and my husband pressed me against him to keep me warm. We felt despondent and crushed. All through that night we did not exchange a single word.

As soon as light began to break the next morning, we proceeded toward the factory to try and retrieve Menashe. Not far from the camp we came upon a collapsed structure which could serve as a temporary shelter for the baby and me. After we settled ourselves inside, my husband left to find out about the situation in the camp, for there had been rumors that even the factory workers were not secure and that a deportation was expected at any time.

When he returned he told me that the Germans had liquidated the entire camp that night and deported all the inmates to Demblin to join the next transport to Treblinka. Among them was our son Menashe.

The bunker where I was hiding with my baby faced the compound where the German factory workers lived. The entire area was flooded by gigantic searchlights which beamed directly into our shelter. The strong light disturbed me terribly, and I began to push further into the ground in order to feel more secure. I buried myself so deeply that when my husband came back the next day from a news-gathering expedition, he could not find me. He then returned to the factory, which had quickly been

restaffed with gentiles workers. As if he had never been there before, he introduced himself as Jan Winiecka, a Christian Pole, and presented the forged identification papers he always carried. These papers might well have protected my husband if not for a Polish woman who recognized him only a week later and reported him to the authorities.

The Germans killed him in a most sadistic manner: they set trained dogs on him. The dogs tore the flesh off his bones. A Polish man who had once been an employee in our business witnessed his death and told me about it after the war.

When I saw that my husband was not returning, I left the bunker and made my way to an intersection where the roads of many of the local villages crossed. After speaking to several peasants, I learned the bitter truth: Demblin had become *Judenrein,* and all the Jews had been deported. Their homes were then emptied by the Germans, who came and divided among themselves all the furniture, linen, and better clothing. The less valuable items they sold to the village folk at an auction, for nominal prices. Every trace of Jewish life in that town had been completely erased from the face of the earth.

I saw with my own eyes how the Poles celebrated the extermination of the Jews, how they pillaged and robbed what was left of the Jewish homes.

A new chapter opened up in the misery of my life. I had escaped the slaughter of Demblin — but I was now alone, with only my baby. I took her up again and began my wanderings anew . . .

I sought a lodging in the nearest village, but although I carried an identification card with my false name, Irena Winiecka, no one would admit me even for the night. They explained that they could not provide lodging for anyone who did not possess a special certificate from the chief of the village.

I went to the chief and asked him for a certificate. I told him that my husband had been apprehended and forced into a labor brigade — a normal occurrence in those days for gentiles as well as Jews — and asked that he have mercy on my infant. He appraised my papers and issued me the certificate. I soon found, however, that this piece of paper was no

simple guarantee of a place to rest. I dragged my feet from house to house, but no one would let me in. When I knocked at the door of the fifth house, the peasant there gave in to my pleas and agreed to let me sleep in his granary.

I lay down on the bundles of straw, but I could not fall asleep. The cold was bitter, and we had no blankets or covering of any kind. My poor baby cried the entire night. She was hungry and seemed to have caught a cold... All through the night my mind was churning, and I finally came to the conclusion that the only choice left to me was to join the transport to Treblinka. I could not make peace with the idea that out of my entire family, my baby and I alone had survived. My two boys were gone, and the thought began to take root in my mind that perhaps the same fate had befallen my husband. What if he were no longer alive? I could not see any purpose in struggling for my life. The one thing that kept me back was my baby...

Rocked by this mental see-saw, I left the granary before daybreak and proceeded toward the railroad station. Along the way I learned that the Germans were about to complete the transport of the Demblin Jews in Pilev, so I immediately boarded the next train going directly to Pilev. The thought of joining the transport strengthened my heart. The fact that I had made a decision somehow calmed my nerves and gave me a renewed sense of confidence.

When we arrived at the Pilev railroad station, I noticed another train near the platform. It was completely sealed and stood waiting; not a sound could be heard from inside. As I came a bit closer, I noticed a very strange sight: a huge pump was open, and massive streams of water were gushing loudly from its spigots. The entire depot was flooded with water... and here next to the pump was a train packed with Jews who were dying of thirst, who needed only to moisten their parched lips. I overheard a passerby on the platform talking to himself: "These are monsters and not people. What kind of animals are they? To starve the victims and then aggravate their thirst by letting such great streams of water run in front of their eyes?" Without doubt the Germans had done this intentionally in order to further torture the people in the sealed wagons — people who were now living sacrifices.

I was standing perplexed and weakened, unable to move. I had come too late to board the transport; the Gestapo soldiers had already sealed the doors of the train. All that remained for me now was to walk over to the murderers, tell them that I was Jewish, and let them kill me together with my child.

At that very moment I felt the caresses of my baby's little hands. Her fingers brushed my face, and I was almost certain that amidst the turmoil of my jumbled thoughts, I heard her whisper: "Mama!" I felt a sudden warmth spreading through me. This tiny whisper, imagined or not, invigorated me in a strange, sweet way which I had never experienced before. I felt an obligation now to battle for the infant's life, even though I did not care much for my own.

I turned around and walked toward the outskirts of the town, a distance of about four kilometers. Pilev, the town in which I had been born and whose streets were so familiar to me from the early days of my childhood, looked entirely different now; most of the houses had been burned down or reduced to rubble by bombs. Only here and there a solitary building still stood intact. I went to the home of Mrs. Kowalska, one of our former neighbors. She allowed me to stay for twenty-four hours, which gave me a chance to feed my baby, wash her dirty clothes, and obtain some provisions. But my mind was far from peaceful; I had no idea what I would do or where I would turn when the day was over.

A friend of my hostess, a Mrs. Kotowski, suggested that I go to Warsaw and even offered to accompany me. She assured me that she had a friend there who would definitely let me stay in her house. What finally decided me was my little one, who had become ill. I knew that the only place I could get decent medical care for her was in Warsaw.

I was in a terrible dilemma, and horribly distraught as well by the lack of knowledge of my husband's fate. This worry gave me no rest, even though I knew that had we been together, my presence would have been a hindrance to him. I knew his nature well. He would not have allowed himself to be taken so easily by the Germans. He would have fought; he would surely have escaped to the forest and joined the partisans. Would I have been able to go with him? And what about the baby?

At the last minute Mrs. Kotowski had a change of heart and decided

not to accompany me to Warsaw. However, she gave me a note of introduction to her friend in the capital city and advised me to go by boat, on the direct line between Pilev and Warsaw. The boats were less crowded than the trains, which would make it easier for me to evade people who might suspect my Jewishness.

I took her advice and bought an expensive second-class ticket, but the plan proved to be a very unsafe one after all. As soon as I sat down in the cabin, a Polish woman came over to me and announced: "I know that you are Jewish! If you don't give me all your valuables, I'll disclose you to the Gestapo!" She forced me to hand over everything I had — except for a sum of money which was safely hidden in the lining of a belt I kept in my knapsack — and then, obviously unsatisfied with a mere bribe, she called the ticket inspector and demanded that he report me to the police, on penalty of his own life.

The inspector promised that he would do so, but he soon showed himself to be a man with a conscience. As soon as the woman had left, he advised me quietly: "You would be safer in third class, where it is more crowded. This monster would have a harder time finding you there."

I went to the third class, but even here people did not spare me their insults and juicy curses. One man tried to incite the other passengers by telling them that it was their duty to beat me up or even kill me. A twelve-year-old boy sitting across from me said: "I wouldn't want to be in her shoes." Another woman added: "I've got no pity for her, but it's a shame about the baby . . ." They were all united in their intention to throw me into the sea or hand me over to the Germans the minute the ship docked in Warsaw.

The voyage lasted two days and two nights, and at each stop I expected that they would indeed carry out their threats. The fact that nothing happened I can attribute only to my little baby . . .

Warsaw

We arrived in Warsaw at ten o'clock in the morning on November 1, 1942. As soon as we docked, I rented a carriage and asked the driver to take me to the address Mrs. Kotowski had given me. The woman who came out took one look at me and slammed the door in my face. I stood

on the other side and begged her to let me in, if only to feed my baby. I tried to convince her that I was a genuine Christian, that my given name was Irena Winiecka, but the "friend" remained unmoved.

Full of shame and disappointment, I returned to the carriage and begged the driver to take me to any inexpensive hotel. We drove from one to the next, but all were completely booked, filled with German soldiers and officials. The driver finally refused to take me any further. I paid him from the small sum of money I still had and left the carriage. I stood in the middle of the street, confused and despondent, not knowing where to turn. I didn't dare ask any passersby where I could find a place for the night; I was much too afraid. It was already two o'clock in the afternoon. I entered the nearest gateway and fed my sick baby, and then suddenly I burst into a bitter and uncontrollable sobbing. I sat there for a while and cried my heart out.

After about an hour a street singer entered the courtyard and began to ply his trade. He then went around and collected the coins that people had thrown out their windows. When he passed me, I gathered up the nerve to ask him if he knew of a place to sleep, or an inexpensive hotel where I might find a vacancy. After looking me and the baby over carefully several times, he told me that he was childless and that he thought his wife would accommodate us.

We took a trolley immediately to his apartment on Powanzkowska Street, but when we arrived, his wife fiercely refused to let me in. The street singer then took me to the home of another woman who lived further down the block, together with her old mother. The woman turned out to be his mistress. She allowed me to stay, but only for one night.

The next morning I was treated to a surprise: my street-singing "friend" appeared at the door and demanded money. "Either you give me all the money you've got," he screamed, "or I'll turn you over to the Gestapo! You are Jewish, and you know well what awaits you in the Gestapo!" I cried and pleaded for mercy, and this beggar replied by beating me in the face and all over the rest of my body. He demanded that I show him where I kept my valuables, and then, without waiting for an answer, he began to search among my bundles. Hidden in the seam of my belt he found 3,600 *zlotys*, which was all I had left. In a fit of "compas-

sion," he returned 80 *zlotys* to me as a "present," saying, "This money is to buy food for your baby."

I had hardly had a chance to recuperate from his visit when he sent along another friend of his to harass me. This one, too, demanded money on the threat of reporting me to the Germans. By this time I was at the end of my rope, and strangely enough it was my utter despair that saved me from this ruffian. I began to cry and scream, begging him to give me over to the Gestapo because I had no more strength to live — and I was completely sincere. The extortionist decided that there was no sense in "working" on an hysterical woman, and he disappeared.

Once again I found myself in the street with no roof over my head, in a strange and savage society, among animals in the form of men, with a sick baby in my arms and no means to live. I was lost . . .

I wandered for a while in the cold autumn rain. Finally I boarded a trolley. At the last stop I got off and boarded the line going back in the opposite direction, and in this manner I spent the entire day traveling back and forth.

At one point a merciful woman on the trolley noticed my plight and came to my rescue. She allowed me to warm up in her house. I fabricated a story, telling her that I lived in a village far from town, that my husband had been sent to Germany for forced labor, that I had come to Warsaw to get medical help for my sick baby. I said that I was penniless and would gladly accept any kind of work. "Do you, by any chance, know somebody who could use some help?" I asked nonchalantly.

"With a child on your hands? It's impossible!" she replied firmly. She advised me to abandon my baby, to leave her in the street outside an orphanage door. I thanked her for her "good advice" and left the house.

For a while I trudged again aimlessly in the streets of Warsaw. And then . . . what an irony of fate! I happened unwittingly to pass by the office of the local SS headquarters, and there in front of the building were standing two girls — one of whom was the street singer's girlfriend! She recognized me immediately and began screaming at the top of her lungs: "What is this Jewess still doing here? She will bring a calamity upon us!"

I summoned all my courage and answered her as calmly as I could: "I prefer that they should kill me once and for all, or that the earth should

open up underneath us and swallow us alive, for I cannot struggle anymore."

The other girl was kinder and more understanding. "Go to my mother," she said. "She lives in Number 7, the small house on this very street. Tell her that I sent you; she will surely receive you."

I did not waste time and went straight to the address the girl had given me. This woman, a poor widow who earned a meager living as a laundress, was extremely kindhearted and gave us food and shelter for several days. She was an exceptional person whose behavior under the circumstances was unparalleled among her fellow Poles.

I have described my desperate fight to save my dear ones, the hardships and afflictions that were my lot from the start. I fought an awesome battle and was defeated: I lost my two children, Yaakov and Menashe; I lost my beloved husband, Shymon. Now the only one of my family who remained to me was my little daughter, Yehudis. Only for her sake did I persist in my struggle for survival.

The time came when I realized that holding on to her meant losing her forever, that if I wanted to save her I had to give her up. With great pain I left her outside a Christian hospital in Warsaw called the Holy Lazarus, and that was the last I knew of her until the war ended.*

The Search Begins

At the beginning of 1945 there were already signs that this accursed war was coming to an end — but not for me. My private war had only begun. As soon as it was safe to begin searching, I began a feverish fight to retrieve my baby.

Upon extensive inquiry I learned that the Holy Lazarus hospital was no longer in Warsaw, that it had been relocated during the Polish rebellion in the summer of 1944. The first lead I received was from a Polish woman who owned a kiosk near the former site of the hospital. She told me that her sister had worked as a nurse in Holy Lazarus during its transition. This sister was now living in Krakow, and she gave me her address.

*Ryvka Waserman spent the remainder of the war in disguise on the Aryan side of Warsaw, one of the small percentage of Jews who survived this way. Her narrative at this point is incomplete and resumes after the war's end.

I traveled to Krakow and began searching for this sister. After countless trials and dead ends I finally located her. She was very cooperative and told me that during the Polish uprising the hospital had been completely demolished, and that some of the younger children had been transferred to a Catholic orphanage in Warsaw. The woman also remembered that in that group there had been a little girl by the name of Teresa Winiecka — the name on my baby's falsified identification papers. She even recalled in detail the circumstances of the baby's acceptance into the hospital.

And so I returned once more to Warsaw to begin the next leg of my search. After another exhausting hunt I finally located the orphanage which the woman in Krakow had described to me. When I confronted the secretary in the office and told her the purpose of my visit, she listened very attentively and then called in the director.

At first both women refused to give me any information about my daughter, but I was extremely insistent. When they saw that I would not relent easily, they finally admitted that a girl by the name of Teresa Winiecka had indeed spent some time in their institution. However, she had disappeared during the uprising, and they had no idea what had become of her.

I sensed that the two women were hiding the truth from me, that for some reason they did not want to reveal my daughter's whereabouts. Although I was very distressed, I was also enormously relieved, for one thing was clear: my child was alive! If she were dead, the women would not have hesitated to tell me so right from the start. I made it quite clear to them that I would not give up my fight, that I would stir up public opinion and would not rest until I found my child.

The women exchanged glances. They began to comprehend that their denial might have adverse consequences. Poland was now under the control of the Communists, who were avidly asserting their dominion in all the internal affairs of Polish life. The complications and embarrassment of a possible investigation by the new regime was obviously something these two women would want to avoid at all costs. After a hushed consultation they asked me to come back the next day.

When I returned, I was received by a representative of the orphanage,

who told me that my daughter was indeed alive and well. She had been legally adopted, and the adoptive parents had declared that they would never give her up under any circumstances. I was so strongly affected by the news that my child was indeed alive that I burst into tears.

The woman added a few details about my little girl's history. She told me that when the hospital had found the abandoned child, they had immediately taken her in. For two weeks she had been ill, and in the meantime they had written to me at the address on the baby's birth certificate. When no reply came, they investigated and discovered that the address was false. After some time the child had been given up for adoption.

The woman stressed again and again that the orphanage had acted according to the letter of the law. The baby had been given over to the adoptive parents only after a thorough investigation of the family's financial status, home, and cultural lifestyle. And now, because the institution had no legal right to reveal the name and address of the parents, she could not help me. She assured me, however, that the child was well and that she was living in a very pleasant and comfortable environment.

My Legal Struggle

Greatly distressed, I turned to the Jewish Committee in Warsaw, one of many organizations which were set up hastily after the war to help Jews with the myriad problems they now faced. The Committee directed me to its attorney general, Alexander Olumotzki, the lawyer for the Warsaw Jewish community. I told him in detail of my search for my daughter and of the orphanage's refusal to reveal her whereabouts.

Olumotzki approached the court with a request that the orphanage be forced to reveal the name of the family who had adopted the baby. As proof, I provided him with the confirmation from the Holy Lazarus hospital, which certified that the child had indeed been accepted there for treatment, as well as a copy of an announcement I had previously submitted to the Red Cross, asking them to help me find my baby.

The Warsaw court appraised the situation and issued an order to the orphanage to release all available information regarding my child. Shortly afterward I received the following notice: the girl Teresa Winiecka

had been adopted by the Szczerbinski family, who lived in Warsaw at 279 Grochowska Street. Armed with this information, I now turned to the Warsaw Jewish Community Council to help me get my child back. The Council referred me to Captain Drucker, an official whose function it was to reclaim Jewish children who had been hidden in Christian homes during the war. Captain Drucker threw himself into the matter with great energy, and even accompanied me himself to the home of the family Szczerbinski.

When we came to the apartment, my daughter wasn't there. I later learned that she had been hidden in the bathroom. At first the Szczerbinskis tried to deny the child's origins, claiming that she was the orphaned daughter of an acquaintance of theirs. They clung adamantly to their story and firmly refused to give up the child. I had no choice but to turn to the government for help.

The attorney Olumotzki submitted a lawsuit in my name to the Warsaw court, claiming my daughter. There was absolutely no doubt as to the child's identity, for she had been registered under the same name in every place she had gone to. She had entered both the Holy Lazarus hospital and the orphanage as Teresa Winiecka, and had been adopted by the Szczerbinski family under the same name. All the facts of the case corresponded, right down to the last detail. The baby also had a scar on her chest by which I could easily recognize her. In fact, I learned later on that immediately after I had told the director of the orphanage, upon my initial interview, about the scar, she had notified the Szczerbinskis, and they had rushed to a surgeon to have the scar camouflaged.

The legal proceedings seemed to drag on endlessly. Almost every day I visited the Prosecutor General's office, and every day I was asked to bring more information — all types of documents from different people and institutions. I traveled again to Krakow to get a sworn testimony from the nurse I had originally spoken to, who had worked for a time in the Holy Lazarus hospital and knew the relevant details of Teresa Winiecka's history. I had to give a sworn testimony of my own, stating that I had had an identification certificate with the name Irena Winiecka, which I had destroyed when the war ended. I also presented a copy of my petition to the Red Cross of February-March 1945, requesting

their assistance. Every week I was asked to present yet another record, but still the Prosecutor General wasn't satisfied.

He claimed that the Szczerbinskis had not committed a crime, that they had adopted the child according to law. Olumotzki disputed his stand: "It is true that when they adopted the child they did not commit a crime," he argued vehemently, "but now, when there is no doubt whatsoever of the child's true identity, they are committing a crime by not returning her to her rightful mother!" All of these exchanges bore no fruit, and the proceedings became deadlocked.

I could not tolerate any more of this. In desperation I turned to the Chief Rabbi of the army, General David Kahana,* and with his help I was able to arrange an interview at the Ministry of Justice. The Chief Justice listened patiently to my story and carefully scrutinized all my documents; and then, right on the spot, he signed an order to have my daughter returned to me. The next day the order was in the hands of the police.

Teresa Becomes Yehudis

This was the happiest moment of my life, the moment I had long awaited.

Accompanied by Captain Drucker and a Polish police officer, I went to the Szczerbinski home several times, but we met with no success. The child was never there, and even Mrs. Szczerbinski had disappeared. Her husband refused to disclose their whereabouts, and neither warnings nor threats had any effect.

Then we decided to change our tactic and surprise them. At six o'clock on the morning of September 20, 1946, without any notice, we knocked at their door. They were very startled and at first refused to open the door, but when the officer threatened to break it down, they relented and let us in.

The Szczerbinskis obviously were horrified at the idea of having to give up their child, and they held out until the very last moment. They asked permission to contact their own attorney, Mr. Jachinowski, to

*David Kahane was a rabbi and a captain in the Polish army before the war. During the war he hid in a monastery in Lwow and was protected by the Archbishop Andrey Szepeticki. When the war ended and the army was reorganized under Russian rule, he resumed his position as its Chief Rabbi.

determine whether the court order was legal, and we agreed. Captain Drucker stayed in the house to watch the girl and make sure she would not "disappear" again, and Mr. Szczerbinski, the police officer, and I drove to the attorney's office. After a short but thorough investigation of the court order, Jachinowski advised Mr. Szczerbinski to honor the decision and give the child up.

We returned to the Szczerbinskis' house. Although they were very agitated, they welcomed us this time with respect. It was not an easy moment. Mrs. Szczerbinski fed the little girl breakfast and then said to her: "Until now I was your mother. From now on this woman will be your mother. Now go with her, but I will come often to visit you . . ."

My daughter was four years old when I got her back. I remained with her in Warsaw for some time and maintained steady contact with the Szczerbinskis. In the beginning they were very mistrustful of me, but as time went on our relationship improved. After I settled with my daughter in Israel, we continued to write to each other.

Mrs. Szczerbinski was an honest and sincere person. After she gave up my daughter, she adopted another little girl, with whom we are still in contact. A few years ago this young woman came to Israel as a visiting student and spent several months with us. We consider her part of our family. Her mother passed away several years ago.

My daughter was finally able to shed her adopted Polish identity and return to the name she had been given at birth — Yehudis. I merited to give her a good Jewish education, and she also graduated from Bar Ilan University with a degree in history. In December 1964 she married Reuven Renston, director of the Israel Conservatory and of all the music schools in Israel.

As a mother and grandmother who now dwells in the midst of her people and her land, I am very happy.

IN THE CAMPS

❖

HELA

Halina Birenbaum
Warsaw, Poland

Majdanek

A raw, gusty wind was blowing. We were standing in a crowd of women and children in the center of a great open space, shivering with cold, exhausted from the sleepless, nightmarish days we had endured in the train wagon. We had no idea where they would take us or what they would do with us. The SS soldiers were busy separating groups of men from the crowd and herding them into barrack-like huts standing nearby. What was inside those huts? No one had come back from them, so we could not tell.

Noon approached; we had already been standing in the square for many hours. The wind drove sand into our eyes and whipped about us so powerfully that we could barely stay on our feet. My mother covered me with her coat and cuddled me lovingly.

"Just a little more patience," she said, stroking my head, "and soon they will take us to the bathhouse. We'll wash and change our clothes, and then we'll go into the camp, to the huts that you can see beyond the wire fence. We will rest there . . . then they will surely assign us to work in the fields . . ."

"Will there be beds in the huts, and blankets, and food?" I wanted to

know, with all the impatient curiosity of my thirteen years. "You don't think they will kill us?" I asked.

"Of course not," she replied. "After all, we saw women prisoners in prison dress on the way here, and now you can see them in the distance, behind the camp wires."

My mother's words calmed me, and I began daydreaming about a bath and about the hut where I would warm up and rest and eat my fill. The line in front of us was moving sluggishly, which agitated me greatly. How much longer would it take before we got to the bathhouse? In later days, my impatience would seem to me the most brutal of ironies . . .

Finally our turn arrived. The storm troopers assigned us to a group: me, my sister-in-law Hela, and Hela's cousin Halina, who shared my name. I remembered my brother Hilek's admonition to practice being more independent and not to lean on my mother, and so I walked forward with Halina. My mother walked behind me with Hela, and I was so absorbed in setting down my feet, which were aching terribly, that I did not even look around to see what was happening to them.

To this day I do not know when and how I found myself inside a large hut, piled to the ceiling with heaps of clothing and shoes. The Nazis ordered us to strip naked and to throw everything except our shoes into this pile. During the process, Hela furtively exchanged her light shoes for a pair of high-top boots. She winked at me to do the same, but I was too afraid and too exhausted; I no longer needed anything, I did not even have the strength to think of my wretched shoes . . .

Pushed on in a crowd of hundreds of naked women, we eventually reached the bathhouse. "A bath!" I thought joyfully. My mother was right; they were not going to kill us, we would live and work! How good that was!

I wanted to throw myself into my mother's arms, to tell her of my love and complete faith in everything she said. I looked around, seeking her in the crowd of women under the showers, but she was not there. I began to search for her frantically. I could see my sister-in-law Hela and her cousin Halina, but my mother was not there. *Where was she?* My head reeled, there was a lump in my throat, I could not get the question out.

"Where is my mother?" I finally managed to whisper to Hela.

My sister-in-law turned to me with a very unhappy face. Then she looked away and said quietly and distinctly: "She is not here."

I felt as though my hands and feet had suddenly been cut off; yet I still did not understand the meaning of her four simple words. I had not seen anyone take my mother away and could not understand how it had happened. Besides, all our friends from the Umschlagplatz, the deportation center in Warsaw, were here. My mother was young — in fact, with her pink cheeks she looked much healthier and prettier than many of the other women. Yet they had taken her! Why? I could not come to terms in any way with the idea that she was really not here, that I might never see her again. I kept looking at the door; she should be coming in any minute to embrace and comfort me.

But she did not come in. I moved around in a mindless circle, like a robot, repeating mechanically: "My mother is not here!" Everything else ceased to exist. I was incapable of anything, even tears. When they gave out clothing and demanded that we dress quickly, without drying ourselves, Hela saw that I was half-conscious and energetically directed me.

"From now on I am your mother, do you understand that?" she said firmly.

But I said nothing. I did feel a vague gratitude toward Hela, but I could not bring myself to express it. At that time in the bathhouse, I was visually still with my mother, cuddled up against her in the great empty field in front of the barracks, protected by her coat from the cold winds; all I had to do was put out my hand and touch her.

Then someone nudged me, and the vision fled.

They had given me a black, floor-length ball gown trimmed with lace and a pair of mismatched shoes, one with a heel and the other full of nails. Hela got me into the dress and tied string around my waist to hold the skirt up. I was to start prison life in Majdanek in this ball dress . . . The other women in our group were also given bizarre party clothes, a cruel joke in such circumstances and certainly an intentional one.

Outside in the yard the storm troopers assembled us in groups of five, counted us, and took us into the camp. Those who had failed the initial selection had already been taken to the crematorium, and I did not realize until much later that my mother had been among those sentenced. Hela

and other acquaintances of ours from the bunker in Warsaw kept telling me that she had been taken to another camp to do easier work, such as harvesting potatoes, and that I ought to be glad . . . Perhaps they really believed this themselves, for at that time none of us knew that there were gas chambers and crematoria in Majdanek.

I consoled myself a bit as I listened to my companions, for the idea that my mother and all those other women had been driven out to their deaths was unthinkable. But the fact that I insulated myself with comforting illusions did not lessen my longing for my mother in the least. More and more I wanted to have her close to me, and I realized with gradually increasing clarity that this was impossible.

The camp horrified me, especially the electrified barbed wire and the watchtowers which bristled with machine guns. I was used to cellars, attics, and other hiding places in the ghetto; I feared open spaces, feared coming face to face with the executioners. Too many overwhelming feelings piled in on top of me: the shock of losing my mother, the terror of the green uniforms of the SS, the impossibility of escaping everything I had learned to run away from during our years in the ghetto. All of these drove me nearly to the point of insanity. I did not even recognize my own face whenever I caught my reflection in a window pane; it had become a ferocious face, with huge, bulging eyes. Sometimes when I looked at Hela, she would turn away and implore me: "Don't look at me like that, you frighten me! Don't look at me like that!" But for a long time this was the look that haunted my face.

Roll call was being held when we first entered Majdanek. That evening it lasted a very long time, longer than usual, apparently as a punishment. Kapos, storm troopers, and German women overseers counted us many times, watching to see that no one changed position. This was the first time I had ever seen women in uniform, armed with revolvers and horsewhips. I had thought that there were only men in the SS; it was hard to imagine women capable of beating, torturing, and killing people. But here that myth dissolved. Female storm troopers, wearing thick uniforms, tall boots, and raincoats with huge hoods, roamed the square, venting their bad tempers on us and arousing terror in our hearts.

During the roll call Hela surreptitiously snatched a pair of scissors that was passing from hand to hand, and she swiftly and nimbly cut off both my braids, rubbing them into the ground with her foot. We knew from the ghetto that lice flourished in long hair, and Hela thus tried to spare me this additional affliction. I accepted the loss indifferently; my hair hardly mattered anymore.

On the day after our arrival at the camp, the commandant entered our hut. He ordered everyone to sit on the floor, took up his position in the center of the room with a revolver in one hand, and began a "speech of welcome." We learned that henceforth each of us was to be only a number. We were immediately to take scraps of canvas bearing numbers and sew them to the front of our clothing. Camp regulations entailed severe punishment for the slightest transgression, anything from twenty-five strokes of the whip on the bare buttocks to shooting and hanging.

The commandant spoke in a very casual manner, as though he were talking of the most ordinary, everyday matters. The impression he made on me was much more frightening than that of the enraged storm trooper, which we had been so accustomed to seeing in the ghetto. The face of that Nazi and his nonchalant speech haunted me for a very long time afterward. Even today I have not really freed myself from the terror I felt at the sight of him.

I was thirteen. The years of persecution in the Warsaw ghetto, the loss of my father and one brother, and — most painful of all — the loss of my mother had weakened my nerves, and at a time when I should have forced myself to be as resistant as possible, I broke down completely. Fortunately, I was physically robust and plump enough not to be taken for a child, and the many selections, which claimed the lives of the weak, pale, and thinner women, passed me by.

Had it not been for Hela's boundless devotion and constant care, I would have perished within a few days. Hela had made a silent vow to my mother that she would take her place, and she kept that vow. She was a true mother to me up to the last minute of her life.

We had to fight for everything in Majdanek: for an inch of floor space in the hut on which to stretch out at night, for the rusty bowl that we needed in order to claim our miserable ration of green soup or the stinking

yellow water we were given to drink. But I was not capable of fighting. I was overcome with horror at the sight of the other women prisoners struggling over a patch of floor space, hitting one another over the head at the soup kettles, and snatching bowls — hostile, aggressive women, wanting to live at any price. Aghast, I stood aside and watched them from a distance.

Hela fought with redoubled strength, for herself and for me. She shared every bite of her own rations with me. Her cousin Halina stayed together with us, but she was not very happy with the arrangement. She too was forced to share everything with me, to bid for a place for me on the floor, to scrounge for a blanket; and after all her efforts I was unable to guard these hard-won prizes, so that time and time again someone would take my blanket from me by force or trickery. This infuriated Halina, and she tried to persuade Hela to abandon me, saying that I was only pretending to be weak and that I wanted to use the two of them.

Halina was fifteen at this time, broad and well-built. Even at home in Warsaw she had liked to avoid her duties and was concerned mainly with her own comforts. She had been spoiled, especially by her adoring father, and now in the camp her attitude was no different. Of course, Hela did not give in to her hints; on the contrary, she showed more affection and attachment for me each day. She gave me all the love she felt for my brother Hilek, to whom she was married, and did everything in her power to make my life in the camp easier. For a very long time I could not rouse myself from my state of listlessness, and had it not been for Hela's efforts I would never have shaken off my apathy and despair.

Only here did I recognize my sister-in-law's true nature, only here did I come to love her. Later I was ready to make any sacrifice for her.

Hela was then almost twenty-one. She was a graceful, slender, blond girl with an energetic but taciturn nature. She had always struck me as inaccessible, even alien. Her gravity and composed manner intimidated me, and I had often accused her of being overly self-assured. But she had many reasons to be proud. In addition to her noble and intelligent nature, she was also very talented; she had graduated from a sewing school before the war and could sew and crochet beautifully, and she had a lovely singing voice as well. Hela was greatly liked by our family, and her

opinion was valued by all who knew her. Her own family was quite wealthy, but they had not spoiled her. I was slightly acquainted with the Herzbergs. They had come to Warsaw from Bydgoszcz at the beginning of the war, and I had often seen them in the ghetto before the first deportation campaign; they were sweet and well-bred people. I had never met Hela's two brothers, for they had fled to Russia at the start of the occupation.

Life in a labor camp proved entirely different from the picture my mother had drawn for me. It was not a quiet routine of work, followed by rest in cozy huts. It was nothing but penal slavery and ceaseless fear, a bottomless pit of hell. How can anyone find words to describe it?

There were about a thousand women in our barrack, and we slept on the ground. At night the women trampled on each other when they went out to the latrine or to get water. The camp soup and contaminated water made diarrhea a common ailment, so that these troublesome nightly trips let no one sleep. The latrine in Majdanek was out in the open, near the barbed wire that divided the women's camp from the men's. We had to relieve ourselves out there in the field, with men walking about not far away. The guards in the watchtowers often used the latrine as a target, firing at it out of boredom or to amuse themselves.

I shivered with terror, shame, and cold whenever I had to go out to the latrine, and tried to do so as rarely as possible. But soon I too contracted diarrhea. Many women with this ailment did not get to the latrine in time, and I too had mishaps, sometimes even before I had gotten out of the barrack. We had no clothes to change into, and most of the time it was not possible even to wash the ones we wore. The women I involuntarily soiled did not spare their blows, curses, and insults. Helpless and miserable, I used to wonder at such moments what my mother would have said to it all. Perhaps it was better that she was not here and did not have to endure such terrible humiliation.

Every morning at dawn Kapos rushed into the huts, cursing and hollering, and woke us up by beating us around the head and shoulders with wooden planks or whips. Then they herded us out to the morning roll call. Sore from lying on the floor and shivering with cold, we sometimes

stood for hours in the huge space between the barracks. Those in the front rank, who were most visible, were in danger of the Kapos' sticks. It was somewhat safer — and warmer — in the middle columns, and we fought for a place in this protected center as though it were a haven in paradise. We nestled close to one another, forgetting recent quarrels and fights, trying only to get warm; but when an overseer or Kapo approached, we drew away quickly to arm's length, and the rain and wind struck us with renewed force.

Most of us were wearing summer dresses with short sleeves, which left us exposed not only to the early morning chill but also to the afternoon heat. There was no shelter from the sun, and our arms, legs, and faces soon became covered with blisters. No medication or help was available, and the worst part was that during a selection the SS would send people to the gas chambers for such ailments.

After several hours, when it was light, a shrieking whistle would indicate the end of the roll call. The Kapos began hustling the women away, forcing them into labor gangs and marching them out to work. They accomplished this in a frenzy of abuse, rushing about the entire camp, blowing whistles, hurling themselves upon us, pushing, pulling, beating. The seriously ill, the wounded, and the feeble were killed off during these wild roundups, which soon became a source of torment for me. I could barely walk. Those accursed shoes I had been given — one with a high heel and the other full of nails — had injured my feet, and I now had a festering wound on one heel. How in the world could I survive a twelve-hour work day? Even healthy, strong adult prisoners collapsed as they pushed heavy wheelbarrows loaded with earth or stones.

As the Kapos ran about the square during the roundups, I would hobble along in a slow, panicked flight, biting my lips in pain. Often I hid behind the huts. When they caught me, I would show them my injured feet and beg them to let me go, and sometimes they actually did — but not before lashing me with their whips.

In this manner I dodged work all the time, pleading with G-d only that they hit me with a whip rather than a plank, whose dry, hard blow hurt a great deal more.

Ironically, it was my clumsy, painful shoes that unexpectedly came

to my rescue one day during a selection. This was the second selection we had been through. It came upon us as suddenly as the first one in front of the bathhouse, when my mother had been taken away.

That night we had been allowed to eat dinner in the barracks and not outdoors, as was the usual rule. While we were eating, a woman overseer appeared in the doorway. Kapos then rushed in and began laying about them with whips, striking bowls out of prisoners' hands and herding us toward the door. The overseer was standing in the doorway, carrying out the selection.

I was sitting on the floor beside Hela, finishing the soup she had procured for me. At first neither of us realized what was going on. We did not notice the overseer until the women began throwing down their bowls and scrambling toward the center of the hut. There was a tremendous rush at the windows, and then terror seized us. I could not have jumped with my injured feet, yet we both realized we must get out of the hut quickly, if only to avoid being beaten.

Hela pressed her tin bowl to her chest and began pushing toward the door. I followed her blindly, as I always did. After a few minutes of dreadful struggling, she managed to squeeze herself outside the hut. But when I finally limped to the door, I heard a loud, harsh "Halt!" and looked around to find myself face to face with a female storm trooper, who barred my way with a whip. I did not understand why she was detaining me when everyone else was being driven out the door. Obsessed by the single thought of joining Hela as soon as possible, I was completely unaware that a selection was taking place and that the overseer was paying special attention to our feet, looking for signs of injury. I was more startled than frightened, thinking there must be some mistake, and I looked at the female storm trooper impatiently, perhaps even a bit angrily.

This gave her pause. She stared at me again and hesitated, for at that time my face was still full and fresh; then she turned her gaze to my feet. She undoubtedly had seen me limping, but the reason seemed apparent — one shoe with a heel, the other flat. Without bothering to check for wounds, she raised her whip and let me pass. This entire drama took up the space of a few seconds. Had the overseer seen any trace of fear in the eyes of a limping prisoner, she would not even have thought of glancing

at the feet but would immediately have pointed toward the left . . .

Hela had been watching the incident from outside, half petrified, for there were trucks nearby being loaded with women whom the overseer had selected for the gas chambers. Fortunately I had no notion of this at all until after the event.

The frequent selections paralyzed our senses, but they were not the only claimants of life here. We were tormented day after day by the roll calls, starvation, slave labor, and beatings, and by the lice that devoured us at night. Death in all shapes and forms decimated the camp, striking down even the strongest and most resistant women. Those of us who hung on grew weaker and weaker — but there was no place in Majdanek for the feeble or depressed. It seemed that the one foolproof remedy for coping with our sorrow was Majdanek itself. Majdanek gave no one time for memories, sorrow, or despair.

Faced by endless suffering, I finally had to rouse myself from the state of apathy that had swallowed me after my mother's death. Gradually I learned to fend for myself a little better: to push in the food line, to flee and hide from the Kapos, to control my trembling and walk erectly and with assurance during a selection. My age was no longer a liability, for I was now dirty, sunburned, and lean, and I looked like a worn-out woman.

Hela proved weaker than I, and I dreaded the thought that I might lose her. The sight of her gray, earth-colored face and her famished, profoundly sad eyes oppressed me more than any other horror in the camp. Her physical resistance began to weaken, and she continually felt cold. I used to cover her with part of my clothing, trying to warm her with the heat of my own body. In time we would change roles altogether . . .

As our stay in Majdanek lengthened, most of the women in our group became hardened and developed a remarkable ability to adjust. Our instincts and vigilance sharpened, our reactions quickened. We learned that staying inside the camp during the daytime was not always safe because of the ever-increasing frequency of selections. It was better to join a labor gang, to drag rocks all day or dig ditches under the blazing sun, than to shudder every time a whistle blew in the camp. We learned to distinguish between the easier and harder work gangs, which to avoid,

who were the "better" overseers and Kapos, and whom to keep away from. The women who tried to get into the better gangs were generally not particular or scrupulous about their methods. Informing and toadyism were common, and fights often broke out among the women as a result.

One of the lightest types of work in Majdanek was weeding the grass between the two rows of electrified barbed wire that separated our camp from the men's camp. It was a narrow strip of space which could only accommodate a slender person. Squatting one behind the other, we would inch forward cautiously. A careless movement meant death, and every now and then someone was killed by touching the electrified wire. Neither the overseers nor the Kapos dared to come between these wires, and so no one urged us on or struck us. We could sit and rest, picking at the weeds and grass . . . I preferred this work to any other, for here I had the peace I longed for.

When we were taken to work in the fields near the Polish villages, it was occasionally possible to bribe an overseer to allow the peasants to toss us food — bread, sugar, sausage, or hard-boiled eggs. Sometimes the peasants would give us this food disinterestedly, out of pity, and sometimes in exchange for money or jewelry which some of the women had smuggled into the camp.

Hela had smuggled in a little money too. She did not tell me about this money at first, fearing that I might inadvertently blurt it out to someone who would inform on us, for such possession was punished with the utmost severity. Sometimes we used the money to buy sausage, bread, or sugar cubes. These purchases had to be made with the utmost caution. If a "bad" overseer caught sight of a "transaction," it would end with a trip to the gallows for the prisoner and severe punishment for the Pole. The Poles frequently paid with their lives for being helpful in any way to a Jew. When Hela had spent all the money she had — and there was not much — she sold her top boots to a Kapo. She got several hundred *zlotys* and an old pair of men's pants in exchange for them. Other Kapos had tried to snatch the boots off Hela's legs more than once, but she had always fought back . . .

Sometimes we worked in fields only a stone's throw from a village hut, with armed SS sentries standing between us and the free civilian

world. I used to look with envy and longing at the children playing happily in the peasants' gardens, at the hens pecking the dust and the people bustling about . . . I simply could not comprehend that there still existed another world in which people were allowed to move about open spaces that were not cordoned off with barbed wire, and in which little children played innocently.

But at the same time I felt an inner quickening of faith that we, too, would at some time in the future be free people. The existence of life outside the camp, the sight of the bright sky and green fields, alleviated a portion of the tragedy for me. More than ever, I believed every rumor I heard of the defeats of the Reich at the front, of the approach of Soviet troops and the liberation that was at hand. Here in the open fields, closer to the houses of ordinary villagers, it was easier to hope. All we had to do, I thought, was to muster our last reserves of strength and hang on until the end.

But where was I to get this strength? Our resources were ebbing away, and our suffering grew daily . . .

One day as we were weeding beets in the vegetable garden, Hela recognized her husband among some men who were working in a nearby field.

"*Hilek!*" she shrieked with inexpressible joy.

"Hilek!" I cried too when I saw my brother, forgetting that we were not allowed to speak to other prisoners.

Hilek turned, smiled at us, and waved. This did not escape the notice of the men's Kapo, who rushed at him with a stick. We crouched over the beets, gritting our teeth so as not to cry out in our pain and despair. Hela moved closer to me, her eyes blazing with anger.

We never saw Hilek again. Much later, when the Nazis began deporting men and women from Majdanek to other camps, he sent us a card through another prisoner, telling us which transport he had been assigned to and asking us to try and join the women's matching transport. That card was the last greeting I received from my brother. He has remained in my memory as I last saw him in the field in Majdanek: tall and lean in his striped prison uniform, with a round cap on his shaven head, crouching beneath the blows of an infuriated Kapo . . .

It was now 1943, and new transports from various parts of Poland continued to arrive in the camp. We, the old and experienced inhabitants of the inferno, taught the newcomers the laws and regulations, the ways to avoid punishment and death. The terror and stupefaction on their faces, their simple questions, their complete ignorance, sometimes appeared almost absurd to me; it was odd to think that I myself had behaved in this same naïve manner at first. But my past was, in a manner of speaking, no longer mine. It did not in any way concern the present reality. The camp had made me a totally different being from the person I had once been.

One day a group of women were brought in from an area in southern Poland where my father's family had come from. The arrival of these people aroused long-lost feelings in me. It was worth making inquiries to find out if anyone knew my father's relatives, and this was how I found Rachel, my twenty-year-old cousin. We gazed at each other like strangers, asking each other about the fate of various members of the family. My appearance shocked Rachel, while her childish questions and fear of things which we already considered unimportant trifles amazed and annoyed me. She was surprised when I introduced her to Hela, for she had not known of my brother Hilek's marriage. After all, we had had no contact with other branches of the family since the outbreak of the war.

My talk with Rachel only worsened my anguish, for I discovered more tragic news: her father and fifteen-year-old brother had been shot in a sawmill in Pinsk, where they had been recruited to work. The Nazis had also shot my father's two younger brothers, both of whom were unmarried. Rachel's mother had died in a freight car on the way to Majdanek. When the people in the wagon, unable to endure the crowding and the stench, had begun shouting and banging on the walls, the storm troopers had answered by firing a salvo of shots through the window. My aunt was hit and died in her daughter's arms a few hours later, before the train reached Lublin.

I thought back to the last time I had seen my aunt and her family. Shortly before the war Rachel's mother had visited us in Warsaw and had taken me back with her to southern Poland for the summer vacation. The family was well-to-do, and their house was hospitable and comfortable. I was then eight or nine and missed my mother dreadfully. Rachel was

about seven years my senior, but she liked children and looked after me well, doing all she could to make my stay of two months a pleasant one. Her parents and younger brother showed me great affection, and my grandparents, whom I had not known at all, could not make too much of their "granddaughter from Warsaw."

Now I gazed at Rachel, recalling the happy days of the past and realizing awkwardly that I had nothing to say to my suddenly rediscovered relative. The past was forever buried, the present unspeakable, the future threatening — what had we to talk about? Rachel was a tall, robust girl, and her appearance gave her every chance of passing selection and getting better work — which in turn meant a greater chance for survival. I told her this frankly and openly, but she was quite hurt. She wanted affection and comfort from me, not brutal words which bluntly expressed the naked truth about her new situation. To be honest, I could not bring myself to feel affection for anyone except Hela. Till the end of our stay in Majdanek, although Rachel tried to become intimate with us both, I remained entirely alien to her.

When we had been in Majdanek two months, the SS began selecting the healthiest prisoners and deporting them in groups of several hundred to other camps. The women generally believed they would have easier work and better conditions in the new places; and in fact, the first transport, consisting of the prettiest and most solidly built women, went to a labor camp near Czestochowa where conditions were not as severe as in Majdanek, and most of them managed to stay alive until they were liberated by the Red Army. Rachel was sent away in this "lucky" transport. "If only Hela looked like Rachel, she would have had the same opportunity," I thought as I said goodbye to my cousin.

During the next recruitment the Nazis selected Hela's cousin Halina and me. Hela, however, had been overlooked, and luckily I found a chance to slip away at the last moment in order to remain with her. I would not leave my sister-in-law for anything, not even the prospect of easier work in a better camp. It didn't matter where we ended up as long as I could be with her — anywhere — to the last . . .

A few days later they assigned us to a third transport. The uneasiness

that had prevailed in Majdanek after the departure of the first two was intensified by the news that the Germans were about to liquidate the camp entirely. We heard that anyone who remained would be exterminated — and this is precisely what happened, so Hela and I were fortunate to get out of the camp in time. That moment when we passed out of the women's camp, holding hands tightly, has remained deeply impressed in my mind. It was a moment of great joy and great hope. Those who remained behind envied us greatly, and their own sense of foreboding was soon tragically realized . . .

We were not taken very far, only to an empty hut in the men's camp. Very many wearisome procedures took place here; they copied down our camp numbers, our first and last names, places and dates of birth; they counted us over and over again. These seemingly absurd formalities went on for hours while we sat crowded together on the floor. Now and then SS officers came into the hut. We froze in terror at the sight of them, trying to guess their intentions from the expressions on their faces.

Male prisoners brought in soup, and it was possible to exchange a few words with them. Many of the women received greetings from relatives or passed on greetings of their own, and some were even fortunate enough to meet a dear one: a husband, son, brother, or friend. Neither Hela nor I met anyone familiar in the men's camp, and no one knew Hilek. But my sister-in-law struck up a conversation with one of the prisoners who was much interested in us. Later on he brought us some bread. An unusually feverish, lively mood prevailed in the hut until evening.

When night fell, the storm troopers locked the hut and switched off the light. I nestled up to Hela, and we both fell asleep on the floor, dreaming of a better place, easier work, tolerable living conditions . . .

In the middle of the night the SS men noisily threw open the hut door once more and began herding us out. They ran around like mad dogs, lit electric lamps, lined us up and counted us again, all the time swearing and shouting in their customary manner. After all this time we had still not adjusted to these abrupt assaults, and a fearful confusion ensued. Sleepy and frightened to death, we crowded to the door, pushing and trampling on one another in the darkness.

"They are taking us to the crematorium!" The terrible news spread

like lightning through the ranks. My heart beat rapidly. I could not believe this. Months earlier, when the Nazis had set up a machine gun in front of us on the Warsaw Umschlagplatz, I had not believed that death was a literal possibility, and this time too I did not yield to the general panic.

The SS gave an order, and we moved off toward a large, vacant building which resembled a bathhouse. Through the gloom we were able to discern stacks of empty gas containers on the ground in front of the hut, and we detected a strange, sweetish odor in the air. There was no doubt now that we were on the threshold of execution. The women went out of their minds. They groaned and wailed, tore their hair out, doubled over in convulsions.

Once we were inside, the door was barred behind us, and we were ordered to undress and hang our clothes up on hooks. We obeyed in silence; we knew there was no way out. We sat down on benches along the walls, waiting in extreme agitation . . .

Time passed. Hour followed hour, but nothing happened, no one came. It was silent both inside and outside the bathhouse. Perhaps they had forgotten us. A faint hope flickered inside us . . . We sat there nearly until dawn, and then the guards came back and led us outside. They counted us — as though anyone could have escaped from that locked building! — and took us straight back to the men's camp, to the hut we had occupied the day before. There we learned from other prisoners that the gas supply had unexpectedly run out during the night.

This strange salvation, however, turned out to be only one more step in an endless labyrinth, a maze of twists and reversals whose unpredictability harassed and wearied us.

We did indeed leave Majdanek the very next evening. We were loaded onto wagons and ordered to sit down on the floor with our legs apart, each woman tucked into her companion, so as to utilize all the space. Two storm troopers stood guard in the open doors of the freight car.

So my second journey into the unknown began. We believed that no matter where they were taking us it could not be worse than Majdanek, for it was hard to imagine anything worse than a night spent in the gas

chambers. It was now the middle of the summer. The train dragged along lazily for two days and two nights. Hunger and thirst took their toll, but much worse than that was the aching of our stiff limbs. We could feel the pricking of thousands of pins all over our bodies, and our legs weighed like blocks of wood, but we were forbidden on pain of death to change positions. I cannot describe the agony of this ride. When I had stood for hours during roll calls in the camp and my legs had given way in exhaustion, when I had dragged heavy rocks for twelve hours at a time under the blazing sun, I had longed to be able to sit down for a moment; I had never dreamed that sitting could be such torture. Every nerve, every muscle cried out to be loosened and stretched.

Suddenly my neighbor moved slightly in her place. One of the guards hurled a threat at her, but instead of complying she began begging him to let her stand up for a moment. Without waiting for an answer, she tried to rise, leaning on the shoulders of her teenage daughter who sat in front of her, a pretty young girl with great brown eyes and black hair. The guard aimed his rifle. Half-standing, the woman kept begging him for mercy. The guard was an elderly man of about sixty, so it seemed to me. Would he really shoot her? After all, the poor woman did not intend to escape, or even to stand up fully, but merely to straighten herself out a little.

The guard fired, striking her in the temple. We watched in utter stupefaction as she slowly sank down on the shoulders of her daughter, a look of disbelief on her face, as if she still could not believe that the old storm trooper had really carried out his threat . . . Her face grew paler moment by moment, life seeped away from her rapidly. The guard, apparently pleased with himself, slung his rifle over his shoulder as though nothing had happened.

A terrible silence filled the wagon. It was broken only from time to time by the convulsive sobbing of the young girl supporting the still-warm corpse of her mother on her slender shoulders.

After a moment, the guard ordered that the body be thrown out of the wagon. "You will not live long either," he said harshly to the young girl. "What are you blubbering for? Silence!"

She stopped. The tears poured quietly down her cheeks.

Auschwitz

The train stopped. As we climbed down from the wagons, those who had died during the journey were tossed from the windows like sacks. We were shoved along in a column from the railroad station, until we saw a sign that said: "Birkenau." So the mystery of our destination was solved.

Birkenau was a major division of Auschwitz. Nazis as well as Judenrat officials in the Warsaw ghetto had long terrified us with the name *Oswiecim*, or Auschwitz, as it is now called; we had shuddered at the very mention of it. Now our column was passing through a wide gate with a sign above it reading: "*Arbeit Macht Frei*" — "Work Earns Freedom." Below it were the initials F.K.L., which stood for *Frauen Konzentrations Lager*, Women's Concentration Camp.

The complex was much larger than that at Majdanek, but its features were only too familiar: the barbed wire, the closely-spaced watchtowers spiked with machine guns, long rows of gloomy brick barracks. A layer of thick, stinking mud covered the ground. Shaven heads appeared in the windows, colorless faces that might have belonged to men or women; we could not tell. In Majdanek the wooden barracks had been crudely constructed, but this camp seemed much more solid and expansive, so precisely organized, as though it were intended to last for centuries.

We will never get out, I thought in terror.

We were registered by insolent women Kapos in dark-blue, striped dresses and beautifully sewn aprons. I later learned that these aprons were the fashion amongst the "aristocracy" of Auschwitz. They were made by women prisoners — mostly Greek Jewesses who were known to be talented seamstresses — for those overseers who had the means to pay for them, either with extra soup or bread, or sometimes with eating utensils. We waited long hours as these Kapos counted and recounted us, shaved our heads, and tattooed numbers and marks on our wrists — the emblems of Auschwitz. The woman prisoner who tattooed me was unexpectedly kind. She saw that I was only a child, shivering with apprehension at the prospect of the operation, and she began to question me gently about my experiences. She spoke in Czech but I understood her very well, for the words sounded almost like Polish, except that she used

the diminutive form. Her voice was so soft that for a short time I felt a little better.

As the long hours of registration dragged on, I became desperate for a drink of water. Through the half-open door of a block overseer's small office, I caught sight of a bucket containing a dark liquid. I crouched over it and began to lap up the water greedily. It turned out to be dirty soapsuds, and for a long time afterward I could feel the loathsome taste in my mouth and throat. I tried to wash the taste out of my mouth when we were finally taken to the showers, but the thin spray of water splashed weakly in all directions, and I could not get a decent mouthful. After the shower they painted huge red crosses on our backs and sent us for clothing.

During all these procedures I lost sight of Hela. I almost went out of my mind at the thought that they might have taken her, as they had taken my mother. To my enormous relief, I rediscovered my sister-in-law at the bathhouse entrance and threw myself into her arms. The clothing and shoes we had worn in Majdanek had been taken away from us before the bath, and "new" clothing was now being distributed. Fortunately, the dress I received was warm and in good condition, but Hela had been given a summer dress, very short and ragged. I did something unusually daring: I gave Hela my clothes and slipped back into the crowd of naked women to receive a second issue. My heart was beating like a hammer, but I was very lucky and fared decently the second time as well. I approached a different Kapo who would not recognize me, and although she was busy abusing the prisoners with great relish, she treated me fairly well and did not even hit me. Had I been caught at my little scheme, I would have been given twenty-five strokes on the rear end — one of the lightest punishments in Auschwitz.

It was already night when we entered quarantine* in Block 15. There were about fifteen hundred women in the block. On either side of the dark, narrow passages rose three-tiered plank beds, and the women lay packed closely together on them under rough blankets. The room overseers ordered us to find places on the bunks. We wanted nothing more, but how could we find space where there was not even room for a

*Many Auschwitz inmates were typically kept in quarantine for a period of time upon their entrance to the camp to weed out those who developed typhus or other contagious diseases.

pin? The other prisoners pushed us away from the edges of the planks, and the Kapos beat those who stood on the ground. This would have gone on all night had it not been for the block overseer, who came out of her room and drenched us with a bucketful of swill and excrement. After this "bath" we managed by some miracle to find room, and we fell asleep for a few hours, packed sixteen to a bunk. A feeble bulb shone all night in the center of the hut. The tiny windows were shut, and the stench was suffocating.

During the initial two-week quarantine, the women worked only inside the camp area. Since there was not enough work for everyone, the majority of us were herded out daily to the *Wiese*, or meadow. The *Wiese* was a large, empty area surrounded by barbed wire. Nothing grew in this Auschwitz "meadow," which consisted of dry sand, cracked earth, and sharp stones. There we would sit for days at a time, shivering in the morning chill and sweltering in the afternoon sun, always hungry and thirsty. Kapos with thick sticks watched to make sure that no one could get into the washrooms and drink the yellowish water that came out in drops from the rusty pipes. We waited impatiently for evening roll call, when rations were distributed — a bit of bread, and soup made from leathery kohlrabi or turnips. Neither the bread nor the quarter liter of muddy swill satisfied our hunger.

Hunger and selections were the prisoners' two primary concerns, and both were controlled by the people who managed our lives most closely — the block and room overseers. These women were always well fed and well dressed, and they did not want for cigarettes or even vodka. They were German, Jewish, Slovakian, Czech, or Polish — prisoners like the rest of us, but marked by exceptional cruelty. They caused us greater terror than the German wardresses or even the SS, because they were always around: in the barracks, at roll call, at the work sites, in the washrooms, even in the latrines. It was they who distributed the bread, taking one-third of each loaf for themselves and selling it for a profit; it was they who replaced the lids on half-full soup kettles and opened the next one, leaving the thicker soup at the bottom for themselves or their favorites; it was they who herded us to selection, making sure no one gave them the slip; it was they who eagerly pointed out exhausted women to

the SS, should the latter by chance overlook anyone. They prohibited the use of toilets and washrooms, beat the feeble and the sick, and vied with one another to come up with the best methods for making our lives utterly unbearable.

In spite of the ceaseless torture, I still looked quite well. I was starving but did not show it, and my cheeks were rosy as they had always been. But to my despair, Hela grew thinner and more frail with each passing day. Her hands and feet were as brittle and slender as a child's. Her eyes became huge and protuberant, with a penetrating and immeasurably sad expression; her face became gray and contorted, her teeth began to loosen, and her gums bled.

In my struggle for Hela's life I was armed only with my great love for her, but in Auschwitz feelings were not enough to save a human being from slow death by starvation. Hela was always cold, and I often hid her in a corner and covered her with a sheet so that she might warm herself and doze for a while. Sometimes I gave her my bread or the occasional extras which were doled out with a frugal hand: a slice of sausage, a scrap of cheese, a spoonful of jam. Each time I had to convince her to take my portion by telling her how much I loathed the taste of camp food . . .

I still believed that Hela would regain her health; but she herself knew that my little sacrifices, the only ones I could afford, were already in vain.

The Laundry

After the quarantine was over, Hela and I found ourselves in Camp B. Our new overseer, a twenty-year-old Jewish girl from Slovakia, had come to Auschwitz in one of the first transports. She had succeeded by this time in learning all the secrets of Hell and was literally a monster.

In Camp B Hela and I worked at first in the laundry. This was a comparatively easy job by Auschwitz standards, since we worked indoors and were not exposed to the rain or the sun. In the laundry we could wash ourselves and our clothing, and sometimes we could even cook a few potatoes bartered for bread or warm up the camp soup, thinning it with water. At least here there was no shortage of water, but the work was exhausting. For over twelve hours a day we scrubbed dirty, torn rags, listening all the time to the derision and curses of the Kapos.

One of the Kapos, a good-looking German woman named Emma, had allegedly been sent to the camp as a punishment for prostitution. She had pale blue eyes and dark hair, and she smelled all the time of vodka and cigarettes. Her assistant, Lotti, was a tall blond woman who had been sentenced for the same offense. Lotti had already been sent several times to the SK, or *Strafkompanie*, a punishment unit for prisoners who violated camp regulations. The SK inmates stayed in a separate, locked barrack and were assigned to particularly hard labor. Lotti's trips to the SK backfired on the prisoners who were under her management, for she mistreated us more often and more ferociously than did Emma, who was her superior. I thought Lotti nothing but an animal.

Emma had shown me a certain leniency from my first day in the laundry. Once she even drew me to her, sat me on her lap, and began asking me questions: my name, where I came from, how old I was. Then she announced that she would make me her "little pet," and suddenly she kissed me. The smell of alcohol assailed me, and I slid off her lap in disgust.

"Pets" were one of the prevailing customs in Auschwitz. The Kapos and block overseers chose favorites, young girls who had some talent such as singing or sewing, and kept them as pet servants. They lavished affection on these little lackeys, dressing them up and giving them all kinds of tasty things to eat — but there was a price to pay for these privileges. "Little pets" had to be on call all the time, ready to flatter and fawn on their "foster mothers" or inform on their companions. I preferred hard labor and hunger to such a position. During my two-year stay in the camp I never became a "pet," although I would have suited the role very well because of my age.

When Emma found that she could not recruit me, she chose instead a small, sly, shrewd Jewess named Henia. Emma did not try to demonstrate her "affection" for me again, but she remained kindly disposed toward me for the duration of my stay in the laundry. She never shouted at Hela or me, and sometimes she assigned us lighter work or gave us a little extra soup from the kettle. I always thanked her, but I never fawned.

Kuk, the plump blond SS woman who supervised the laundry, also treated me reasonably well. Sometimes I noticed her watching Hela or me

at work with a sort of curiosity, perhaps even with sorrow or pity. Once Kuk brought me a piece of bread, and on another occasion an egg. I sometimes thought that she must have had a little daughter at home and had "transferred" her compassion here. She never spoke to the other women in the laundry, and her behavior toward Hela and me was astonishing.

Our colleagues in the laundry envied us Kuk's consideration, and they took out their resentment by bullying both of us. The greatest harassment came from Henia, Emma's "pet," who continually intrigued and stirred up the other washerwomen against us. I watched this strange, malevolent human drama with great bitterness and fear, for there was no escape from it.

Henia was one day promoted to manageress of the laundry. Her rancor toward us had never abated, and she was constantly looking for ways to turn Emma against us, hoping to have us pushed out of the laundry altogether. One day an incident occurred that provided the final straw in her fire.

It was a hot, stifling August afternoon, and we were waiting impatiently for a rest and the bread distribution. Hela was hanging up laundry on the clothes line outside while I stood indoors, scrubbing linen with a hard brush. Recently Hela had been running a high temperature in the afternoons, and on this day she could scarcely walk, so I kept going out to check up on her. Just before work ended, I glanced out again.

Hela was not there.

I asked the other women if they had seen her, but no one had. I wondered if she had run across to the latrine or crept back into the block, but as I looked, my uneasiness mounted. Hela never went anywhere without me, or at least without telling me where she was going. The hour of roll call drew nearer, but still Hela had not appeared. I sought her everywhere, calling her name. Time passed, whistles resounded on all sides for the roll call.

The Kapo counted us and inspected the ranks. One prisoner was absent! The other women scowled at me aggressively, and the overseers panicked, for they would be held accountable for the missing prisoner. They scoured the camp in search of the truant, looking in all the nooks and

crannies, in the washrooms and latrines, and then they counted us again — but one was still absent! She had vanished as though at the touch of a magician's wand.

A storm trooper marched into the square. The block overseer stiffened to attention, casting me a glance full of hatred and terror. She reported that one prisoner was absent in her block. The storm trooper conducted his own count, slowly and precisely, inspecting each column. Our heads were reeling from all this counting! After a short time the ominous news spread through the entire camp that a prisoner was missing in Block 27. This meant that instead of being able to go to the latrine after a hard day's work and sit down to eat our crusts of bread, we had to stand in line until the culprit was found. I felt stares of hatred piercing me on all sides, while the burden of my own responsibility and my anxiety for Hela weighed me down.

At last they found her. She was lying unconscious in the grass, not far from the place where the linen was hung to dry. The Kapos dragged her triumphantly over the ground as though she were an escaped convict, pulling her through the stones and mud and kicking her as they went along. Then they handed her, bleeding and half dead, to the block overseer.

Finally the roll call disbanded. The crowds of women dispersed like a herd of animals cooped up too long, some to the barracks, others to the washrooms or latrines. I pulled Hela onto her bunk, washed her scratches and bruises with an herb concoction that we had been given to drink, and wrapped her in a blanket. I tried to comfort her; I told her we should certainly live to see the day of liberation, as everything pointed toward a rapid end to the war. My words were very far from convincing, but they clearly brought her some relief, even though she could not answer me.

The next day the two of us were dismissed from the laundry. Henia, Emma's little pet, had used Hela's "delinquency" to convince Emma to get rid of us. We left with tears in our eyes and grief in our hearts, for not only had we lost the benefits of working in the laundry, but the blow had been delivered by a fellow prisoner and Jewess. The complacent looks of Henia's friends pained me as well; they were enjoying our defeat.

The Factory

Fortunately, Hela and I did reasonably well at our next assignment in a nearby underwear factory. We were able to work sitting down, which was a tremendous relief, and the Kapo did not beat us or insult us coarsely as others had. We repaired the camp linen, sewed on buttons, and darned stockings, wondering all the time for whom these clothes were intended, as we ourselves rarely received any good, whole clothing. At noon we went back to the block for our soup ration. The evening roll call took place in the factory, so we did not have to stand outdoors for long hours in the hard frosts of winter.

There were alternating day and night shifts in the factory. The night shift was especially exhausting, not only because of the tediousness of the work, but because it was impossible to rest or sleep in the block during the daytime. The room orderlies continually forced us to perform various tasks, such as cleaning the barracks or carrying soup kettles. In addition, remaining in the blocks exposed us to frequent and unexpected visits from Dr. Mengele, who roamed the grounds during the day, looking for women to use as subjects for his scientific experiments. We used to dodge him by jumping out the windows or hiding between the huts and in the latrines.

The night shift always seemed to drag on interminably. Dozens of weary women sat at tables in the feeble light, crouched over their sewing machines. The room was stuffy and hot, and talking was forbidden. The darkness of the night was spotted by the burning glow of the crematoria, and the silence was broken now and again by the whistle of locomotives or the roar of trucks, some bringing in new loads of Jews, others hauling people away for cremation . . .

When the Kapos took us in groups to the latrine at night, my eyes would be riveted to the truck caravans. Although I knew what was going on here, I still could not believe it. Anguished sounds sometimes came to us from the barren expanse of the field: the shrieks and groans, sobbing and prayers of the condemned . . . sounds that seemed to bubble up from the murky, cavernous pit of hell itself.

The day shift in the factory was somewhat easier. We could sleep at

night, and we did not have to listen to the terrifying noises of the midnight hours. If the German overseer was in a good mood, she would pick out singers from among us and urge them to perform. As we listened to the beautiful songs of many different countries, we would forget our own bitterness for a few moments. There were excellent singers in the factory, with a very wide repertoire — particularly the Jewish women from Greece. They were frail and suffered greatly from the Polish climate and the harsh conditions in the camp, but they nevertheless sang beautifully.

At the end of the summer of 1943, scabies* began to rage in the camp, causing us additional torment. We were covered from head to foot with red scabs which itched mercilessly. We scratched until the blood flowed and the sores filled with pus. The crowding in the barracks only aggravated this condition, and quarrels and fights inevitably broke out. We slept eight or ten to a bunk, and on the hot August nights we would lie soaking in sweat, sticking to one another and itching interminably. By the time morning came, our sores had become glued to the straw mattresses and were festering again. It was hard to draw stockings on over these inflamed ulcers. When we tore them off in the bathhouse, our legs were invariably drenched in blood. As if this suffering were not enough, the lice swarmed about our open sores, swollen and aggressive, satiated with our blood!

I became so enraged by the itching that I lost my temper at the least provocation and quarreled over the slightest things, even with Hela. Hela had more patience and showed me unlimited tolerance. In the evenings, when I flung my clothes around in a fury of scratching, she would quietly put them in order again. She sat by me for hours at a time, sometimes until late into the night, fanning me with a piece of rag and calling me her "little chicken," an affectionate nickname she had used ever since my hair had begun to grow in again . . .

Throughout this period I continued to go to work in the underwear factory. I was suffering and starving like everyone else, yet somehow I retained my health and good appearance. I still do not know myself to what I owed this physical resistance.

*Scabies is a contagious skin disease which is caused by mites burrowing under the skin and is marked by severe itching.

The Children

There was a small group of children in Auschwitz, ranging from one to fourteen years of age, and some of the Kapos and even the block orderlies showed a slight interest in them. The sight of live children was quite a novelty here.

One fine day a special block was assigned to these children. The conditions there were reputed to be excellent: clean, four-person bunks, new straw mattresses, warm blankets, large rations of white bread and milk, and a piece of butter every day — not to mention the promise that the children would not be forced to work. Many young girls dreamed of getting into this alleged paradise, as did a handful of grown women, who, with their shaven heads and terribly emaciated bodies, might indeed have passed for children. They adopted various devices and tricks in order to gain entry, and those who succeeded aroused general envy. As for me, I did not go to the block with the other children, even though I was entitled to because of my age. I maintained stubbornly that I was seventeen, for I did not want to leave Hela under any circumstances. I was also secretly afraid that the white bread and milk was merely a ruse, and that within a few weeks trucks would come and take all the children from this "marvelous" barrack straight to the gas chambers. The prisoners mocked me for my stubbornness, but I let their jeers go in one ear and out the other.

My suspicions were confirmed to the letter. The fate of the Jewish children in Auschwitz only reinforced my belief that in a time of crisis and privation, a person must listen to the voice of instinct and do everything possible never to forget his or her own dignity. The lure of the white bread had been powerful, but somehow I found the strength to draw the line between my hunger and my better judgment, and thankfully I was rewarded. Such internal vigilance was required constantly in the camps. From the beginning I had always stood aside when prisoners surrounded the soup kettles, trampling on one another and pushing in order to grab a couple of potato peelings or a portion of the thicker broth. This grappling always drew mocking laughter from the storm troopers and their toadies. Sometimes I would tell Hela that we two, at least, had given them no cause for mirth.

But the soup kettle was a source of anguish for me on another account. Hela was now so weak that she no longer had the strength to starve, or even to think straight, and she often begged me to go to the orderly handing out the food and ask for another helping. "You are a child," she would implore me. "She will not refuse you. Try — after all, they will not kill you for it."

I suffered extreme torment on such occasions. Hunger drew me like a magnet to the soup kettle, and I felt I ought to do what Hela asked, but I could not overcome my fierce resistance. Sometimes, though very rarely, the orderly herself would call me over and pour a little more soup into my bowl. I would quickly put the bowl down to disguise the trembling of my hands, furious with myself for being unable to control either my hunger or my need for a little human kindness, but proud at the same time that I had not demeaned myself to beg.

These occasional bonuses eventually rendered me insensitive to my sister-in-law's pleas. "Halina, go and ask her, please try . . ." she would beg, and I dared not look her in the eye then. I could hardly keep from stopping up my ears; my feet were rooted to the ground, my lips sealed. The thought that the orderly might hit me, push me away, speak crossly or make a coarse joke while I was standing in front of her with an empty bowl in my outstretched hands — this thought tortured me even more than Hela's beseeching expression.

I realized that I was doing Hela an injustice, that I was behaving stupidly, childishly. "Are we the only ones going hungry?" I wondered, trying to find my way through this dilemma. "Others are crazy with hunger too. What of it? They are not ashamed, they keep asking for more — and they usually get a blow on the head with the ladle, and insults instead of soup." I served Hela blindly in every way possible, but in this one matter I could not bring myself to obey her.

Hela's condition worsened daily. She had become a living skeleton. No one would have recognized her as the young, graceful, charming girl with golden hair and merry blue eyes of only a few months ago. Terrifyingly thin, with her bald head, protruding eyes, and earth-colored face, she looked to me sometimes like a very old woman and sometimes like a physically underdeveloped child. It cost her a great effort to climb

into her bunk and get down again, and she could now hardly stand for roll calls. She sat hunched up over her work at the table in the underwear factory, tortured by a cough, scabies, diarrhea, and scurvy. She often collapsed, and I had to hide her wherever we were — from the block and room orderlies in the barracks, from the Kapo in the factory. I was afraid they would send her to the sick bay, the "hospital" whose name was synonymous with death.

Some of our neighbors on the bunk advised me to abandon her, as she assuredly had tuberculosis and would soon die. I listened indignantly to these diagnoses, made with all the inhuman frankness of Auschwitz. I loved Hela and believed she would conquer even tuberculosis, that she would live to see the liberation with me . . . At the same time I watched as some of these very women who shared our bunk, those who were healthy and strong and had the greatest chance of survival, slowly break down and become what we called *musslemesses*, women who had lost the will to live.

The camp authorities and their prisoner assistants treated the *musslemesses* with outrageous cruelty, beating them at every opportunity. When a German doctor selected these weakened women from a crowd of inmates by the movement of a finger, they were taken directly to the gas chambers or to Block 25. This block was separated from the rest by a high wall. Its inhabitants languished there in total isolation, deprived of food and drink and the opportunity to use a latrine, sometimes waiting weeks at a time for death. They usually went toward this death, however, without the slightest resistance, seeing it as their only escape. When anyone spoke of Block 25 in my presence, I forgot my hunger and exhaustion at once . . . and I worried more and more for Hela.

Just as her condition had taken a sudden plunge, the entire block was put under *Blocksperre*, an order prohibiting prisoners from leaving their quarters under any circumstances. Such an order facilitated selections by making it impossible to flee from one block to another, and it prevented the prisoners from watching the deadly proceedings in the square.

We lay sweating on the packed bunks, quarreling continually over an inch or two of space. Prisoners crowded around the door of the hut, begging to be allowed to go to the latrine. The block overseers set about

these unhappy women with fists and clubs, beating, threatening, and drenching them with swill baths — all to no effect. The crowd did not relent. As the *Blocksperre* continued, the prisoners' desperate, riotous demands only increased. Occasionally the overseers were forced to yield.

In order to get out to the latrine with a group of lucky women, we had to carry on a fierce fight with other prisoners at the door. Only comparatively strong people could manage this. The sick women, especially those with diarrhea, did not have a chance — and even if they had been fortunate enough to get out, they did not have the strength to reach the distant latrines.

The humiliation these women suffered is impossible to describe. They had nothing with which to wash their soiled legs, and a change of blankets was out of the question. In addition, their illness put them in danger, for the Germans had created a classic trap; they had confined us to the block and then forbidden us to relieve ourselves there. Any evidence would be taken as an indication of sickness, which could easily make one a candidate for selection. Many women with diarrhea relieved themselves in soup bowls or coffee pans which had been stolen. They hid these utensils under their mattresses, hoarding them at great risk; the punishment for such theft consisted of strokes on the rear end, or kneeling all night long on sharp gravel while holding up bricks in the air — punishments which frequently ended in the death of the "guilty."

Diarrhea deprived Hela of the last remnants of her strength. Sometimes when she tried to get down from the bunk, she would be seized by a sudden bowel spasm. I concealed her with a blanket so that she might relieve herself unobserved into a pan. This required great caution, for if a neighbor in our bunk were to notice, she might report us to the room orderly.

I knew that I could not dump the contents of the pan anywhere near the block; and so, with a beating heart, I would struggle to the exit with that sinful pan, maneuvering and dodging like a criminal, fighting off the other prisoners, scratching and kicking in the unearthly crowd, knowing that I had to get to the latrine at any price. On the way there, in a close-packed group under the guard of numerous orderlies, I hid the pan as best I could, shifting it from one hand to the other, guarding it like a treasure.

I smuggled out that stinking pan innumerable times during the *Blocksperre*, undergoing panic and terror each time. Fortunately, no one ever caught me committing this "crime."

Hela was already so weak and exhausted by her illness that she wanted to go voluntarily to the sick bay. But I opposed any such thing adamantly, assuring her that her sickness would pass. Inwardly I was dying of despair.

That fall, heavy and persistent rains made our lives even more difficult. We waded in mud puddles that covered our ankles, cold and soaking in our rotting clothes. The storm troopers deliberately prolonged the roll calls, and on rainy days they seized any pretext to give us "exemplary punishment," such as forcing us to kneel in the mud or run with rocks in our hands. We were punished for a variety of reasons: because we marched out of time with the band that accompanied us to work; because our shoes were not properly cleaned; because we did not behave quietly enough during *Blockruhe*, a mandatory period of absolute silence. There were any number of such "offenses."

In the evenings, after hard days like these, we would return to the block to discover that they had taken away our straw mattresses and our few blankets for delousing, and had smeared the bunks with a stinking fluid that was supposedly a disinfectant. Unfortunately we never felt the blessed results of these hygienic procedures.

An Encounter With Hessler

One morning after the night shift, we had just returned to the block and lain down on the bunks, nearly paralyzed with exhaustion, when a terrifying whistling suddenly arose on all sides of the camp: "*Get up for roll call! All Jewesses for roll call!*" The orderlies pulled blankets off sleeping women, cursing and belaboring them with their fists. Agitated and chattering with cold, Hela and I finally managed to drag ourselves out to the compound, where ranks were being assembled. We had no doubt what this special "roll call for Jewesses" meant; those who stayed in the barracks during the working day were always vulnerable to selection. We glanced at one another in terror. Which of us would pass the selection and return to the block?

I was seized by the monstrous and desperate certainty that this time they would take Hela away. I had long since ceased to believe in miracles. Feverishly, I tried to persuade my sister-in-law to run away, to hide in the latrine or in some other nook... but Hela refused. She remembered how they had beaten her when she collapsed outside the laundry, and declared she would rather die than go through anything like that again.

We proceeded in fives to the large empty space in front of the bathhouse and stood there in a single line, stripped naked. There were hundreds of women in the line, from numerous towns and countries, speaking various languages: tall and short, fat and thin, some healthy and smooth, others with scabs, wounds, and bruises all over their bodies.

The SS tribunal took its place opposite the line, and the little finger of Dr. Mengele's elegantly gloved hand passed final sentence — left to death, right to a bit more life in the Auschwitz dungeon. The line of naked bodies moved toward the bathhouse. Dr. Mengele, accompanied by Unterscharfuhrer Taube, sorted out his victims with calm deliberation. The women whose life he spared went into the bathhouse, and after a brief shower returned to their blocks. Those he condemned were herded by Lagerkapos to the left side of the square; their numbers were written down so that they could be crossed off the list of the living.

The day happened to be a very beautiful one. The sun shone in a clear, bright sky, and the selection was proceeding smoothly and correctly, as usual. The doctor's finger moved slightly: right... left... left... right. The procedure was so accurate, so systematic. I walked immediately behind Hela to keep her in my sight all the time. As we advanced toward the judges and executioners, I moved closer to my sister-in-law. The line moved on steadily. My heart was beating so hard that there was a darkness in front of my eyes. Mother, what was going to happen? A few more steps, one more step...

We were standing face to face with the fresh green uniforms, round green caps with stiff peaks, cold eyes calculating our usefulness, our physical condition. I pressed against Hela, wanting to protect her from those eyes with my own body. At that moment the gaze of Dr. Mengele fell upon us, cool and implacable. His finger moved casually, dividing me from Hela: to the right — to the left.

My heart stopped beating. I embraced Hela. Curiously enough, I suddenly felt young, healthy, and strong. I no longer saw or feared anything — all I knew was that I had to be with Hela, no matter what happened.

Already a tumult had broken out in the square. The progress of the selection had been interrupted, the iron discipline broken. Everyone was staring at us; Unterscharfuhrer Taube was dumbfounded. Kapos began to close in from all directions, trying to tear me away from Hela, but I would not yield. I clenched my fists, kicked, shrieked, a naked little thirteen-year-old girl clinging ferociously to a half-dead skeleton. Who knows how long the Kapos would have gone on scuffling with me if Taube had not decided that since I did not want to be parted from a condemned woman, I should share her fate. So the Kapos wrote down my name on the list of the selected.

Meanwhile, the group of SS officers in the center of the square stood watching, shading their eyes from the sun. The scene apparently amused rather than angered them, since not one reacted or expressed the least indignation at my act of rebellion. Such passivity on their part was rare in the camp, where the authorities were accustomed to blind obedience. Perhaps my childish resistance held a sort of dramatic attraction for the bandits; at least, this is the way I explain it to myself today.

Then something even more remarkable happened, something none of us could ever have imagined. Hessler, the deputy camp commandant, beckoned to me with a finger. I clutched my dress and ran without thinking toward the group of storm troopers. They were all tall, strapping, self-assured men; Hessler seemed even more formidable and ruthless than the others. I looked up into his face. He asked me the identity of the woman for whom I was fighting so hard. I began to explain in a rapid, unchecked flood of mixed Yiddish and German, as though I had been waiting a long time for the opportunity to give voice to everything that filled my heart.

"She is my mother, my sister, my family, I cannot live without her," I cried.

The officers listened in silence. Not one of them moved or gestured; they seemed to have turned to lead.

Then, in the tone of voice people use to scold a disobedient child, Hessler told me to be quiet — "Otherwise, you will go in there with this *Schwagerin** of yours, do you understand me?" — and he pointed to the crematorium smoking beyond the wires.

I shut my mouth instantly, but not before a single, brief, incredulous word involuntarily escaped: "Me?"

The storm troopers snapped out of their freeze and burst into harsh laughter, mimicking me with a fiendish, cruel mirth: *"Me? Me?"* Hessler called the Lagerkapo and ordered her to cross Hela's and my numbers off the list. I could not restrain my wild joy and, forgetful of everything, rushed toward Hessler to thank him.

A hard slap stunned me, and I lost my balance and fell. In my brief and powerful burst of gratitude, I had forgotten one important fact: animals will always remain animals, even if they make an occasional, seemingly humane gesture. So I was punished and brought back to reality; but even though we had escaped death, it was not easy to forget the shame of that brutal slap.

Now the Kapos smiled indulgently, vying with each other to show us "kindness." A crowd of women surrounded us in the bathhouse and later on in the block. All that evening people in the camp talked of nothing but my "adventure."

When our block overseer, a nasty, bad-tempered woman, heard the news, she smiled with a touch of pride that anything so extravagant had happened in her block. She wanted to know which little girl had saved her sister from selection (camp gossip had turned Hela into my sister, which apparently made my deed seem more understandable) and had actually dared to try and embrace Hessler! When my neighbors produced the "heroine," she came over to have a look at me, and I saw surprise, contempt, and disappointment in her expression. I was undistinguished, nothing but a starved, miserable child who looked like so many of the other victims here, and who would any day join the crowd of *musslemesses*. Yet even though the overseer could not understand how I had "won over" the Nazis, she stopped preying on Hela and me.

*Sister-in-law.

Our strange victory in the selection line did not strengthen Hela's belief in a better future. Only her love for me kept her going. Sometimes she would show me her arms and legs, which were as thin as twigs, and say, "As it is, I am no longer alive. I only live through you, Halina, with your breath . . ." Once she added in thoughtful amazement, "I never dreamed you could bring yourself to do such a thing, that you would want to go with me to . . . the very end."

I replied frankly that I had not expected it either, that if I had been asked before the selection whether I would willingly accompany anyone to the gas chambers, I would have said, "No." Any other response would have been a lie, for I was terrified at the thought of death. But when I was faced with the threat of losing Hela, I could not resist the prompting of my heart and acted instinctively, to my own surprise.

Hela looked at me with great affection, and an upsurge of warmth for her flowed through me. I kept telling her, as I had so often before, that she would live to see the day of liberation, but she persistently and sadly denied this. She knew she was mortally ill, that her days were numbered.

Soon afterward there was another selection in front of the bathhouse, and this time Hela obeyed me and hid in our barrack. Such a trick sometimes worked when the selection did not cover the entire camp or did not occur during a roll call.

Hessler recognized me instantly among the hundreds of prisoners in the square. "Ah, that's the girl who made a scene recently," he exclaimed as I passed him in the line. "And where is your sister-in-law?"

Terrified, I replied that Hela had gone by earlier. Fortunately Hessler was satisfied with this fabrication. Had it occurred to him to check whether or not I was telling the truth, there would have been no help for either Hela or me.

Hela's Concession

In November 1943 the early frost began to make itself felt. An epidemic of spotted typhus broke out in the camp. Thousands of women lay half-conscious, burning up with fever, their lips parched and cracked. They died like flies — in their bunks, during roll calls, at work, in the sick bay, in the gas chambers. The number of women prisoners shrank at an

incredible rate, and the barracks became emptier each day. In our block, which had housed thirteen hundred prisoners before the outbreak of the epidemic, only two or three hundred remained within a few weeks.

Hela's life too was flickering and fading, like the flame of a dying candle. I began to realize that sooner or later I would have to give up the fight and allow her to be taken to the sick bay, but I tried to delay it as long as possible. I continued to take her pan to the latrine and to quickly cover the places where she relieved herself during roll call. Since the incident with Hessler, I was no longer very much afraid of the block overseer or of any of our companions, and somehow no one dared to bully us.

One morning the whistle that summoned us to roll call no longer penetrated Hela's mind. She could not understand what I wanted her to do and remained deaf to my appeals. She lay motionless, resigned to her fate. The room orderly put her on a stretcher and placed her alongside the other sick women in the block, all of whom would be taken to the sick bay after the roll call. This procedure had taken place daily for months; the only difference was that Hela was now among these helpless women. She lay on the stretcher as though it were a coffin. Only her eyes, huge and wide open, were still alive, staring at me as though bidding farewell, as if imploring my forgiveness or pleading to be remembered . . . No, I cannot describe all the things there were in Hela's dying eyes. I cannot describe how awful this twenty-year-old girl looked.

Today when I recall that scene, I cry. But at the time I was too stunned to summon any tears.

I had to leave Hela in the bunk and go to roll call alone for the first time since we had come to the camp. I stood alone in an enormous crowd of women, all suffering, all indifferent to the suffering of others. I was of no use to any of them, my fate was of no concern to anyone; each had her own past, her own tragedies. The law here was the law of the strong, and these women showed me no pity. They threw me out of the food lines, stole my blanket at night, or pushed me off my mattress onto the bare boards or on top of the muddy boots that lay against the wall. I was surrounded by hostility, yet I was affected by it more deeply now than ever before, for Hela, who had always stood up in my defense in spite of her own ill health, was no longer there.

I fought for myself as best I could. I did not cry or appeal to anyone for help. Like the others, I grew indifferent to anything that did not threaten me directly. It was as though I became a different person after parting from Hela . . .

I saw her once more before she died. The deputy block overseer, a Polish woman named Zosia who had known us before the "celebrated" selection, took me to the sick bay one morning when she was on her way to deliver more victims.

I barely recognized Hela in that hospital hut, among hundreds of near-corpses.

"Halinka, is that you?" she whispered in a feeble voice, as though aroused from a deep sleep.

I could not speak. I placed some bread beside her, a portion which I had been hoarding for several days, ever since Zosia had promised me this visit. Hela paid little attention to the bread, but her eyes did not leave me. When I had managed to gain control of myself and was about to say something to her, the orderlies drove me away.

Great heaps of corpses rose between the barracks in the sick bay yard. The corpses were naked and stiff and reminded me of frozen, dried-up bundles of cordwood. Their shaven heads were thrown back, their limbs mere sticks. Every few days prisoners from the Sonderkommando* would drive up and pile the corpses onto their trucks, then tip them like so much rubbish into the ovens. I had never seen so many corpses at one time, and my sister-in-law now differed but little from them. I went back to the barracks half-conscious with grief and despair . . .

*The men in the Sonderkommando worked in a world of terror beyond the scope of human imagination. They witnessed the greatest evil of Auschwitz and were unable to help.

The Sonders' task was to sort and dispose of the bodies of all the victims of the gas chambers. They would enter the chamber after a mass gassing and hose down the mound of corpses with a strong torrent of water in order to remove the excrement. Then they separated the bodies, shaved the victims' heads, and searched their teeth and private parts for hidden gold and diamonds. Finally they loaded the dead on elevators and delivered them to the crematoria. The Sonders often recognized their own parents and relatives among the victims.

The Sonders were chosen for their positions and had no say in the matter. They were fed and clothed well and were never allowed to leave their posts. They were not permitted to live more than four months after they had been on the job, for they knew too much. At the end of their term they were murdered and replaced by a new group of prisoners. No Sonder ever escaped. Those who tried were caught and thrown alive into the crematorium.

Some weeks later, when Zosia was counting us, I asked her shyly whether she knew anything about Hela. Zosia was in constant contact with the sick bay and always had information about anyone from our block who had gone there; she knew who had died, who was improving, and who had been taken to the gas chambers, and she recorded these facts in her logbook. However, she had not spoken to me of Hela since my visit to the sick bay. Like most officials in the camp, she was ill-tempered and treated the prisoners with contempt, and this was why I hesitated a long time before daring to ask her. I was also afraid of bad news.

Zosia was startled at first by my question and said nothing. I was sure she would instantly snap at me or curse, but she only looked me straight in the eyes. For a long time nobody had looked at me with such a human, everyday expression.

"She is dead," she replied briefly. She did not move away immediately; I could still see her face through a mist, through the darkness that suddenly surrounded me. I groped through the mist, for I had to know more. I had to learn exactly what had happened to Hela — if they had taken her in a selection, or if they had gassed her, or . . . Every detail was indescribably important to me.

"She died a natural death," Zosia said with a strange smile, and then I heard her a moment later, shouting at a woman further down the line.

Halina Birenbaum was liberated in Auschwitz. In 1947 she immigrated to Israel, where she married and raised two sons. She is the author of the book Hachaim K'Tikva, *as well as several volumes of poetry and dozens of articles in Hebrew and Polish. She lives in Hertzliah and travels extensively in Israel and abroad, lecturing on the Holocaust to students and general audiences.*

IMAGES FROM THE DEPTHS
❖
Berta Fredreber
Krakow, Poland

Plaszow

All the years of suffering and hardship, both in the ghetto and in the camp, took a tremendous toll on my husband's health. Since the beginning of 1943, when we were brought to Plaszow,* he had suffered from furunculosis. His entire body was covered with lesions which exuded pus. At night his pain was much worse because he slept on a hard, naked board, and those few hours that were granted for rest he spent in terrible agony. His teeth also began to fall out, one after the other.

Thanks to a few connections, we succeeded in getting him into the revier, the camp hospital. The revier was not a place where people received any kind of treatment; in fact, it was more or less a dumping ground for the sick, but it was the lesser of two evils. If my husband remained in the block, his chances of survival were almost nothing; in the revier we might be lucky enough to arouse the mercy of one of the workers and get a bit of aid. The doctor, who was a prisoner himself, told me that my husband's condition was critical and that the only way to save him was to cultivate a sampling of the pus from his boils and then inject him with it as an immunization. However, this procedure could not be

*A labor camp on the outskirts of Krakow.

carried out in the revier. Shortly afterward I learned that many of the patients there were being given lethal injections.

I was among a contingent of prisoners who were escorted out of the camp each day to forced labor assignments in Krakow and various other work sites. Once as we were leaving the camp, our guard let slip some news: all of the sick in the revier had been killed that day. When I heard this, I almost lost my mind, but there was nothing I could do. I spent the entire day at work in agony. When I returned to the camp, I ran straight to the revier and found it empty. All of the sick inmates had been sent to the crematorium — except my husband and one other patient, neither of whom suffered from contagious diseases!

This reprieve was no guarantee of any kind, however, and my husband's sickness was a continuing threat to his safety. In desperation, I asked the doctor to draw some pus from the boils and grow a culture from it, as he himself had suggested. With the help of a Polish messenger, I sent the sample to a laboratory in the city, and two days later I received the immune serum. I took my husband out of the revier and asked the doctor to begin treating him in secrecy, and thankfully he agreed. No bandages were available, so I tore my blouse into strips, and every night I washed my husband's wounds and changed the dressings. Slowly the boils began to heal, but visible marks remained on his body.

In May a selection took place. All of the chosen prisoners were ordered to appear stark naked before a medical commission. The weather at that hour of the day was frigid, and the men stood for hours. My husband's body turned blue and the redness of his healed scars was very conspicuous, but he successfully passed the selection and was sent back to the block to dress himself.

Only moments later, the head of the commission called him back, reexamined his scars — and sentenced him to death!

My husband was put on the "unproductive" list. He knew then that his days were numbered, but since he did not know which one would be his last, he took leave of me every evening for a week, giving me comfort and encouraging me not to give up. He reminded me that our two young daughters, who had been hidden with a gentile family in Krakow, were waiting for me. "You've got to live," he kept on saying. "You've got to

promise me to fight for your survival with all your strength." He talked at length with Sabina, my sister's nineteen-year-old daughter, and tried to inspire her too, telling her that her youth would enable her to overcome all the hardships. He made her promise that after he was gone she would take care of me.

I asked him what had made him lose the will to fight for his own life. He answered that he had an inner feeling that he would not escape his fate.

At that time close to three hundred children were still in Plaszow. These children had been smuggled through the gates by various means. Some were given sleeping pills and were then packed into their parents' luggage, others were left in the city and brought into the camp later on by Polish drivers who had been bribed. The drivers usually hid the children underneath sacks or boxes, and once past the camp gates they turned them over to their parents. Legally, only the Jewish policemen and Jews who had held "high positions" in the ghetto had the right to bring children into the camp.

The Germans were not blind to this situation. Early one morning in the spring of 1944, the camp authorities notified us that a special children's house would be established so that parents could go to work "undisturbed," and their "poor" children would be able to spend the day in pleasant surroundings. That same day they ordered all of the children to be concentrated in a specially assigned hall.

The hall was new, clean, and brightly lit. In front of the building stretched a beautifully manicured green lawn, adorned with colorful flower beds. This was the first time that some of the little children had ever seen a real flower. Special kindergarten teachers were brought in, as well as a new SS woman who took over the supervision of the home.

This woman was blond and attractive, with an extremely slim figure. It was hard to believe that inside this beautiful exterior lodged a soul so dark and murderous that even Satan himself would have been unable to create it. Her name had preceded her; even before she arrived, the news reached us that she was known to be a "specialist" in the murder of young children.

During the few weeks that the children stayed in the new residence,

they were well cared for. They were kept clean, given enough to eat, and allowed to run and play freely in the garden in front of the hall. The color returned to their sunken cheeks, and the characteristic fear in their eyes disappeared. They began to look like normal, healthy youngsters again.

Then came May 13. We stood *appel* as usual in the early morning hours, but this time we noticed a few cargo trucks standing on the death path — the road leading to the exit gate in back of the camp, through which the condemned passed on their way to the distant death camps. Children's songs were booming over the loudspeakers. We looked on as all the children were led out of their building toward the trucks. The Germans then began to pull people out of our ranks too — all those who were listed as "useless," unable to do hard work.

Among the sentenced adults was the overseer of our block, a woman of beautiful spirit. She was one of the few exceptional souls who did not exploit their authority, and she had always tried her best to assist the other prisoners. Because of her position she was allowed to remain in the block during appels, but her heart always sensed when dreadful things were taking place outside, and she could not remain comfortably sheltered. She would peer out from the doorway to see which people were being sentenced and to participate in their pain. The doctor in charge of the selections began to notice her pattern and finally consigned her to the transport. She was led away with the children.

At some distance we saw the slim, pretty children's murderess supervising the operation. She seemed to be enjoying the scene immensely. With one of her white palms she covered her eyes so that the rays of the rising sun would not obscure her view and disturb her satisfaction in the fate of the little children. All I could feel at that moment was immense relief, knowing that our two daughters, for the time being, were safely hidden in Krakow.

The next moment my husband too was dragged out of the line and led to the waiting trucks. I never saw him again. His words rang in my head: "You must live, the children need you." These words were my constant companions and followed me along the unending path of anguish and suffering that lay ahead . . .

Six months passed. There were still several thousand women in

Plaszow, but they were only enjoying a brief reprieve on their way to a common destiny. In the fall of 1944, the order came to liquidate the camp entirely. We knew this meant that we would be sent to the place where our dear ones had met their deaths. The storehouses were opened, and each of us was given "provisions" for the journey: two kilograms of milk powder, a bit of jam, and a loaf of bread. I tried to prepare myself as best I could. I took two blankets and turned them into coats, one for my niece and one for myself, and by some strange accident of fortune, a friend who had access to one of the storehouses obtained a decent pair of shoes for me. This was more than I could have hoped for.

The train was waiting for us at the gates. I held on to my niece and my sister-in-law as the crowd hustled us forward. People began to push and shove to get on the wagons, even though they did not know their destination. My niece held me back. "What's the point of pushing?" she asked. "We'll get in even if we don't push." I listened to her because I did not want to be separated from her, but I had no idea at the time that she was actually saving my life. The three of us boarded the last wagon.

Through a crack in the wagon wall I threw a last glance in the direction of Krakow. In my heart I said farewell to my daughters, whom I had left behind, and asked their forgiveness for leaving them among gentiles. I heard myself murmuring: "My dear daughters . . . will I ever see you again? . . ."

After a prolonged ride, the train made its first stop near Shtuthof,* on the shore of a vast body of water. The people in the first wagons were ordered to get down and were herded onto boats. As the boats set out into the water, the Germans threw the prisoners overboard. All of them met their deaths in the sea.

We who remained in the last wagons continued our journey. For several more days the train dragged in slow motion on the tracks. Just as the sun was coming up on a gray autumn morning in November 1944, it stopped. We had arrived in Auschwitz. In front of the gates hung a huge, glittering sign, reading: *"Arbeit Macht Frei"* — "Work Earns Freedom."

*Shtuthof is the German name for Szczecin, an execution site on the Polish shore of the Baltic Sea, where many victims were drowned.

Welcome to Auschwitz

We were led immediately to a gigantic barrack which served as a corridor to the gas chambers. Facing this building was the "factory," which operated at full steam twenty-four hours a day.

The barrack consisted of four walls and a roof. There were no beds or benches to sit on, so we sat on the bare asphalt floor. There were thousands of women in the transport, all exhausted beyond description, but we soon found that we could not even sit for long. As more and more women were brought into the hut, there was no place left on the floor, and we had to get up and stand on our feet. Our stomachs were achingly empty. We began to take out the little food we had received in Plaszow and shared it amongst ourselves. I decided not to try and save scraps for later; one could tell from a quick look around what the purpose of the camp was, and I thought it would be better not to die hungry. I told my niece I was happy that I had finally come to the end of my suffering, that I would be glad to die in the same place my husband had died, to think that perhaps the dust of our remains would mingle . . .

That evening I saw a group of men returning from labor. Among them I recognized a close relative of mine from Krakow! I ran to him and asked him how long he had been here. He told me that half a year ago, when the earlier transport from Plaszow had arrived, he had met my husband and his own sister and brother-in-law. All had been taken directly to the crematorium. I had tried mentally to prepare myself for this news for some time, but his words put an end to all the secret hopes I had cherished . . .

He pointed to two gigantic chimneys which puffed out a dense white smoke, and whispered: "You women who have just come might have a chance to remain alive. You see, only two crematoria now function. The third one has been destroyed . . . sabotage!* . . . The burning of the bodies slackens somewhat. There are long lines to get in . . ."

This news did not encourage me. All I wanted to hear was that I was nearing the end of my suffering.

A few hours later the women from our transport were led to a bathhouse. We were ordered to strip naked in front of it and to leave our

*For a full account of the underground conspiracy in Auschwitz, see "The Auschwitz Revolt" in Volume One of *Women in the Holocaust*.

clothes in a large pile which had already accumulated at the entrance. We were allowed to hold our shoes in our hands.

I had two photographs, one of my two daughters and one of my nephew. Realizing that I would soon have to relinquish these precious mementos, I cut the heads of the children out of the photos and put the pieces under my tongue. I also happened to have one slice of my bread left, and my sister-in-law had a two-dollar bill. When I noticed that she was about to throw it away, I took it from her, folded it up, and hid it in my piece of bread.

Two entrances led to the bathhouse, and at each entrance stood a group of Slovakian girls with scissors and razor blades in their hands. From our places in the back of the line we could see them conducting a meticulous inspection of each girl before she entered the building. They searched each person's mouth and the soles of her feet, looking for hidden currency. Those who had scissors cut off the hair, and those with razor blades shaved the private parts of the body. One of them held a paintbrush, and when each girl came before her, she dipped the brush in a thick, black, stinking liquid and smeared all the shaven parts of the body. Each girl was ordered to dip her shoes in that foul liquid, and then she was pushed through the door.

The inspection and shaving were done quickly, since there aren't many places on the naked body where a person can hide things. The line proceeded rapidly, and soon I was next. One of the women took my piece of bread, broke it in half, and found the two-dollar bill. Swiftly, she hid it in her apron. Then she pushed me ahead, winking to her friend to process me quickly. The friend hastily cut my hair, and without even shaving or examining my body, motioned me to continue. Six women, including my sister-in-law and my niece, were standing behind me and witnessed the scene. They too were processed quickly. We realized that these Slovakian inspectors must have been working in partnership, dividing among themselves the loot they found on the prisoners. They worked hastily so that none of their superiors would find them hoarding Jewish possessions which were meant for the German warehouses.

Beyond the door two more women were standing. One of them collected our shoes and gave us rough wooden clogs instead. The other

distributed rags to cover our naked bodies, pulling random pieces of clothing from the pile in the doorway. I was given a long brown silk dress with white polka dots. The woman who had once owned this dress must have been tall and very overweight, while I weighed only forty kilograms. The dress had a cut-out neckline which sagged near my waist, but fortunately it reached the ground and covered my bare legs. My niece received a woolen dress, for which I was very thankful, but my sister-in-law was given a skirt large enough for a ten-year-old girl and a boy's pajama top. We were not given any underwear or coats.

Attired in this bizarre clothing and wooden clogs, we stood in a column, shivering in the November cold. The crude cutting and shaving had left many women wounded. I had been scratched beneath one arm, and the black, stinking liquid that the Slovakian had brushed on me aggravated my wound and later caused a serious infection.

After standing for several hours, we were led to a block, where we found ourselves in a huge crowd of bald women. All of us stared at each other; no one recognized her neighbor. Among several thousand women there were about twenty or thirty whose hair had not been totally shaved off, and I was one of them. Those who still had a bit of hair on their heads were looked upon with great envy.

We were a terrible sight, more appalling than death itself. At first we were shocked by our looks, but then suddenly, all at once, we broke into hysterical laughter.

After a while we slowly began to absorb the reality of our new surroundings, and our initial hysteria dissolved into a sinking depression. The block was long and dark. Fastened to the walls were shelves which were to serve us as beds; there were no straw mattresses and no blankets to cover our trembling bodies. There was so little space on the shelves that we had to lie on our sides, pressed against each other, without any freedom of movement. If a woman wanted to turn over, all the others on the bunk had to agree to move too. We realized that in conditions like these we would not last long. Each passing day and each passing hour would bring us nearer to our end.

We were not allowed to leave our room even during the day, for most of the time the blocks were under strict curfew. The Germans wanted to

keep panic to a minimum by preventing us from seeing the thousands of people being led daily to the gas chambers. Only the day before our arrival, the block next to us had been full of Gypsies; today it was empty.

One morning during the appel, a selection from our own block was conducted by the notorious prince of demons himself, the murderer Dr. Mengele. At one point he separated a small group of women for work, but soon changed his mind and made them return to the death line. His decision was casual, assured. We knew that if the lives of thousands of people hung on such erratic whims, our fate was certainly sealed. If we did not go now, our turn would come in a while . . .

From time to time we were given a portion of foul-smelling soup and a piece of bread baked from a mixture of flour and chaff. My sister-in-law, my niece, and I combined our three portions. Two we divided among ourselves and the third we kept for an emergency, for there were days when no bread was distributed at all. One day we found ourselves in possession of a great treasure: three slices of bread, in addition to our regular rations! Though we were elated, we were faced with a terrible dilemma: where should we hide our prize?

Many women were not able to withstand the moral trial caused by the hunger in Auschwitz, and were driven to steal bread from their neighbors and friends. When they smelled the aroma of a slice of bread coming from the next *pritsche* at night, they could not fall asleep. They would lie in wait for hours until the other woman was asleep and then, without conscience, reach out for the hidden bread and devour it.

However, not all were so daring. Some women resorted to begging a last bite from the portions of others. If one had a piece of bread, she had to hide it quickly from sight. The most secure way to do this, especially at night, was to tuck the bread into the armpit and hold the arm close to the body while pressing the elbow against the pritsche. I once tried to do this myself, but soon found that it was not always a successful tactic.

It happened when we were punished and did not receive any bread for several days. I decided that now was the time to make use of the treasure I had kept hidden in my armpit for some time. However, the first bite made me nauseated; the bread was saturated with pus and blood from the wound under my arm, which had still not healed. While I hesitated, I

noticed a girl staring at me with hungry, begging eyes. I scraped off the dirt and gave the slice of bread to her. This was one of three times during the war when I voluntarily gave up my portion of food to someone else.

It was December of 1944. The cold consumed us. All I had to wear was the silk dress I had received upon our arrival over a month ago, but I was clothed luxuriously compared to my sister-in-law, whose short skirt left her knees exposed to the bitter air. Once when I was in the latrine I discovered a long, black, triangular piece of cloth about ten centimeters wide. It looked like a strip from an old, torn umbrella, but to me it was a treasure. I snatched it eagerly and gave it to my sister-in-law, and it turned out to be just long enough to wrap around one of her knees. Then a second miracle occurred; a friend of ours who was a veteran prisoner found a piece of a torn shirt on her way back from her labor shift. She gave it to my sister-in-law to cover her other knee.

Our streak of luck was not over. One day I passed by the wire fence which separated us from the men's camp and struck up a conversation with one of the prisoners. He told me that for a portion of bread I could get a suit. Then he pointed to a boy who was cleaning the roads in the camp and promised that the next time this boy came to work in the women's division, he would send along the suit.

That day the three of us saved one whole portion of bread. When the boy came the following day to clean the road in our camp, I gave him the bread, and on his next trip he handed me a worn, quilted suit. I kept the jacket for myself and gave my sister-in-law the pants. We were literally saved from freezing to death! When my sister-in-law put her hands into the pants pockets, she discovered a golden wedding ring and a pair of golden teeth. She was afraid to keep this unexpected find and gave it to me to safeguard for her.

A Prayer in Bergen-Belsen

At the end of December we were transported to Bergen-Belsen. The camp at that time was full to capacity, and we had to wait for space to open up. In the meantime they set up tents for us as a temporary shelter. The tents were separated from the main compound by a small wooded area,

and there were no sanitary provisions in this encampment. Water was supplied through a pipe, but only at night, and we relieved ourselves in muddy pits which had been dug for that purpose. There were no beds or blankets; we slept on the ground, which was sparsely sprinkled with sawdust. Soon the sawdust settled into the mud, turning it into a sticky dough. And as if all this weren't enough, a mixture of snow and rain began to pour down on us, accompanied by strong winds. One night the wind was so fierce that it blew the tents away altogether, and we remained under the open sky, buffeted all night long by vengeful gusts of freezing air. The previous night I had sensed pain in my throat, and now my temperature began to rise. All around me were the moans and groans of sick, wounded, and dying people . . . They died like flies before they even had a chance to get into the camp. They died in the open field, and their bodies sank into the muddy earth.

On the third night several "rescue" teams arrived. They brought us into a spacious and well-kept tent, where various tools and kettles were stored. We remained there for a few days until there was room for us in the barracks.

We were not sorry to be indoors after this bitter week; but aside from the roof over our heads and the narrow planks we now had to sleep on, the conditions were not much better than they had been in the woods. Most of the blocks were windowless. A ration consisting of a bit of watery soup and a very thin slice of bread was distributed once a day, and there was only one latrine for all of us.

It was clear to us that this camp was just a way station to death, that no one would get out alive. Our murderers had simply replaced the faster methods of cremation and poison gas with a slower route. Here there were no appels, no organization, no labor—but these were no longer necessary. On the wooden planks in every block, hundreds of people died each hour.

And yet, even here in this pit, one could find a few stubborn people who tried, with their last drop of strength, to arouse those who were on the threshold of death. Why — for what purpose? We ourselves did not know why we put out the effort; perhaps we did it just to infuriate the Germans. We used to go from one dying person to another, shaking and

pulling them down from their stinking planks and dragging them outside to get a breath of fresh air. We did not have much more energy than they did, but together we would drag our feet to the entrance of the block, and then, with a superhuman effort, take a few faltering steps outside. The movement thawed out our frozen limbs a bit, and when we turned back inside, the contrasting warmth was pleasant at first. But a moment later the terrible stench of the block would begin to choke our throats, and we found ourselves once more buried alive in that stinking sewer.

One day when I was standing outside the block with a few other women, an echo reached my ears. At first I thought I had lost my senses — but no, there it was again, a faint but distinct voice whispering a prayer: "*Elokai Avraham, Yitzchak v'Yaakov . . .*"*

I was shocked. My entire body began to tremble. I didn't even notice when my friends left me standing there and returned to the block. I was drawn to that voice, mesmerized. Images from my childhood raced before my eyes, one after another: here was my father's home at night, after the Sabbath had just gone out, here was my mother holding me in her arms and whispering "*Elokai Avraham, Yitzchak v'Yaakov . . .*" in a voice full of warmth and radiance . . . and there was I, a child of five or six, repeating the words of the prayer after her. I do not know how long I stood spellbound in this enchanted world.

Then, suddenly, I found myself standing in front of a broken window, looking through to the interior of the block. Peering at me from a third-tier plank right near the window was a yellow skull emblazoned with a pair of dying eyes. As though from a very far distance I heard the open, toothless mouth murmuring: "*Shavua tov! Shavua tov* to you, to the family, *ul'chol Beis Yisrael, Amen! . . .*"

For a while I could not tear myself away from the spot, but finally I decided that I must meet this deathbound murmurer of prayers. In my mind I marked the location of the plank and entered the block. I pushed my way through the crowd of women to the far end, near the broken window, stretched out my hand, and tugged lightly on the leg of the expiring woman.

*"G-d of Abraham, Isaac, and Jacob," a prayer recited at the end of the Sabbath.
▶"A good week to you, to the family, and to all the House of Israel."

"Do you pray to the Almighty?" I asked her.

In a weak voice that was barely audible, she answered: "We have to praise the Almighty always and everywhere. For He heeds our prayers even when they come from the deepest well . . . and even if He does not come to help me, there are still other Jews in the world for whom we have to pray for a *shavua tov* . . ."

I asked her how she knew that today was the Sabbath. She told me that she had come to Bergen-Belsen several weeks ago with one of the transports from Hungary, and that she had kept count from the first Sabbath in the camp by making knots in her dress. I promised her that the following week I would come and pray together with her.

That Sabbath I kept my word. I climbed up onto the third-tier plank, but the prayerful murmur, the voice whispering *Kail Elokai Avraham*, had been extinguished forever. On the plank lay another woman . . .

Berta Fredreber was liberated in Bergen-Belsen and emigrated to Israel after the war. She is the author of the book V'Hashemesh Lo Zarcha. *The two daughters whom she mentions in her testimony also survived and now live in the United States.*

THE GOLDEN COIN
❖
Flora Rom-Eiseman
Vilna, Lithuania

Favors

Soon after we moved to the ghetto in Vilna, I was assigned by the Judenrat administration to take over the Technical Department. I was an experienced architect, and my job was to oversee the construction and preservation of various buildings in the ghetto. My supervisor was an engineer named Guchman, and we worked closely together on all our projects.

My position was one of considerable prestige in comparison to that of the average ghetto Jew, and I was entitled to certain privileges because of it: extra food rations, mobility, the power to make decisions within a limited framework. I was very involved in my work, but it was impossible to take even a brief glance at the dismal conditions around me without being stung by a prick of conscience. The most vulnerable people in the ghetto at that time were the ones who did not have jobs, for the newly imposed German law dictated that those who did not work had no right to live. They were sent to Ponary, a former resort village on the outskirts of town, where they were shot and thrown into mass graves.

The more I thought about it, the more I realized that I could not simply sit back and enjoy the comfort of my position when others in the ghetto

were being abused and sent to their deaths. Surely I must use my advantage to do what I could for others . . .

I made up my mind to invent employment. There were several other influential personalities in the ghetto whom I was able to involve in my project, and together we decided to create as many work places as possible. Though each of us had his share of responsibilities, the major burden of creating these jobs rested on me, for in my capacity as manager of the Technical Department, I had the resources and authority to carry out the plan.

One day I happened to come across a text called *A Guidebook for Ceramic Creations*. I became fascinated by the subject and saw in it a wonderful opportunity: the establishment of a ceramics workshop where many ghetto residents could find shelter from deportation. We built an oven and obtained the needed tools, and before long the workshop was a reality. I inquired how to go about hiring "legal" workers and then contacted the principal of a school. He gave me a list of fourteen- and fifteen-year-old students who were ready to start right away.

I was very encouraged by the success of the ceramics workshop and continued to broaden my activities. During the winter of 1942-43, I turned my attention to another pressing problem: the need for recreational facilities. These were perhaps as important as the workshops themselves. The young people lived with the fear of death hanging over their heads, and they needed activities to boost their morale and alleviate their tension. The projects which I had a hand in developing included a sports square, a coffee house, a disinfection chamber for delousing, a youth club, various shops, and a resource center to help young artists organize their exhibitions. To people who lived constantly in the shadow of persecution and whose future was entirely uncertain, the value of these services, even in terms of mere distraction, was inestimable.

Our department also designed various mechanical gadgets and tools which were later produced in our workshops and marketed to both Germans and Jews. We wanted to keep the ghetto productive and maintain a steady monetary flow, believing that as long as we were working there was a possibility that we might stay alive. Time became the essence of hope, the anchor for a dream, and the ghetto Jews clung desperately to

these dangling threads — for who knew? Perhaps the war would end at any moment; perhaps we Jews would survive and continue to live on G-d's earth, just like any other people.

Out of all the workshops created in the ghetto, I was most pleased with the ceramics workshop and put a great deal of effort into protecting and supervising it. I enjoyed my visits there and was delighted to see the young people working diligently. One day when I was passing through a work room where several girls were sitting at their machines, I heard one of them singing a piece by Chopin. This girl, whose name was Hinda, had a beautiful voice and sang with great feeling. She must have noticed me watching her, for she stopped awkwardly in the middle of the song. I asked her to come forward and present herself, and inquired whether she took music lessons. She told me that she did, adding with a hint of wistfulness that she wished to return to her previous teacher, a well-known music instructor named Tamara Gershowitz, but that her present teacher refused to part with her.

I somehow felt prompted to ease this young girl's discomfort and immediately paid a visit to the "reluctant" teacher. "Why do you refuse to let her go? Don't you know that our days here are numbered anyway?" I asked her. "Let her have a little freedom to go where she is most comfortable."

Then I went to Tamara Gershowitz and asked her if she would admit the girl to her class.

"I would gladly admit her, but her teacher does not permit her to leave," Tamara said.

"She permits," I replied. "Hinda will return to you."

My joy was complete when I attended Hinda's first recital. Later, when we were deported to the concentration camp, I adopted her as my daughter, and she brought a measure of liveliness and hope to our wretched group . . .

The episode with Hinda was only one of many situations during the war in which I intervened rather than sitting back complacently and allowing things to run their course. In the ghetto, and later in the camps, there was no shortage of cases where people needed some sort of help, whether it was urgent material help or just simple advice and a listening

ear. Any type of favor or assistance was valued beyond normal proportions, and if one could lighten a friend's load by granting even a small wish, it was not too trivial a task. Though I was always overloaded with work, I never refused a request. I could not have behaved otherwise.

There were some people in the ghetto, however, whose attempts to give help died in the morass of the ghetto bureaucracy and whose best intentions were misunderstood. One of the most vivid and interesting memories I have of the war is my encounter with Yaakov Ganz, the Judenelteste of the Vilna ghetto, who made a surprising confession to me during the last hours of his life. Ganz often visited the Technical Department. As the chief civil authority in the ghetto, he was ultimately responsible for all our projects, and he followed our work at close range. He tried to provide us with the raw material, tools, and other essentials we needed, and went out of his way to keep our workshops going. We did not give him enough credit for his help at that time, for we saw him instead in the light of the decisions he made as leader of the ghetto.

All of the Judeneltestes during the war were appointed by the Germans to manage the internal administrative affairs of the ghettos. They were also required to supply lists of people for deportation to work sites and concentration camps, and sometimes to assist in the roundups. If they refused to comply with orders, they endangered their own lives. Although these Jewish officials lived better than others in the ghetto, we were mostly ignorant of the moral and physical price they paid, sooner or later, for their high positions.

Ganz once tried to justify his actions to me. He told me that his method of saving the young in exchange for the old was not unique, that all Judeneltestes acted in the same fashion, hoping to keep the ghettos productive and thereby save as many people as possible in the long run. He had even asked Rabbi Menachem Mendel Zalmanovich, one of the *poskim* (rabbinical arbiters) of Vilna, for a rabbinical decision* about whom he was allowed to send away when the Germans demanded a quota

*Rabbi Kalman Farber, a student of the Chafetz Chaim who lived in Vilna at the time of the war, kept a diary in which he recorded the discussion between Ganz and Rabbi Zalmanovich. The rabbi's answer was: "How can I permit something that the Torah forbids?"

of people for deportation. But he also admitted that the attempt of all the Judeneltestes to be "servants to two masters" had failed miserably, and that despite his best efforts, the sacrifice of the non-working people for the protection of the general ghetto population had yielded no positive results. In the end, people were dragged to deportation regardless of the bargaining, and even his own life became forfeit.

I was impressed by Ganz's confession and saw him in a different light, as a man of conscience and great self-control, trapped in an ethical dilemma from which there was no escape. In retrospect it becomes very clear why more than one Judenelteste committed suicide before the Germans had a chance to decide their fate.

I remember when Ganz was called to the Gestapo office. He knew that this would be his last walk on earth; as a Judenelteste, he had seen some of the German tactics of genocide at close range and was considered a dangerous property. He told me that the Germans might shoot him on the spot, but that he had no other choice; to escape and not to appear before them would result in the deaths of the hostages who would be taken in his stead. Then he showed me where the money and other important documents of the Judenrat were kept, secrets that he had held exclusively until now. His voice was sad, but steadfast and resolute. He did not reveal any sign of fear.

This candid glimpse of Ganz and his tragic fate, so poignantly symbolic of the double-edged sword that confronted so many Jewish leaders in the ghettos, will live in my memory forever.

The Golden Coin

I remember another incident in the concentration camp where a sincere attempt to give was severely misunderstood. It happened in the A.E.G. factory in Riga, and in quality it is very nearly a fable.

My story is about a gift I received from a fellow prisoner in the camp, a girl named Mussia Deiches. Before the war Mussia had been known for her talent as a dancer, and since her very early years she had been labeled a "wonder child." But in the camp she became famous for an entirely different reason: for her great heart and noble soul. Mussia and I became

Algemeine Elektrische Gezelschaft, the General Electric Association.

close friends because of a peculiar incident. It is only now, after so many years, that I can even bring myself to talk about it.

I was one of the most hungry inmates in the camp. I never expected to get the additional piece of bread or spoonful of soup which girls sometimes received, mostly because I was too proud to ask. And I was not an "organizer." Most people in the camps did not think twice about getting food in any way they could, but I couldn't bring myself to steal, especially when I was trying to convince others not to do so. I believed in setting an example by action and not by words alone, and I tried to carry out my convictions to the last degree. On only one occasion I failed deeply; for although I constantly exhorted my friends not to despair, I myself once had an attack of despair.

I vividly remember this time. I had reached a point of such deep depression in the A.E.G. camp that I decided to commit suicide and end my suffering once and for all. I was standing on the landing of the upper floor of our building, looking out the window and waiting for the right moment to jump. It is possible that if I had stopped to consider all the consequences, if I had remembered those who needed me and who depended on my help, I would have had second thoughts.

In that moment before my senses came back to me — indeed, in that very split second — a lovely young girl who must have been in her late teens caught me by the arm. As though she had read my silent decision, she said: "Cast your bread upon the water, and with time you will find it."* She laid a golden coin in my palm and added: "This is bread for a month."

I was taken aback, and my first thought was that she must not be in her right mind. I stared at her and asked: "What's this?"

"Look at it!" she replied. "It's a five-golden-ruble coin!" And then she turned and disappeared.

I looked at the coin and thought, If there is someone left in the world who is ready to help another human being, in spite of everything, then even such a rotten life is still worth living. I took the coin and sewed it into a corner of my shirt. A delightful fantasy ran through my mind: I decided that I would save this coin until after the war and donate it to a museum

*Ecclesiastes 11:1.

as proof of the performance of a humane deed in a dungeon of suffering. I imagined myself a free person, walking into the museum and handing the coin to the archivist, asking her to display it in a special place where it would be visible to all who passed. I would remember to affix a note to the case, reading: *"This golden coin is a present from a girl I hardly knew. She gave it to me in the concentration camp so that I could buy bread and not starve to death. Her gesture proved to me that even in the darkest hour our girls maintained very high ideals and were able to live up to them."* This mission seemed somehow more important to me than using the money to buy bread. I don't know how seriously I took my own flight of fancy, but in the meantime I did nothing about the coin.

Three days later at work the girl came over to me again and said: "You are trampling on your golden coin. Pick it up and put it into your mouth instead of leaving it in your shirt! . . ." and she walked away again. I could make no sense of her mysterious behavior, but I could not stop thinking about her.

The following evening she approached me once more and said: "Excuse me, but please give me back the money that I gave you three days ago." I did not question her but went straight to the latrine, ripped open the seam of my shirt, took out the coin, and handed it to her. After she had left, I remarked to the girl who slept next to me: "I don't understand this at all. This young girl performed a remarkable act of charity, and then she revoked it. It is really sad . . ."

A day later, when I returned from work, I was about to lie down when I noticed something sticking out from beneath my raggedy pillow. I lifted the pillow, and there on the plank was a whole loaf of bread!

The girl sleeping next to me saw it and begged: "Please, give me a little slice!"

"It is not mine," I said. "How can I give it to you? Someone must have conducted 'business' and hid this under my pillow."

I tried to solve the puzzle but failed. Two days went by, and I was still thinking about the golden coin and the loaf of bread. Then, on the third evening, when I was about to lay my tired head on my plank, I found yet another loaf of bread! Now I was completely dumbfounded. The loaves were multiplying as though in a fairy tale, and their appearance in these

miserable circumstances seemed like an absurd joke. Did I have a "fairy godmother" — and if so, why did she favor me above all these other starving women? I had no idea what to do with all that bread, and besides, I was very cramped. The bed was too narrow to accommodate both me and the loaves of bread!

As I was pondering what to do, I saw this same girl approaching me again. By now she seemed like some sort of unearthly, prophetic figure who spoke in metaphors. This time she had a very strange expression on her face, and suddenly, in language not very delicate, she burst out: "That you don't know how to buy bread in exchange for money, I can understand. That you're afraid to approach the fence to barter, I can accept. But that you're such an idiot that you don't know how to eat bread when it's handed to you on a golden platter, this is beyond my comprehension! I buy, I smuggle, I leave it in your bed, and what do you do? You cause me terrible embarrassment!"

Only then did it dawn on me that the girl was not a ghost, nor was she playing games; she was actually worried about my health. One did not expect such largesse in the concentration camps, especially from people who were equally as miserable. Later I learned that this girl was Mussia Deiches: Mussia, the famous and remarkable, the talk of the block, who saw that I was not as capable of defense as some of the other women and did not want me to starve to death . . .

The Dolls' Theater

Starvation was the most potent weapon the Germans used against us, but it wasn't the only one. We were also stripped of any morsel of nourishment for the soul. For some of us the absence of books and cultural activities was no less devastating than the lack of food and water. This spiritual hunger was so distressing that it caused me many sleepless nights. I lay awake on that filthy, bare, lice-infested board, trying to see a way out of this trap. Finally one night, an idea hit me: we could take this matter into our own hands and devise our own entertainment. The more I thought about it, the more important such an undertaking seemed. I discussed it with some of the girls, and together we decided to create a satiric dolls' theater.

I immediately started to work on the project. It was soon clear how desperately the girls needed and looked forward to this diversion from the cruel monotony of their lives. They were so eager to contribute that those who wore longer dresses did not hesitate to tear off strips of fabric from their clothing and donate them to my scrap collection. Once I had accumulated enough bits of cloth, I began sewing.

The ideal place to work was in the latrine, for a tiny bulb burned there even at night, so I could see what I was doing. To represent our Lagerelteste, who always wore a blue knitted dress, I made a doll with a blue dress and matching turban; for the nurse doll I made a white dress and decorated it with a red cross. The other dolls, who represented the prisoners, were all made to look alike: white, flat, and without expression, almost surrealistic. They bore numbers on their striped frocks and wore kerchiefs, as we did, to cover their shaved heads. (I was the only one who refused to cover my head. I told myself: "It is they who should be ashamed for making us look the way we do. Let our image follow them all their lives.")

After the sewing was completed, we began to compose and arrange a program consisting of songs, poems, and satiric recitations. We even produced some makeshift scenery in order to give our production as authentic an air as possible. I managed to concoct a replica of the camp fence. Every evening as I returned from work I made sketches of it, designing and revising to make sure it was very exact, and then I constructed a replica that was accurate right down to its moving gate and dangling lock. The only thing I could not duplicate was the gigantic white electric lamp that sat astride the gate, for I had no material left. However, luck was with me; a Latvian work manager in the camp brought me some scraps, and at the last moment I was able to make the lamp. Now the scenery was complete, and all that remained was to set up a stage. We assembled a few benches and arranged them about five centimeters apart. The space between the benches served as a path for moving the rows of dolls.

The performance was a great success. Several of our girls played the dolls' roles, providing their voices and pulling their strings. The dolls marched in a column, three in a line, and "sang" as they moved. One of

the songs, I remember, was called "Reizele." The play portrayed a happy future, an end to the slave labor at our loathsome machines, the swift arrival of freedom and liberty. "Long live freedom!" was the final outcry in the performance, after which the lock fell and the gate symbolically opened. Then the dolls began to dance to the tune of *Kol Rinah V'tzahalah* ("The Voice of Joyful Song and Gladness"). When the overseers left for the night, we even managed to smuggle in the *Hatikvah*.

We repeated the play several times, and it had an enormously positive effect on the morale of all our girls. It even encouraged us to conduct other cultural evenings. Somehow we managed, in the midst of our enslavement, to gather from time to time and hold discussions, to talk about books we had once read, tell interesting stories, and sing songs. These evenings inspired our friend Ryvka Bosman to write some of her most memorable poems. Ryvka was only a teenager, but even in the ghetto she had been known for her writing. She warmed our hearts with her talent, often reading her poetry aloud to a broad circle of listeners.

These hours of salvaged inspiration were precious and had the power to lift us above our desolate existence. But when they were over, we were forced once more to confront the renewed pain of our bitter reality.

Mrs. Reiches's Relative

One of the major struggles we faced was the battle to save the very young girls and the older women. The Germans considered them worthless and were constantly looking to deport them in exchange for a more "productive" element. We somehow managed to disguise the young girls as grownups, but we had to fight viciously to hold on to the older women. I looked for any excuse or occasion to prove to the Hauptscharfuhrer that we needed these women because they had experience in cleaning and were better able to keep the blocks in order. Most of the time he acceded with a nod of the head. But once he mentioned, with some degree of restraint, that he was aware of our maneuverings.

Sometimes I thought that perhaps he was not a professional sadist like the others, even though he was a representative of Himmler and carried out all the Nazi orders scrupulously. Whenever I intervened and asked pardon for the life of a friend, I knew that I was endangering my

own, for such a gamble was nearly unheard of in the concentration camps. In cases where the prisoner's "transgression" was minor and did not jeopardize the Hauptscharfuhrer's own position, I succeeded, but when it came to selections he was very strict. In one case only did he make an exception.

There was an elderly woman in our block named Mrs. Reiches. I had noticed that during selections the Hauptscharführer always moved her to the "right." I had the feeling that she served him as an amulet, a good luck "charm" that soldiers sometimes adopt in the form of a puppy dog or baby monkey. Once the old woman asked me if I knew the name of her benefactor. I happened to know that his name was Ludwig Blatterspiel, because he had once ordered me to write it on a wooden case in which he kept his private belongings. When the woman heard this bit of news, she left without responding; but a few minutes later she found me again and told me that this Blatterspiel looked just like her sister's son. She then told me many details about him and concluded by saying: "This man is passing himself off as a gentile, but he resembles his father like two drops of water — they have exactly the same face."

At first I thought that Mrs. Reiches's tale was the fruit of her imagination. It was now 1944, and all kinds of hopeful fantasies were flourishing: belief in miracles, swift redemption, the exact time of the Germans' defeat, and other equally optimistic and preposterous predictions. So it was only natural that I looked on the woman's story as just one more fabrication to add to the pile. Something happened, however, to change my mind about Mrs. Reiches and her "benefactor."

Manya Notik was the cook and distributor of our meals, and she was one of the few people in her position who was just. She treated all the inmates equally; when she doled out the soup, she always pushed the ladle to the bottom, unlike so many others who saved the thicker broth and gave it to their "favorites." Even though the soup at the bottom wasn't all that much better, it lightened our burden to see that Manya at least tried to be fair, and this knowledge made our meals more satisfying.

Now we heard that Manya had just been put on a list for "deportation" — which meant certain death. She became anguished and cried day and night. A friend and I decided to go to the Hauptscharfuhrer and plead with

him once more to make an exception. I had already taken advantage of his "benevolence" more than once, and this time I knew there was only a slim chance that we would be successful.

It was very dark at that time, and we were the only two people outside in the compound. We knocked at the door of the office and were allowed to enter.

I spoke.

"Herr Hauptscharfuhrer," I said, "it is in your power to give one of our inmates a present. Today is Manya Notik's birthday, and we are coming to beg you to take back your decision. If you leave her among us, you will be giving her the most valuable present — her life."

He didn't answer, but instead began to chat casually. He asked me what my birthdate was, and informed me that he, too, had been born in that month. "It is known," he said, "that people under this sign are very intelligent."

"Of course," I agreed. "This is as clear as the sun on a bright day."

"You desire that this woman should remain with you?" he asked.

"Very much. We would not have come to you at such a late hour to disturb you if it were not so very important to us."

"Good," he said. "Here on the table is the list of those to be deported. Add two names and erase hers."

He was asking us to consign two other women to death in exchange for Manya's life. I refused and started to beg again.

"I'm entitled to keep only eight hundred inmates in the camp," he responded calmly. "This is an order from above. You can keep this Notik if you exchange her for two others."

I knew with certainty that there were actually 810 working inmates in the camp — and he knew this too. He was playing games with me. I said to him: "Look, Herr Hauptscharfuhrer, as for numbers, I think that the number 812 looks much nicer on paper and even sounds better than the number 810."

He seemed to be giving in. "Good. Add the two names to the working list, and I'll erase two others."

"Oh, no!" I cried.

"I see that you really want her to be with you," he replied finally, with

a small smile. Then he made a strange and unprompted revelation about his past. "When I was a little boy I was fascinated by ships, and once I sneaked aboard one. The people on the vessel let me in, but later they got tired of me and wanted to throw me out. I begged them to let me stay, because I had gotten used to them and liked them. I remember how hard this was for me . . . I'll see what I can do."

And he kept his promise. Manya Notik was not deported.

Perhaps Mrs. Reiches had not been imagining things after all. It seemed to me that only a person with a Jewish heart would have given in to our pleas so many times . . .

Very soon afterward, in the winter of 1945, the Germans liquidated the factory camp, anxious to retreat deeper into Germany to escape the advancing Russian army. They sent all of us on a death march.

I survived the march by fleeing the column. This was one more in a series of miraculous flights from death which had begun with our confinement in the Vilna ghetto. I had withstood hunger, deportations, "classifications" and "selections," the terrifying order of "Right-Left" which had sent me to the concentration camps. Perhaps the greatest miracle was that through most of these ordeals I was lucky to find myself in a circle of true human beings, and to be in a position where I could help others — especially the young girls and the elderly women. In encouraging others I created my own spiritual reservoir.

Some dozens of years have passed since the liberation. Life in Israel has brought forth new desires among the victims of the Holocaust, and has enabled them to focus on establishing a normal family and national life. Yet not even for a moment can I forget the horrifying picture of those dark days.

Perhaps my story, as well as those of my friends, will serve as a truthful picture of life in the women's concentration camps. Authentic eyewitness reports, in spite of their limitations, may become more valuable than books by professional writers, especially for our children. It is true, of course, that this kind of literature is subjective, for each of us saw with her own eyes and her own understanding; and when one is encaged, she often cannot comprehend what is happening around her.

And yet, a mother's true experience of the Holocaust is more real and comprehensible to a daughter or son than a thousand fictions written by the best writer.

To me, these testimonies are also very unique in that they portray the prisoner's paradox: the way he continued to go through the routines of daily life while death hovered over his head. And perhaps most importantly, they show the prisoners' triumph; for side by side with the unrelenting fear of death, there existed a friendly relationship among the inmates, for whom the struggle to maintain a healthy spirit was just as important as the struggle to stay alive.

A BITTERSWEET LAUGHTER

❖

Mussia Deiches
Vilna, Lithuania

Arrival

Upon wakening from the deepest slumber, while I lie with my eyes closed, memories float up like a rising tempest: memories that bring back the indescribable horror of the war, memories with the power to kill. I do not understand what force kept me alive in those days, for just the thought of them sends convulsions down my spine. Many of us try to forget altogether, which is in complete contrast to the urgency of the Divine dictate: "Remember, and do not forget what Amalek did to you!"

But it is really not possible that we will forget. It is impossible to forget the two words which still echo in my mind: "Right — left! Right — left," words which decided our destiny.

It happened in the Rosa square in Vilna. I was twenty years old then. My friends and I who were sent to the "right" were told that we would now go to work. We were pushed like cattle into sealed freight wagons. In that wagon, filled to the brim with people and packages, I experienced the greatest fear of my life. I call it "my first fear," a terror that emanated from the innermost depths of my being. It welled up in me the moment the murderers sealed the wagon, gripping my throat and threatening to strangle me.

The Germans had loyal helpers — the Ukrainians.* As soon as the doors were closed, these wild and drunken brutes pushed their way into the center of the cars and began raping the Jewish women. As the darkness and gloom of the night descended, their attacks became more violent. My sisters-in-law and I tried to escape the onslaught by crawling underneath a pile of bundles. We stayed crouched tightly in this airless pocket, literally choking.

The screams and sobbing of the girls around us were horrifying, and we shivered in fear of being discovered. I wished I were dead. We heard a girl being thrown out of the speeding train after she was raped. I do not remember her name, but her screams broke my heart. There was another woman in the wagon who saved her two beautiful daughters by covering them with her own body.

After a long night's ride, confused and despairing, half-suffocated, we were brought to the Keizerwald concentration camp in the vicinity of Riga, in Latvia. Until the outbreak of the war, Keizerwald had been a prestigious health resort, shaded by majestic trees, where only the very rich could afford to spend their leisure time. It now bore no resemblance whatsoever to its former life.

The doors of the wagons were banged open, and we were blinded by the daylight, for the wagons had been completely dark. We did not even have a chance to orient ourselves before we were bombarded with a barrage of shouted commands: *"Jump! Run! Run fast! Run! Leave your belongings! Leave everything! Anyone found carrying gold will be shot on the spot! Hurry!"*

The shouts were followed by a hail of cudgel blows on our heads and backs. The cudgels kept rising and falling . . .

In time we learned that this tactic was a well-calculated one, intended to baffle, frighten, and paralyze the victims, for the same scene was

*During the summer of 1941, the *Einsatzgruppen*, the special-duty groups deployed by the security service of the SS to begin the implementation of the Final Solution, began to invade the Jewish settlements of Eastern Europe. They found willing accomplices in the Lithuanians, Balts, and Ukrainians, who were eager to vent both their anti-Semitism and their hatred of the Soviets. The Germans enlisted these vicious collaborators to assist them in door-to-door manhunts and in the roundup and murder of countless Jews in Vilna, Kovno, Lwow, and other cities in the eastern territories. The Ukrainians were not officially admitted into the German army, but they were appointed as overseers in the camps and factories, and in some of the ghettos.

repeated later on in Torun. There, too, we were met with a tornado of abuse: screams, blows, lashings, commands — *"Run! Jump!"* — until we lost our breath. The Germans attempted to overwhelm us with terror, to numb all our thoughts and feelings and turn us into dolls which they could manipulate by tugging on the strings. They were largely successful.

The people who "greeted" us in Keizerwald were German messenger girls. We called them *Blitzmaidlech*, meaning "lightning girls," because they rushed us to do everything at high speed. They were professional sadists who must have taken special courses to learn their art, and they enjoyed it greatly. Their enthusiastic "welcome" was a good indication of the kind of treatment we could expect here.

Our most immediate predicament after the long ride was the need to relieve ourselves. We were ordered to run in groups to the latrine. On the way the Blitzmaidlech showered us with blows and insults.

When we entered the latrine, we noticed that the pits were filled with gold and valuables, thrown away by courageous women who preferred to abandon them to a cesspool rather than hand them over to the Germans. Such action was considered sabotage, but the women were not deterred; they felt it was better for the earth to swallow their precious belongings than for the Germans to enjoy them. It is hard to find words to describe the strength these women needed simply to throw something away.

On the evening of our arrival, one of the Blitzmaidlech burst into our midst. Her name was Kuba, and she was literally a born devil; we saw in her the image of the Satan himself. She began snapping out orders: "If you've got questions, ask them fast! You've got to carry out my orders quickly! Run! Jump! Crawl! I will not tolerate any delay, not even one second!" To prove that she meant what she said, she literally shoved one of the women out the window. I don't know if this poor woman died or was just wounded; I only know that she wasn't seen anymore.

Terror was not the only tactic the Germans used to subdue us. One day we were led to a bathhouse for a disinfection which they called *Antlausung*, or delousing. They rushed us into a gigantic barrack and ordered us to undress and run quickly to the showers. From there we were pressed into another huge hall, where young SS officers walked around,

checking and scrutinizing us. This was the end of our self-respect as women and as people. Our morale was broken in that disinfection chamber. For the first time we felt as though we weren't women, that we weren't even human beings, but cattle. As a result, we began to look upon ourselves in the same way.

When the "disinfection" was finally over, we returned to the barrack where we had left our clothes, but they weren't there anymore. Piled up on the table was a heap of strange garments which had been allotted to us instead. We weren't allowed to touch them; we just had to take whichever garments they threw at us. I received a long dress and a little girl's coat.

Shivering in our funny clothes, our hair still dripping from the kerosene they had splashed on us, we entered our barrack. My friends all burst into a hearty laughter, which soon turned into frantic crying.

"*Kinderlach!*" I said to them. I don't know why I called them children — maybe out of pity for them, maybe because I wanted to encourage myself . . . but this word seemed to take hold in my speech. "Children, from crying our redemption will not come. What we've got to do is hold on . . ." Even as I spoke to them, I doubted my own words.

Later on, after they shaved our heads, we looked at each other and burst again into a false laughter, and again I tried to encourage them: "Kinderlach! The most important thing is that we still *have* our heads. We've got to laugh! Then please, let's laugh. Let's laugh! . . ."

We tried to joke about our bitter lot and to cast droll insults at our shaven friends:

"You've got a big head!"
"Your head is narrow!"
"Your head is small!"
"Your head is sharp!"
"Your head is square!"

In Yiddish there is an expression: "*Men lacht mit yashchierkis,*" a laughter with lizards — a tearful, bittersweet laughter. This is how we laughed then. And yet, when we lay down to go to sleep, we did not laugh. All of us cried, quietly, into our palms. All night long I heard a jarring mixture of crying and anguished giggling.

I too wept that night.

The Electronics Factory

In Keizerwald we were interned only ten days. On the eleventh day we were called out to an appel, but this time we did not return to the barracks. The suspense ended more favorably than we had expected, for we were transported to the A.E.G. electronics factory in Riga, a Jewish "paradise" on the Nazi earth! We worked in a closed building with paned windows, and we had a roof over our heads. The roof was broken — but it was still a roof! There were even toilets, and a shower with warm water. This period in the A.E.G. factory was comparatively the easiest time of the war for us. We did not lick honey here and swallowed our share of misery, but it gave us a reprieve so that we were better able to endure future hardships.

In the factory we were crowded like sheep, a hundred and fifty women in one room. We slept on wooden planks that were attached to the wall in three tiers. This reminded me of the *Teivah*, the ark where Noah and his family took shelter along with the animals and birds during the Flood, for that boat had also had three levels. I wondered if we would merit to be redeemed from our own "flood" . . .

The middle tier was the worst of the three, and I had the great good "fortune" to share one of these. The space between the top and bottom boards was so narrow that it felt like being stuffed in an airless drawer. One could only remain on that plank in a lying position. If she forgot and sat up, she got a *zbenk* (bang) on her head from the board above, which caused her to fall back with a tremendous smack because of the tiny space. The only way she could get into that "bed" was to slide in from a horizontal position in the air — and without bending her legs, for otherwise she would hit the girls on the plank below her. This daily exercise required ingenious acrobatic maneuvering.

Some time later the Nazis "generously" provided us with paper mattresses and blankets, both stuffed with sawdust; but this gift brought its own curse. Lice and bedbugs soon appeared from nowhere and attacked us from all sides, literally sucking our blood. This was a horrifying plague, too terrible to describe. Once a bedbug found a comfortable abode in my ear, and until it was removed I climbed the walls. One of the girls coined the name "raisins" for the bedbugs, a name

that we used all the time we were in the camp. To this day I cannot look at raisins.

The work routine in the electronics factory consisted of one day and one night shift, each lasting from six until six. At first I worked on antenna cables during the day, but later I managed to switch to the night shift, which was quieter. I could rest and get some sleep during the day, when most of the 160 women in our group were at work. There were two appels a day, one in the morning and the other in the evening, each lasting for two hours.

During each shift we were given a half-hour break to eat our soup. Actually we had only ten minutes to eat because the walk to and from the factory took ten minutes each way. When we came running in to eat our "dinner," the bowls of soup were already set out on the tables so that we would not waste time. Everything had to move at a lightning speed, with a *blitz* . . .

We were always very hungry, and a hot soup was more filling than a cool one. Each of us wanted the bowl that had been filled last, but this too was problematic because a hot soup took longer to eat, and we had to be back in the factory on time or suffer the consequences. Bread, too, had varying value, for everyone wanted a dry portion. Fresh bread was soft and quickly devoured, while stale bread could be chewed longer, each crumb enjoyed separately. Such problems consumed us.

A great number of our girls were also afflicted with boils. The Germans were in need of our labor, but they did not hurry to open a revier to tend to our illnesses, even though the courageous Dr. Slitowna was ready to supervise it. In the meantime the girls suffered. The only thing they received for the boils was a foul-smelling ointment whose odor was so terrible that it was impossible to sleep next to those who had been smeared. I tried to overpower my disgust and applied the ointment myself to many girls who were ailing, and afterward I slept near them.

The plagues of hunger, lice, and boils fell upon us simultaneously. Our suffering reminded me of the account of the Ten Plagues in the book of Exodus. Our leader, Moshe Rabbeinu, had been much more liberal with the Egyptians than the Germans were with us, for he did not send a new plague on them before the old one was lifted . . .

The Bank

Hunger is a subject which is a focus of all survivors' memories. It was endless, and all our days and nights revolved around it. Even though our lot in the A.E.G. factory was slightly better than it had been in Keizerwald, we were tormented no less by it.

Most of us had already experienced the shame of hunger in the ghetto, but those who had not yet encountered it in its worst form had no idea how devastating it could be. It was painful enough to suffer an empty stomach, but the awareness of the Germans' intention made us psychologically hungry as well, for it generated the dreadful fear of dying from hunger. It was not in our power to overcome this form of inner starvation, which was a much worse torture than the hunger pangs themselves. I would have drunk waste water from the sink or the latrine if it had been available; I would have swallowed it in the blink of an eye, not to fill my stomach, but to settle my mind.

I remember that once they gave us a thin white soup that looked and tasted as though it were made of plaster powder. Yet I ate it and would have eaten more if they had given it to me, not so much from hunger as from the psychological *fear* of hunger: the fear of knowing that just as you have no food now, you cannot expect to get any later. This expectation of slow death was a calamity, a killing suspense . . .

We were particularly concerned about the older women and the very young girls, especially those in their early teens, whose physical development might be retarded by a lack of nourishment. The daily portion of bread was nowhere near sufficient for them. There were a lucky few in the camp who had connections to the Latvian supervisors and were able to obtain an additional portion of bread each day; but the older women and younger girls had no such contact, nor did they have access to the local villagers with whom some trade was occasionally possible. We tried to come up with a scheme to help these two wretched groups survive.

I decided to create a bread bank. I began by making two lists. The first contained the names of about eighteen women from our group of 160 who were in special need. Among them were Mrs. Reiches, Mrs. Tzinder, Mrs. Geller, my sister-in-law Masha's mother, and the very young girls. The second list was longer than the first and consisted of the names of all

the girls who received additional food from various sources. Then I began the exchange process. Each week I collected one portion of bread from the inmates who could most easily do without it and divided the collection into equal rations, so that each of the needier people could receive an extra portion every day. The "bank" saved the lives of several women in the camp.

The success of this project filled me with a sense of purpose. I knew that it was a special privilege to be in a position to help people, and this awareness strengthened my own desire to live; it made the slavery and the humiliation bearable. My objective now was to survive at all costs, even though it meant suppressing my own needs.

Each day when I came back from the appel, tired and hungry as a dog, I restrained myself from running to grab my portion of bread. As a matter of fact, I was the last one to receive the handout. Masha would take mine and guard it for me until I had finished my daily mission of collecting contributions to the bread bank. I had to make the collection quickly, before the women had a chance to eat the bread and tell me that they had forgotten their pledges. I held these gathered bits of bread in my hand, I smelled their aroma, I felt their taste as saliva dripped from my mouth — but I gritted my teeth and crushed the impulse to dip into the treasure.

Only after the fifteen portions of bread had been distributed — when I was on the verge of emotional and physical collapse — did I allow myself to satisfy my own hunger. I had never been able to tolerate an empty stomach before, yet now I learned to endure prolonged periods of starvation, including the psychological hunger. But neither then nor any time afterward did I regret my undertaking. On the contrary, I looked on my self-imposed difficulties as a challenge and found satisfaction in my ability to overcome them.

Punishment

Punishment was an integral part of camp life. The Germans looked upon us as stubborn dogs who refused to be disciplined, and we were flogged for the smallest infraction — even those we had not committed.

One of the most serious crimes was menstruation. Most of us were young and more or less healthy when we came in, and in spite of the

hardship and hunger we continued to have our monthly periods. This recurrence turned into our greatest predicament.

Of course the Germans did not provide us with any hygienic necessities, but if an SS officer or a Blitzmaidel detected any sign of discharge on a girl's legs as she walked to work or stood appel, all of us immediately got a lashing. We had no means of protecting ourselves and were continually subject to punishment.

After months of this anguish, our periods suddenly ceased. The Germans had put some kind of "medicine" in our soup which inhibited our natural functioning. There was a measure of sadness mixed in with our "joy"; for although the lashings ceased and we were rid of one heavy burden, we feared for the future. We still hoped that we had a life ahead of us, and we never stopped believing that our redemption, though it tarried, would one day come. We were no different from any other believing Jew who waits every day for the Messiah to come — a belief without which many of us would have committed suicide long ago. And now we worried that this drug might turn us permanently into barren women, that we might never be able to create a new generation of Jews.

But to our great relief, this fear proved groundless. Not all of the women recovered their cycles after the war, but most were able to lead a normal life and to have children.

Ironically enough, it wasn't only the Germans who inflicted punishment on us. There were rare occasions when we were forced to pass judgment and carry out a verdict on one of our own, for the sake of mercy.

At the time of our evacuation from Keizerwald, the Germans had divided us into groups based on our physical strength. I was placed in the "strong" group because I was tall and swollen from hunger, which made me look bigger than I was. And although my hands were weak, the muscles in my feet were very strong, for in my childhood I had danced.

Among us there was an old, unmarried woman from Germany who was demented and physically malformed. She had been placed in the group because she was strong as a horse, in spite of her deformity. After some investigation, we discovered that she was informing on a younger woman in the group, who was beaten daily as a result by one of the block

officials. It was not difficult to tell that this constant beating would soon end in the young woman's death, and we knew we had to find a way to stop it.

We decided that mere words would have no effect on the old woman from Germany, for she could not be approached in a rational manner. The most effective method would be a taste of her own medicine. I sensed that Hinda Fus, the Jewish overseer of our block, knew of our plan but intentionally looked the other way.

There were girls among us who were burning with the flame of justice and revenge, and they were eager to carry out their task. At the right moment one of them threw a sack over the demented woman's head and gave her a rich beating. Even though I had taken no part in it, the woman suspected me, and for a long time I feared her reaction. But nothing happened, and the "stunt" proved effective. The old woman ceased her "informing" routine, and the innocent girl was not beaten anymore.

A Semblance of Culture

In spite of all the hardships, I still retain several happy memories from the concentration camp — if they can be termed so. I remember the times we conducted "cultural" evenings: singing, reading, storytelling, dancing, the memorable theater of dolls. Here I must mention the devotion and loyalty of many women who worked hard to provide entertainment for us on those evenings, among them Flora Rom, Leah Wapnik, Tzirele Lipowski, and Ryvka Bosman, the wonder child of our camp. I remember the times Ryvka and I used to closet ourselves in the latrine so that she could write her songs without being disturbed.

Of all our "extracurricular" activities, the puppet theater was the most outstanding achievement. We invested an enormous amount of work and energy in this production, under subhuman conditions. We composed a special satirical text, in which I took part. The puppets were created from nearly nothing, and several of our girls provided their voices and pulled their strings. Flora Rom was the living spirit in this project, as in all others, and contributed most to its success.

I paid a very high price for my participation. I danced during the performance. When the Germans found out, they decided to punish me

by preventing me from ever dancing again. Under the guise of a medical experiment which would convert me into a more "productive" laborer, they drilled a hole in my foot and stretched the veins.

There are no words to describe the pain of this "medical" procedure. The hole was broad and open, extending to the bone. To add to the torture, I was now about to spend several days being tossed back and forth like a football, on a foot that I could not move or step on.

Since I was now effectively an invalid, they packed me up and shipped me from the A.E.G. factory back to the Keizerwald concentration camp, where I had originally been interned. At that point Keizerwald was in the process of evacuating the mentally ill and sick inmates to their deaths, and I arrived in time to join them! I would have perished together with the others if not for the intervention of my sister-in-law, Masha. By some miraculous twist of fate, she succeeded in having me transferred back to the factory. But only one day after I returned, all the A.E.G. inmates were evacuated from Riga to Torun.

The Fortress in Torun

The ride to Torun lasted four days and four nights. We sat on the floor of the wagon with our chins pressed against our knees, packed together like herring in a barrel. I was in a special predicament, for I had to sit with my injured foot resting on the shoulder of the girl in front of me. This young girl kept telling me that she was proud of the "great honor" of holding the foot of Mussia Deiches, the famous dancer, on her back. For four days and four nights she held my foot, and when I tried to convince her to trade with someone else, she did not want to hear about it. She just sat patiently, stroking my other foot with a gentle and loving touch. This dear little girl did not survive, and I am sorry that I do not remember her name. I would gladly have taken her place!

That long ride was a voyage in hell. I came to realize during those four days that the torment of thirst is worse than the torment of hunger; it is a living inferno. I sat rigidly, half crazed with thirst. None of us dreamed of bread, but only of a drop of water, and we tried to produce a bit of saliva in our mouths, just to have a sensation of wetness. Ironically we did not lack for moisture. We were all soaking in our own sweat, for the humidity

in the air was unbearable, and the barrel in the middle of the wagon that served as a latrine was overflowing. Each time the wagon jiggled slightly, the barrel poured out its contents on our heads and bodies. To reach it we had to climb on top of one another, but I could not even entertain the notion of such a feat.

When the doors were finally unbolted, we had no idea where we were, whether we had been brought here for slave labor — worse than that in Riga? — or simply to die. The Germans' shouting seemed to cut our lifeless feet as though with a knife; we could hardly straighten them out. My back felt as though it had been broken.

They did not even give us a chance to stretch, but ordered us immediately to run about eight kilometers to reach the gigantic square of the Torun fortress. To this very day I do not understand how I made it. I was overwhelmed by the pain in my foot, and sick to my stomach from having been unable to relieve myself all through the journey. When they ordered us to stand appel, I passed out. Such a thing had never happened to me before. I was young and healthy, and had always belonged with the "strong."

The compassionate Dr. Slitowna, who had been a good friend to us in the Riga factory, approached the Hauptscharfuhrer and said to him: "One of our women has fainted. Am I permitted to give her a bit of water?" With great compassion this murderer — whom we later nicknamed "Father" — pointed to a pool of muddy sewage water and allowed her to give me a drink from it. Finally they brought me to my senses. Later I learned that all of the women, including my own friends, had envied me greatly for two reasons: I had been allowed to lie down, and I had been given a drink. Almighty G-d! I lay on the ground and drank water from a sewage pool — and people envied me!

We were imprisoned in the fortress of Torun for six months. We slept on the floor, ninety women in one room. The floor was made of boards which had been divided according to the number of girls. Each girl had a space of two boards to sleep on; it was a very precise calculation. We could not sleep on our backs or on our stomachs, but only on our sides, and only on one side. No one could turn around or change position, for then all the others had to turn too, as in a game of dominoes. But it often

happened that in her sleep one of the girls involuntarily pushed her neighbor — who in turn pushed *her* neighbor, and so forth. The bout of quarreling and screaming that inevitably ensued was a nightly occurrence.

The fortress was hundreds of years old, and most of its structures were beneath the earth. During the entire period that we were kept there, with one or two exceptions, we never saw the light of day, for we left for work before sunrise and returned to the fortress long after sundown.

Our labor was dangerous. We spent our days examining cables immersed in tubs of water, and if we weren't extremely careful we received electric shocks. The screams and shrieks of pain from women who had been shocked echoed around us all day long. The walk to work itself was backbreaking, for we were forced to carry entire walls and poles which would be used to build a new concentration camp. Twelve women carried one wall, six on each side, and as we walked we sang. We were always singing . . . it was a wonderful, therapeutic medicine, and kept us from spiritual devastation . . .

The Wehrmacht's Property

The greatest calamity that fell upon us in the fortress of Torun was the accusation, made in all seriousness, that we had sabotaged the Wehrmacht's property.

There were some women who cut strips of cloth from their long dresses and used them as belts or brassieres. When the Germans noticed that the dresses no longer reached the floor, they became infuriated. How dare these slaves alter or destroy the property of the German army!

As a punishment, they ordered us to stand in position, without moving hand or foot, for the next eleven hours. A raging rain hammered down on us, penetrating our bones. We were sure that they meant to kill us there, that it was only a matter of minutes. On top of the walls, guards stood with their machine guns trained on us, ready to shoot at the slightest movement.

After a while the twelve girls who were in charge of our room were commanded to step out of the line. As they stood there, dripping rainwater, the Germans read them the verdict that had been decreed upon

them for sabotaging the Wehrmacht's property: death by hanging! The twelve girls were taken away and never seen again.

We remained standing, shaking like twigs in the wind. The rain whipped us ferociously. We stood and cried, and the rain washed away our tears . . .

Once or twice during the spring, the Germans allowed us out on a Sunday to breathe a bit of fresh air. To this very day I do not understand what possessed them to perform to such a "generous" act. Maybe they had been promised rewards for keeping the German war machine running efficiently, and thought that by giving us a small physical reprieve they could wring another few weeks' labor from our drained bodies. Whatever the reason, we were brought out one day from the depths of the earth, to our great surprise. It was the first time that we had been exposed to daylight since our imprisonment.

These moments were a tragic pleasure. We smelled the aroma of the lawns, the freshly cut grass, the trees in the nearby woods; we smelled the fragrance of the flowers. We — young girls who had lost husbands, friends, little children, infants — were moved to the core of our souls. We were hit with a rush of indescribable longing for freedom, for happiness, for love. These thoughts broke our hearts.

We were snapped back to the present by shouts: *"Run! Run down! Run fast!"* The bitterness settled over us again like a stinging blanket. When I heard the shouts, I started to scream too, but in a voice that was not mine: *"Girls, girls, run to the steps! Run down the stairs! Let's go down — down underneath the face of the earth!"* I don't know what triggered this outburst or what I wanted to prove with it; perhaps it was a subconscious cry of defiance, or perhaps merely an attempt to drown out the Germans' shouts with my own.

One day we were moved from the fortress to the barracks that we had built with our own hands. The new building was very poorly constructed, with many cracks and gaps between the boards. In the autumn the wind and rain penetrated, and in the winter the snow swept in. Girls who slept close to the walls often arose to find their heads covered with snow. Although we each had a head kerchief, we were not allowed to wear them

in the barracks, but only on the way to and from work. The Germans were very strict about this. Maybe they did not want the local civilians, whom we often met on our march, to see our shaven heads.

At about this time a group of us were dismissed from our work in the Torun factory and were forced instead to transport heavy sacks of cement and iron rails from the train station to the barracks. We carried these loads from dawn till sundown. I had to walk many kilometers each day, dragging my crippled foot behind me.

One of the prisoners gave me a wonderful present: a pair of warm, knitted stockings. The stockings were long and thick, and kept my wound from rubbing against the side of my wooden clog. However, to my great dismay, I had to throw them out after only a short time — or, to be more exact, they walked away on their own! I awoke one morning to see the stockings moving slowly across the floor. There was a simple solution to this mystery, and one that was not new to me: lice.

The lice were a terrible torment, just as they had been in Riga. There was one woman in our room who lost her mind because of them. Once the lice attacked, she gradually withdrew and no longer talked to any of her friends. After a while she became so infested that the Germans took her out of the camp, stripped her stark naked, and threw her swarming clothes into a blazing fire. She looked at the flames for a moment and then suddenly threw herself into them.

We were not done with afflictions. In addition to the unrelenting hunger, biting cold, hard labor, and lice, we were hit with insomnia. This new and unexpected plague threatened to finish us completely. We became restless, lethargic, apathetic. We lost our longing for our mothers and fathers and thought only of warmth and a bit of food. We began to disintegrate, physically and morally.

It was aggravating enough to lie awake during the precious few hours allotted for sleep; harder still was to lie awake in the midst of a crowd of people from all walks of life, people with diverse personalities who would not have gotten along well under normal circumstances. Personal characteristics ballooned out of proportion here. Those whose ordinary conduct was uncouth behaved abhorrently in the camp. They plunged into a moral abyss and literally turned into animals.

Those who speak of lofty moral achievements in the camps exaggerate. Their words are only hollow rhetoric and do not represent the full truth. The Germans were out to crush us, and they succeeded. Very few people did not change to some degree, and those who changed only modestly deserved great respect, for this was a considerable feat. Only a very few unique individuals had the spiritual power to remain uncorrupted in those subhuman conditions — and these were true angels. Maybe they were given this strength in order to prove that even in the midst of the most gruesome bestiality, an individual has the ability to remain a human being if he really tries. And perhaps it was in the merit of these remarkable few that we survived.

It was now January of 1945. The Allied forces were advancing, and swift preparations were made to evacuate the camp in Torun. The cold of that winter was burning. The strength began to seep out of us almost visibly, and the revier became overcrowded. We were enveloped in fear and depression and felt that the end of our journey was near, that when we left this camp we would meet death on the road.

There was a rumor that we would be transported to Gdansk and from there to extermination camps. Each of us received two loaves of bread for the journey, but we were so weak that some of us could not even carry them. We realized at the last moment that the Germans were planning to abandon the people in the revier, who were now no more than living corpses. The question arose among us whether there was anything that could be done for them.

I should not praise myself, but neither can I deny the truth. I was the only one who stubbornly demanded that we not abandon the sick. We had no horses or sleds, only wheelbarrows, but I told the others that this was no excuse to leave these poor people to their deaths. "We'll take care of them — and whatever happens, happens," I screamed and begged. "We'll sing and we'll pull! If we had the strength to carry walls and iron rails, why should we not find the strength to carry our friends? They are our sisters, and we share their fate!"

We loaded the sick onto the wheelbarrows and started out on the death march. Pushing and hauling the barrows through the snow was

dangerous and frightening. We threaded our way along clumsily in our wooden shoes, which rubbed painfully against our feet. We fell often, for the snow clumped up into balls and stuck to the soles of the clogs, and we had to stop frequently to remove the lumps.

In spite of our efforts, the condition of our sick friends only worsened. Not one of them survived; they died on the way, one after another. As each one breathed her last breath, the others pushed her down from the wagon. I buried most of them with my own hands. They did not merit a *"kever Yisrael,"* a Jewish burial; they did not have anyone to say *Kaddish** for them, but at least they had a burial . . .

The sick people were not the only ones to die. Some of the women did not have the strength to keep up with the column and collapsed on the road. The rest of us searched for hiding places to escape from the bullets that were now whistling all around us.

Finally we were liberated by the Russians on January 25, 1945, and since then I have fasted each year on that day.

Sadly, liberation did not mean life for everyone. There were many whose bitter fate it was to die after they had obtained their freedom. One of them was a young girl named Ethel'e Krizhowski, who had been shot in the legs just hours before the Russians took over. Many women died when they were given something to eat, for they could not digest normal food. Those of us who remained were faced with another struggle, for the Russians who had just come from the front, filthy and odorous, now tried to rape us. They did not see anything unnatural in their behavior; they had liberated us and given us food, and they took it for granted that we should show our gratitude by giving them what they wanted. Our freedom only served to beset us with new afflictions.

Today, when I look back on that time, I can barely comprehend where I drew the strength not only to stay alive but to help others survive. I had always been a very pampered child, whose every whim was satisfied and who received everything on a silver platter. I ask myself: Where did I acquire such resilience, the ability to ignore my wounded foot, to think of it merely as a log of wood which I had to carry?

*Prayer said for the soul of a dead person.

It is possible that I managed because of a very personal vision which I kept deep inside me, a dream that I never revealed to anyone. I remember that when Chayale, Masha's sister, fell down in the marching column, I carried her on my back, pushing and straining against the strong wind. During that march, I envisioned myself as a ghost-spirit in whom reigned a boundless power. I had a refrain that I would repeat to myself, sometimes silently, deep in the well of my heart, and sometimes aloud so that others might hear: "We are going toward life and not toward death. Toward life and not toward our death! . . ."

Mussia Deiches lived in Tel Aviv after the war and passed away in 1982.

A BUNDLE OF POEMS

❖

Ryvka Bosman
Riga, Latvia

On the surface all our stories are alike . . . and yet in each there is a specific character, an expression of unique feeling. My story resembles so many others, and yet it is not quite the same . . .

I loved my father very much. I remember as though it were yesterday how he was standing not far from us, and that when I moved forward to bring him closer, a German blocked my way. He poked at me with his rifle — no crossing! It was then that our tragedy began.

My family had fled from our hometown of Riga to Vilna. When the Germans liquidated the Vilna ghetto in September of 1943, they deported most of the Jews to concentration camps in Estonia and also to the Keizerwald camp, near Riga. It was here that my mother and I were sent. I remember when we arrived in Keizerwald; I was shocked beyond imagination. The hunger and filth were beyond the power of the pen to describe. All I had were my brother's sweater, a tea kettle, and a bundle of my poems — the only things I had succeeded in keeping with me.

In the beginning we did not know anyone who had come with us from Vilna. We had been in the ghetto only a short time and had not had a chance to acquaint ourselves with the Jews there; so now we were in a camp with no friends at all. My mother and I were very lonely.

Then, unexpectedly and out of nowhere, a woman approached me and asked if I had brought my poems with me. I was only sixteen years old then, and yet someone had found out about my ambition as a writer! How the woman discovered this I never knew, but her question made a tremendous impression on me. At that moment I felt an inner encouragement. I was not lost, not yet! A renewed yearning to write and to create rose in me. Suddenly all the poems I had ever written began to race in my head, and the terrible reality around me vanished. I was caught up in the net of an irrepressible longing to live and to create. My desire became my stronghold, maybe not only for myself but for others as well. The specific feeling I had at that instant is still as vivid in my mind as though it had happened just now.

After a while some of us were transferred to a nearby camp in Vilna, where we worked in the A.E.G., an electronics factory. Conditions there were terrible; a heavy and depressing pall hung in the air, an intense fear hovered in every corner. In the beginning I knew very few people, but soon I became acquainted with the other girls and women in the camp. We had all been uprooted and orphaned from our families, and we clung to one another fervently. We began to search for ways to strengthen ourselves and keep our spirits up. One of the first things we did was to set up a "cultural group," getting together at appointed times when it was safest to do so and holding discussions on various topics. During these talks we worked hard to try and find a positive aspect even in the saddest news, actively using our minds as a weapon against the evils around us.

We fought the dreadful affliction of hunger by talking about food and creating the most wonderful recipes for dishes we would cook and bake when we were free. We also promised ourselves that after the war we would eat only very thick soup, as different as possible from the thin, dirty water we were given in the camp. At our gatherings we also told stories or read poems, and when our imaginations were at their most powerful, we were actually able to transport ourselves to another world. These moments gave us the courage to believe that we would not be crushed, that regardless of our bitter situation we would endure.

Engraved in my memory is a special evening when our girls got together and I read a poem I had written just the night before. Then my

friend Flora Rom, who always found ways to cheer us up, narrated an interesting tale; and to "cap" the evening, Mrs. Alperowicz, one of the married women in the group, suddenly appeared with a surprise — a "cake" made of dry bread crusts which she had saved for a long time, just for that special evening. I can hardly remember a cake that tasted so good. It was an occasion of near-exultation. I remember thinking of the great spiritual power our Jewish nation possessed.

It was an unusual period of time, positive in a strange way. There were sparks of enlightenment in those weeks that to me were clear signals of a future. I remember that shortly after that memorable literary gathering, I caught a cold and my glands swelled up. Our camp doctor, a Jewish woman named Slitowna, rubbed the swelling with *ichtiol,* a black ointment that my father had always used on us at home whenever we caught colds. It was a rainy evening; the smell of the ointment reminded me of my home, and tears came to my eyes. The doctor noticed, and with her gentle hands wiped away my tears. I remember thinking that not everything was lost yet; a bit of compassion still existed.

In retrospect I realize that I was never so absorbed with the fate of our Jewish nation as I was then. I wrote a poem entitled *"Ver Zenen Mir?"* ("Who Are We?"), and I remember trying to make sense of the tragic events that were so incomprehensible to us. I felt a strong bond with our suffering people, and it gave me a sense of belonging to a special epoch.

For most of that time I was in a poetic mood. In the most critical situations I tried to think of words and to compose them in my head. I think that this state of mind kept me from drowning.

I managed to save a bundle of poems that were written in the concentration camp. They are authentic, in their original form. I even have the piece of shirt cloth that I used to cover them with, and the pencil that my friend Masha Kesler gave me. I went to great lengths to save these poems, for I sensed instinctively that they were actually saving *me*. More than once I had to hide lines that I had just written in my mouth, under my tongue, so that no one should see them. I actually learned to talk with a poem in my mouth!

I kept my bundle of papers hidden on me whenever I wandered from

place to place, and I also memorized the poems in case I should lose them. The bundle is a special one; it is a bundle of Jewish sorrow.

Today I examine and criticize the poems only from a literary perspective, but not for their fundamental value. For me they are priceless because they were created amidst physical and spiritual suffering. They are not only a documentation of an era — they are my life and soul.

I am convinced that these poems helped me to survive.

THIRTEEN

❖

Drora Eisner
Lodz, Poland

On a freezing cold winter night in 1943, I arrived with twelve other Jews in the town of Blachstadt. Here the Germans had established their central administrative office for the Bautrop North district, and on the same grounds they had created an unusually small labor camp for Jews. The thirteen of us — eight men and five women — had been chosen as the sole labor force.

As soon as we arrived, we were taken to a spacious, well-lit mansion, the home and headquarters of the chief SS officer and his family. Several of its rooms were also used as offices for the Service Center. Outside in the garden stood a grove of lush fruit trees, and in the center of the garden was a small two-story house which was to serve as our quarters. On the ground floor there was a kitchen and a very small bedroom for the female inmates, and on the upper floor one large room for the men.

The women's bedroom had three beds for the five of us, which meant that only one fortunate person would have a bed to herself. There was one child among us, and I always wondered how she happened to be selected for the group, but I never found out. When we made our sleeping arrangements, I chose her as my partner.

The next day we were given jobs. Seven of the men were assigned to work in the garden, stable, and cowshed. The eighth man was a dentist.

He worked several hours a day treating the teeth of the Germans, and the rest of the day in the garden. Two of our girls worked as cooks, and two, including the child, worked as maids for the head SS officer, shining his boots, cleaning the rooms in his office and house, and performing other domestic tasks.

I was assigned to the office. My work shift was twelve hours long, but that was not the most troublesome aspect of my new job. A paralyzing fear gripped me as soon as I entered this office. I envied the girls who worked in the kitchen, for they did not have to look into the faces of the Germans all day long; I, on the other hand, was surrounded by Nazis from morning till night!

On the first day a German clerk handed me a bunch of papers and ordered me to copy them on a typewriter with German-gothic style letters. He then left me alone to my task. I was horrified, so frightened that I did not lift my eyes from the machine all through the day. Any little movement or sound caused me tremendous anxiety. At lunch time, when all the German clerks left their desks in the surrounding offices, I continued to sit over my papers, while the hunger gnawed at my stomach. Later, one of the clerks remembered me and came back to tell me that I was permitted to return to my quarters for lunch.

After several days I was transferred to a room where only SS officers worked. They were all soldiers who had been wounded in battle and had now been placed in high administrative posts. Three of them were middle-aged men, and the fourth was a young Bavarian soldier who had returned home from the Eastern Front without one of his legs.

In the beginning I did not speak to any of them during my entire twelve-hour shift. I wanted to create the impression that I did not understand their conversations. I had had a very good education and understood German well, but I hoped that perhaps if I played "dumb," they would loosen their guard and talk freely in front of me, and I would be able to learn some news of the war and of the Jews. My ruse succeeded. After a few days the officers no longer took notice of me and began their political discussions as soon as they arrived in the morning. Most of their talk was inconsequential, but one morning in July of 1943 I picked up an item of news that was greatly encouraging.

It was a day like any other. The chief director went from room to room and greeted all of the workers with a loud "Good morning!" As soon as he left, four officers got up from their desks and approached the map on the wall. The youngest pointed out several sites and explained to his friends: "We've suffered our first serious defeat. We suffered setbacks in 1941 too, but at that time the highway to Moscow was not obstructed as it is now. Then, we had no idea what the 'Eastern Front' meant . . ." He returned to his desk without finishing the sentence. I assumed that he was referring to the unexpected resistance the Germans had encountered on the Russian front. In light of this news of a setback, the chief director's cheery "Good morning" was somewhat puzzling; perhaps, I surmised with a touch of sarcasm, he was secretly relieved, for if the Germans were losing, he might not have to go to the front . . . or perhaps he did not want to dampen morale.

The young Bavarian soldier who had lost his foot worked in the same room with me. He had been a staunch, indoctrinated Nazi just like the others, but apparently his battle experience had changed his opinion of Hitler. The first time he entered the office, he approached my desk, extended his hand, and greeted me in a friendly fashion. I was afraid he had mistaken me for a German clerk, and I rose quickly and declared that I was Jewish. I was partly afraid of the potential danger that threatened any Jew who held confidential information inadvertently slipped by a German; and I was also nauseated by the touch of a hand that had been drenched in Jewish blood.

The young soldier, however, was not deterred by my declaration. That evening he visited our quarters. It seemed as though he wanted to share some information with me and the other prisoners. He began by questioning us about our private lives, and then suddenly he started to comfort us, saying that the end of the war was near, and that soon we'd be free . . .

The thirteen of us in this strange, anomalous labor camp were like a tiny island in a vast ocean of captive Jews. Though we may have been considerably better off than many others, in our physical circumstances alone, we too lived under constant tension. This strain emanated not only

from our fear of the Germans, but from each other. We suffered from the simple social ailment of being a disparate group of people whose paths would not have crossed in any substantial way if the Nazis had not thrown us together. We were all strangers to each other, people of unlike mentality, and serious conflicts often arose among us.

Each week I counted the days until the Sabbath, for then I was free to go to the nearby camp where several people I knew were interned. Among them was my best friend from Riga, Gucia Beham. We were extremely fortunate that the restrictions in the camp were mild enough to permit contact with outsiders. It was a very far distance to walk there, but I would not forgo the pleasure of these visits.

Gucia was several years younger than I, a dark, pretty, and very charming girl with a great deal of intelligence. Shortly before the outbreak of the war she had graduated from law school and gotten married, but her husband was killed by the Germans almost as soon as they took over our town. Sometimes during our visits she would talk to me about him. On the days when I could not visit her, she went to great lengths to send me small parcels of food and letters. I treasured these letters and read them many times over. I remember once writing back to her about the strong tension and gloomy atmosphere that enveloped our camp. I told her how depressed and lonely I was, for I never would have believed that to live together with people of different natures could cause such great distress. Among other things I related a recent incident that had disturbed me greatly:

It happened at the distribution of the horse-meat rations. The cook had doled out unequal portions, and one of the prisoners thought that his portion was smaller than those of the others. His nerves must have snapped, because he burst into a screaming rage and threw his meat to the dogs. Gucia replied with a sensitive bit of insight, quoting a verse from a poem by Julian Tuwim: "Small people deserve great pity." She was the only person to whom I could open my heart, the only one who understood my terrible isolation and knew why I cried at night.

There were many such incidents in Blachstadt, and although we were not tortured physically, there was a deep undercurrent of emotional torment. One day a shipment of clothes for the office staff arrived from

Auschwitz. Never in my life will I forget this scene. The Germans brought their wives and children, and they threw themselves on the pile like wild animals. All day long they tried on suits, dresses, even underwear — the last remnant of Jews from all over Europe who had been brought to Auschwitz to be murdered. I was shocked when I saw pictures and documents falling out of the pockets of the garments. I glanced at the photos and read the names on some of the documents, and I thought about these people who had once been alive.

The shipment was guarded by one of the most notorious murderers of the local SS police force. I saw with what pleasure he watched the German women ransacking the pile of clothes; but even on them he did not waste the opportunity to exercise his tyrannical authority. "Toss your garbage around and enjoy it now!" he shrieked through clenched teeth. "You had better be grateful for the opportunity we give you — for if the Russians were here, they would toss you away together with the clothes!"

I watched as the Germans grabbed from the pile and adorned themselves in our clothing, everyone from the wife of the SS chief all the way down to the lowest office clerk. It grieved me to see these women, with their hands and eyes, exploiting the clothing of my murdered people. I could not restrain myself and asked one of them if she knew where these clothes had come from. "Yes, I know," she replied, "from the Jews who were killed. But if I do not take them, someone else will, and nowadays it's so hard to get any clothes . . ."

At times when I felt particularly low, I tried to remember the saying from *Ethics of the Fathers*: "In a place where there are no men, strive to be a human being." I worked very hard to keep my balance and never showed any sign of weakness. For this reason the other prisoners always turned to me for advice at any fateful time when a quick decision had to be made or immediate action taken; and I must say honestly that there was no one among us who was emotionally stronger than I.

Passover of 1943 was now over, and the Warsaw ghetto had gone up in flames. The German Reich was already "cleansed" of Jews; only the Lodz ghetto continued to operate. It became clear to us that there was no safe haven for Jews, that all would eventually be strained out of the

regime—and that included the thirteen of us, despite the relative leniency we had enjoyed until now. Deportation was a near certainty. We discussed the possibility of escaping but could not reach agreement, and in any case there was no place to escape to.

A few people in our group finally decided to flee and return to the Protectorate,* hoping to hide there under Aryan identities. They actually managed to get out, but were quickly caught and put to death. In spite of their unlucky fate, the episode spurred me forward, for I knew that to take no action would certainly be fatal. I had no doubt by now that one bright day we too would be deported to Auschwitz, and I could not reconcile myself so easily to the thought of being led to my death with no resistance. The prospect of escape nested in my mind and gave me no rest.

The next time I visited my friend Gucia, I discussed this idea seriously with her, and we started to outline a plan for our escape. Two brothers and their sister joined our group. Fortunately none of us looked very Jewish, and we felt we could pass for Aryans. On the night before we planned to flee, the five of us were sitting together discussing last-minute details when I suddenly felt someone fingering the buttons in back of my dress. I turned quickly, and to my surprise I realized it was one of the two brothers. It was commonly known that Jews used to hide gold, jewels, and other small valuables inside their buttons and buckles in case of an emergency, and it dawned on me that this boy had intended to "clean me out" of whatever I still had. There didn't seem to be much point in escaping with people I could not trust, and I decided at that moment not to join the group but to stay put. I told myself that whatever would be, would be.

In the meantime I began to notice a change in the behavior of the people who worked in the office. From the time the Polish region of Upper Szlezia had been "cleansed" of Jews, my "colleagues" had begun to show a great interest in me, very much in the manner of the young Bavarian soldier. Every day another member of the staff was called away to the Eastern Front, and before leaving, each one came over to say

*The Protectorate refers to those territories occupied and controlled by the Nazis but not included in the Reich, the umbrella term for the countries and territories which had been officially incorporated into the German government. Parts of Poland were in the Reich and parts in the Protectorate.

goodbye to me. Almost to a man, they used the same line: "Yes, Mrs. Eisner, I would like to meet you after the war." It was not difficult to see through this veneer of civility and to detect the deep insecurity that prompted them to try to cover their own tracks in the event of defeat.

The last person sent to the front was an SS man named Kollar. In an unusually congenial tone, he too expressed his "wish" to meet me again after the war.

I replied: "How will that be possible? For when you return there will be no more Jews."

"One never knows, Mrs. Eisner. It's a war, and the Russians fight like wild dogs . . ."

Kollar and his daughter, who was the chief secretary here, were the most evil people in the entire office. Every word they uttered, even their pretended pleasantries, reeked with Jew-hatred. About a week before he was to depart, Kollar approached me again and said in a mildly ribald manner: "You're such an attractive woman; why don't you go off for a while and spend some time with your young 'friends' over there in the other camp?" Kollar evidently thought nothing of such behavior. German women were well known for their brazenness, and this man had no idea how offensive his casual remark was.

I replied simply: "When the war is over, I will return to my husband in Lodz."

"Silly girl," he said, in a reversal of the ingratiating optimism he had practiced on me the week before, "when the war ends there will be no Lodz and no husband."

"Even this is impossible to know, Mr. Kollar," I answered, handing back his own line.

It was very tempting to trust in the "changed" attitude of these soldiers, but very unrealistic, for their hypocrisy was not as well disguised as they might have wished. More than one incident had served to prove this to me.

I thought of the dog that Kollar had brought home one day from a hunting expedition — a very ugly dog whom he named Zysko. He kept Zysko on a leather leash, but one day the leash broke, and soon afterward the dog began to follow me. I never understood why; sometimes I thought

that perhaps it sensed in me a trace of its previous mistress. But who can understand the soul of a dog?

Whatever the reason, Zysko continued to trail me wherever I went. At night I used to lock the door of our hut, but as soon as he heard the latch turn, he would begin to howl and bark. Finally, with the permission of my roommates, I cleared a place for him to sleep on the floor, and in the morning I would invariably wake to find him at the foot of my bed. The dog did not leave me for a single moment. He would curl up underneath my table in the office while I worked, and then in the evening, when I was busy cleaning up the yard or the lavatory, he stayed at my side as though wanting to help me. I could not understand it, nor could I explain what motivated me to love this ugly dog. Possibly it was not much different from what happens when a man or woman falls in love and no longer sees that the partner is unattractive. To me this repulsive dog seemed beautiful and loving, and he brought some enjoyment into my wretched life. The Germans, however, begrudged me this "pleasure" and resented the dog's loyalty to me.

One day I returned to the office from my lunch break with Zysko at my heels, as always. Several Germans were standing in the corridor absorbed in a discussion, but they fell silent as soon as they noticed me. Their silence told me more than their words; surely they had been talking of the war. Some impulsive streak of indignation and pride suddenly possessed me. As I passed them I looked at the dog and remarked, as if to myself, "Zysko does not know that I'm Jewish, and he likes me . . ." The Germans must have heard the comment, but they did not react; only their eyes glittered like fire. I immediately regretted my rash remark and had the frightening feeling that something would happen, either to me or to the dog. My premonition was justified. A few days later I found the dog shot to death. I should have been relieved that nothing happened to me, but my tension did not subside . . .

There were others on the staff whose overtures belied their true attitudes. Even the chief SS officer and his wife had begun to show a different face to us. One of our girls, who worked as their maid, reported that the officer's wife inquired about each of us and expressed sympathy for all the expatriated Jews. The young girl took this professed concern

as a good omen. Later, when we were all about to be deported, she asked the woman to allow her to stay on and continue working, explaining that she had no strength to wander again. The SS wife, who had been so "merciful" of late, fell into a sudden fury and screamed, "You cursed Jewess — get out of here, but fast!"

This woman had two sons. The older one was a dull-witted boy of twelve, and the younger a much brighter child of six. Both had free run of the estate, and they would often show up unexpectedly in odd corners of the buildings and grounds, watching us curiously as we worked. The younger boy apparently sensed that something was amiss, but did not understand that to persecute Jews was wrong. Once I asked him if he knew what a Jew was. He did not respond. I asked him if his mother had ever told him about Jews, and again he said nothing. I could not restrain myself and continued: "Do you love us Jews?" The face of this six-year-old flushed crimson red in a look of disgust, and he spit on the floor in anger. I realized that he had indeed been brought up as a loyal German, a true second-generation Nazi; that there was no mercy to be expected from the most pleasant-mannered German — not from the mothers and not from their sons.

The rumors of our deportation seemed definite. It was no longer a question of "if" but of "when," and this vital piece of information was zealously guarded from us. We were now faced with a new dilemma: most of us had smuggled valuables into the camp and hidden them here, but since we would be forced to leave on a moment's notice, there was a good chance that we would have to leave all of our belongings behind. We discussed various ways of obtaining information from the camp commandant about the exact time of the deportation, and came to the consensus that no one was in a better position to do this than I. I was then in the process of organizing some papers in the office, and it was decided that I should find an excuse to talk to the commandant and ask him casually if I would have a chance to finish my work before we left.

When I came to the central office with my batch of papers, two SS Shupo* policemen were waiting there. They were very polite and

*An acronym for *Shutz Polizei,* guard police.

informed me that the few of us in this little camp were the only Jews left in the area. I gathered from their talk that an order of deportation might even come that very evening, but it was also possible that we might stay for several more days. Nothing was certain. I guessed aloud that most probably they would send us to Auschwitz.

When he heard my words, one of the officers advised me in all seriousness to hurry and leave the camp. Then, as if checking himself, he added: "But where will you go? Wherever you go, you'll meet us. You could even earn a bullet in your back . . ."

His remark confirmed our fate but did not give me a clue as to the timetable. After further pondering, we decided to send another member of our group on the same mission. He went in to his supervisor with an unfinished document, explaining that he needed some more information in order to complete it. After supplying a few details, the German snapped: "But do it fast because you might have to leave at any minute!"

"What? Where to, Herr Kommandant?" the prisoner asked, feigning surprise.

"We don't know yet, but you've got to leave. You're the last Jews in this district, and it's only thanks to me that you're still here."

"But sir, where will we be sent to?" the man begged. "If we have no right to live here, where else can we live? Don't we have the right to fight for our lives?"

"Do not look at your situation that way," the officer answered. "You are young and will most probably be sent to another labor camp — and even this might be delayed."

When our friend reported this conversation to us, we began to brace ourselves mentally for another stretch of wandering. An uncanny silence blanketed the camp, but even as we prepared ourselves for the oncoming storm, we were aware of an underlying sense of tranquility. Perhaps there was a measure of relief in having our fate sealed at last . . .

The Germans did not pressure us to work at this point and did not even force us to run through our daily regimen of exercises and drill. Then one night, when we were already in bed, the camp commandant came in. With his hands folded behind his back, he asked us in a very polite tone to relinquish all of our money and valuables. When no one responded, he

repeated his order, but this time in a more threatening voice. "Children," he said wryly, "you know that you must leave. In the other place you'll be forced to give up everything. Better hand it over to me!"

None of us moved. After a couple of minutes he left the room, but no one could fall asleep that night. A profound fear overwhelmed us.

At dawn, just when we had fallen into a restless slumber, we were awakened. We jumped from our beds and ran to the window. In the yard we saw groups of men, prisoners from the nearby camp, lined up against the opposite wall. Our hut was surrounded by SS men. We were given a few minutes to dress and gather our belongings, but this did not take much time; we had slept on our bundles for several nights now. Then we were ordered to go outside and stand next to the line of men. A few guards encircled our group, while several other Germans went to search our rooms. The commandant was nowhere to be seen.

We were led to the square in front of the local police station, where we sat for several hours. From time to time the Germans brought new groups of prisoners into the square. All through the day they hunted down the last Jews in the district. By evening the crowd had swelled to two thousand people — old, young, and children.

Night fell, and we sat there in the open square as a fierce rain began to pour down. The sand turned into mud, and puddles of dirt lapped over our feet. We hadn't been given anything to eat or drink that day, but the hunger did not plague us as much as the wetness and cold. We spent the entire night sitting out there in the cold rain, tired and despondent . . .

In the morning the weather improved, and with it the Germans' attitude toward us. They acted friendlier than they had the day before, and we tried to take advantage of their good mood. Some of us had indeed left behind valuable items, and now we decided to trick the Germans into giving us permission to return to the camp. We told them that we had left some clothes there, and they allowed three of us to go back. They even permitted us to go without an escort, but we were hesitant about this and replied that we were afraid to walk in the open without a guard. They said they would notify the police that we had been permitted to return to Blachstadt, and assured us that we would not be mistaken for escapees, since there were no other Jews left in the entire district.

We did not meet a single person in the yard when we got back to the camp, and we had a chance to recover all of the valuables we had hidden at the last minute in the oven. We were lucky that the Germans had not thought to search there. Then we quickly returned to the square, no longer entertaining any thoughts of escape.

We were kept in front of the police station for three days and three nights. SS men were patrolling all of the local roads and pathways, and on the third day they began to haul in the bodies of Jews who had been caught trying to escape from the square. Later we learned that the chief pursuer was the commandant of our camp. Perhaps that was why he had not been around to "bid" us farewell . . .

On the fourth night we were surrounded by a squad of policemen in brown uniforms, accompanied by trained dogs. We were ordered to take our bundles, form lines of five in a long column, and start walking. Our escorts led us to the Klobutzk railroad station, where we were loaded onto a train like trapped animals. The Germans sealed the doors and blocked the tiny windows, and immediately the train began to move out.

After a long, dreadful ride in total darkness, the doors were finally unbolted. The first sight that met our eyes was a group of high chimneys. We were now in the gigantic transit camp* Blachhamer.

Drora Eisner has served in an Israeli embassy position in South America and now lives in Rechaviah in Israel.

*Transit camps were stopping points on the way to the major extermination camps.

A DIFFERENT PLANET
❖
Sara Selver-Urbach
Lodz, Poland

How should I start relating my chapter in Auschwitz? A description of the place must by necessity be inadequate, for it is literally impossible to encompass all the facts and implications pertaining to this particular man-made Hell. The many attempts at such description have all fallen short of what Auschwitz was and represented.

I was one of the lucky ones who were allowed only a brief glimpse of the place. I was kept there for only one week, and therefore was unable to see and comprehend fully all that took place there. And yet, one glimpse into that fiendish kingdom sufficed to deprive one of his sense of reality. Every minute that I spent there, I was unable to grasp that I was not trapped inside a horrible nightmare. But though I pinched myself and rubbed my eyes, I could not shake myself free of the terrifying dream.

It was August of 1944. Our train finally stopped. We had reached our destination: Mother and I, my four brothers — Fulek, Dovid, Leyzer, and Yankush — and Miss Marila, who had lived with us in the ghetto for more than a year. A cold sweat drenched us, the ground shook under our feet, we felt that we were falling amidst a vast commotion, falling straight down into a bottomless pit without any stages or transitions, hurtling and pitching down, down, down, at a dizzying speed.

In those first moments after we left the train, a number of tall, robust men dressed in strange, striped uniforms virtually pounced on us and grabbed the loaves of bread we had saved. Then they rushed into the wagons and began tossing out everything left inside: baggage, people, even babies. These were Jewish prisoners, among the "privileged" few who did not waste away because they took the food of the people on the transports. Their feeling was that we would have to relinquish all our food anyway, so at least someone should benefit from it.

People milled around us, screaming and crying hysterically. We looked for each other in a wild fright, trying to stay together. Within a very short time, we were pushed forward toward a gate, where SS men tore us from one another and tossed us about as though we were rags, the men on one side of the gate, the women on the other.

At first it seemed only a separation between men and women. My mother and I were hurled away from my brothers. Their terrified looks followed us pleadingly, but we didn't even have time to wave to them. Mother held my hand and said, "Surcie, *vain nisht* — Sara, don't cry."

Everything happened at such a dreadful speed that our footsteps became detached from us. A few moments later we found ourselves before a second gate. Suddenly Yankush appeared at our side; he'd been sent back to Mother, but in another split second our group was severed again. This time Mother, Yankush, and Miss Marila were dragged to a third entranceway, through which they disappeared with lightning speed. I was shoved forward with the endless stream of people, the Germans raining blows on us whenever someone stopped for a moment in confusion or terror.

My dearest ones had vanished to the other side of the gate. They were gone, and I was left all alone.

It is a superfluous task to relate all the details of what came next; these facts have already been described many times. It is well known that our heads were shaved, that we were forced to run barefoot over miles of razor-sharp gravel and flogged pitilessly, all the while crazed with thirst. After this ordeal we were brought in front of a few solitary water taps so that we could fling ourselves on them like beasts, ready to trample and kill anyone who stood in our way, for a few drops of water.

My tongue is too poor to do justice to all the things I saw and experienced during that endless week in Auschwitz, and so I will tell of only a few scenes which have imprinted themselves on my memory...

The first Auschwitz appel that I saw seemed to emerge out of an hallucination. I was marching along in a column, still aching with emptiness at the terrifying separation from my family, when I saw a group of people standing in the distance. But were they people? Human beings? No, the whole thing seemed like some sort of grotesque stage set, illuminated by the last rays of an artificial sun. The skeletons standing there had no lifelike shape, they were flat and two-dimensional, as in a picture. They stood motionless, without a sign of life, without the slightest gesture. Rags hung from their frames, delineating their outlines sharply, as if some artist had traced their pitiful figures with great precision. A grasping pain seized me, freezing my limbs. I was carried along by the stream of marching people, swept past this macabre painting, helpless, half-fainting, my heart alone alive, on fire with dread.

The transformation of human beings into cardboard figures did not take very long in Auschwitz. Our downfall was so precipitate that it robbed us of every restraint. Just as our exteriors were altered beyond recognition in only a moment, so too were our innermost beings transformed. We were no longer the human society we'd been in the ghetto. Of course, even there we had given expression to our anger and aversion, but here in the concentration camp, feeling underwent a complete metamorphosis, the relationships between people changed, as though all the prisoners were total strangers who could not communicate at all. And yet they acquired a common language — an entire lexicon of expressions that they mastered immediately! A special argot reigned in the place, consisting of the rudest and most vulgar terms and definitions, stripped of every ordinary human feeling. It was another world, another planet, governed by different concepts and laws.

Sometimes I used to think that perhaps our new callousness was a hidden trait which had simply lain dormant all our lives and only now rose to the surface; but no, it was the Nazis who did this to us, it was they, deliberately and with all their scientific and brutish might, who unleashed

the most bestial qualities in the prisoners. For now it was not merely that manners and accepted norms of interaction had receded from our lives; there was much more than the absence of politeness. A force of rudeness and cruelty had superimposed itself unchecked. Our facial expressions, our tongues seemed to spit a venomous anger and hatred, and there was no shred of consideration for others.

Never in our past had we encountered such abysmal hatred. Each face among us seemed contorted and crazed, many foaming at the mouth from hunger and torment — each was the image of a beast of prey threatening to pounce. The very sight of our fellow prisoners made us cringe.

There were, of course, exceptions, people who did not succumb to the dictates of this newly created society. Among them, I am grateful to remember, were the girls in my own group. I was fortunate to become part of a close-knit team of five girls who were my substitute for family and home here in the camp. The first was Salusha, whom I'd met in the ghetto and who had come to Auschwitz with me in the same cattle wagon. She had recognized me in the camp despite my shaved head, and we clung to each other from then on. The other three teammates were Blumka, Bronka, and Fajga. We guarded and preserved our team with all our might and were not parted until the very end . . .

Whenever we had to lie down on the damp dirt that served as a floor in our barracks, we would spread our legs and fit into each other as snugly as we could. It was, of course, very hard to stay in the same position for long, but even though our limbs would grow numb and start to ache, we had to try to remain rigid. The slightest movement would cause discomfort to others in the line, provoking protests, oaths, and even blows; but at least the five of us were together.

I don't recall that my friends and I ever shrieked or cursed or scratched our fellow inmates. We were stunned into silence, repelled by the torrent of ugliness that surged around us. My own face was so paralyzed that one of the kommando leaders once reprimanded me, scornfully and very aptly: "*Was kuckst mich so blöd an, he?* (Why are you staring at me so stupidly?)" This outward stupor never left me, but it belied the ache in my chest that burnt like a fiery ball, shrinking and expanding as though trying to slice my heart in two.

And yet I suffered no heart attack or breakdown, as did so many of the other women. I despised myself for this, because I thought there was something inhuman about my survival in a world devoid of every value, emptied of every moral and mental foundation. If I was able to endure this void rather than drop dead, it could only mean that some lifeless mechanism must be beating inside my chest, for a human heart would have cracked long before.

I never thought of taking my own life, and this to me seemed entirely illogical — for how could I possibly go on living? I did keep a steady lookout for a knife or razor blade, something that I could keep handy in case a German tried to assault or rape me; but I did not think of using it on myself otherwise. And yet, the longer I continued to live, the more intense became my shame, the more obsessive my self-contempt at being able to withstand the nightmare.

I felt like vomiting my very entrails in the stifling stench of that hell.

Later, I understood the reason for my survival: I had not really been alive. My body alone had gone on living, but my soul, or at least the larger part of it, had perished and was buried among the ruins of my fallen world.

I continued to tag along after the others, never putting out any effort to make things easier for myself, never fighting over anything, whether it was food or water or a chance to defecate properly. For this latter function we were forced to relieve ourselves in groups at the spot and moment determined by the overseers. Anyone who failed to finish when ordered was driven away with whip lashes. Some who suffered from diarrhea would defecate while running, others would let loose a stream of urine and blood which they could not possibly conceal, and still others, like myself, could not get their bodies to function in any way.

I remember a woman in our block from the Lodz ghetto, a well-known physician, who suffered severely from this brutal form of humiliation. She had broken down completely from the start, lost control of her bodily functions, and would defecate wherever she stood.

The woman's daughter did her utmost to conceal her mother's state and to protect her. One of the women Kapos noticed the daughter's efforts and beat her so cruelly that she fainted. The rest of us watched this punishment mutely, stonily, keenly aware of our powerlessness . . . all of

us, that is, except Salusha, one of the members of our team of five. The incident had occurred very soon after our arrival in the camp, and Salusha had not yet sufficiently grasped the supremacy of the laws that governed Auschwitz. To our horror, we suddenly heard her childish voice ring out in the deadly silence: "Why are you beating her? It's so unfair!"

Salusha had barely finished her remark when the fat Kapo burst into a wild fit of laughter. Her underlings joined in the sickening merriment.

"Fairness! She's looking for fairness! Did you hear that?" they screeched raucously, holding their bellies, their faces twisted in exaggerated mirth. One of them imitated Salusha's outburst in a strident cackle, exaggerating every syllable: *"Why-are-you-bea-ting-her-it's-so-un-fair-hi-hi-hi! . . ."*

But the incident did not end there.

Our barracks had once been a stable and contained a long stove, now cold, which had been used to keep the horses warm. The Kapo dragged Salusha out of the line-up and made her climb on top of the stove. She pushed her onto her knees, placed heavy bricks in her hands, and ordered her to raise them above her head. Poor Salusha was forced to remain in this position for some hours. Never again did she ask for fairness or justice.

One other incident stands out in my memory, but for the opposite reason; for it was so radically out of keeping with the prevailing norm that I did not absorb it consciously while it occurred. It was only later, much later, that I realized how, in the midst of the assault that hemmed us in on all sides, a single pearl glistened, an isolated spark of humanity came to life for a moment among a group of people who had long ago lost every vestige of their human essence.

Estusha Kanner was ordered to climb on top of the stove and sing. Estusha had a beautiful voice, for which she had been famous in the ghetto. The guards had some free time now after the beatings they had administered that day while checking our block. They wanted some entertainment and had probably promised Estusha an extra portion of soup in exchange for her singing. A number of SS officers also crowded into a corner of the block to watch the "show."

Estusha began to sing an aria from a well-known opera. Her performance was surreal. Her crystalline voice filled the room, and the fat, satiated faces of the Kapos and soldiers reflected their immense pleasure. Even we, the human rags who happened to be present, listened wordlessly, forgetting for a moment the pangs of our hunger.

When Estusha finished singing there was an outburst of applause, and the Kapos asked for a second song. This time she sang in Yiddish.

To my regret, I've forgotten the words of the song and remember only their gist. I had never heard it before, and it seemed to me that Estusha spontaneously improvised it especially for us, especially for our unique misery. It spoke of the trials and tribulations of the Jewish people, of our interminable odyssey of adversity and bloodshed, of self-sacrifice and *Kiddush Hashem* — martyrdom. The song ended on a note of consolation: *"Zorgt nisht, Yidden, ess vet noch zein gut* — Don't lose heart, Jews, things will yet be all right!"

On both sides of the stove stood two groups of prisoners, human wrecks, each and every one of them crying, every single broken-down wreck.

I don't know how long we wept. When we raised our eyes we saw that the Kapos, too, were standing there, their truncheons hanging loosely at their sides ... weeping! Tears were trickling down from the eyes of the Kapos!

Out of the ruin and devastation of Auschwitz, I have preserved this one pearl and treasured it in my heart. I would often recall this incident in the later days of my captivity and find solace in it, clinging to the faintest evidence that despite all, something of our human spirit was salvaged from extinction. But at the time that I witnessed it, I was in such a state of shock that nothing could bring me comfort, there was nothing in the world that could encourage me, nothing at all.

At the end of one week my group was transferred from Auschwitz to a labor camp in Mittelsteine, a small town near Gross Rosen in the vicinity of Glatz. Today I know how fortunate I was, because the new camp was comparatively better than most others; and yet Mittelsteine was only a lesser hell, and our portion of torment there was undoubtedly an indivisible part of that vast system which I think of as a different planet.

I am among the handful who lived to see the downfall of the Nazis and the rebirth of the Jewish people in their homeland. I have been granted the privilege of a constructive new life. Yet despite all this, there is a tear mingled with my every joy, and there is no time when I feel free of the duty to commemorate the destruction... a destruction which, to this day, has not lost its potency, its power to rob my life of its fullness and to expose my soul to the mercy of every evil wind.

Sara Selver-Urbach spent nearly five years in the Lodz ghetto before being deported to Auschwitz. After one week there, she was transported to Mittelsteine, where she was liberated. She alone survived of all her family. Today she is a grandmother and lives in the Yad Eliyahu section of Tel Aviv. She has written extensively on the Holocaust. For a description of her life in the ghetto, see "A Brief Spring" in Volume One of Women in the Holocaust.

A MIRACLE IN AUSCHWITZ

❖

Esther Weiss
Lodz, Poland

Mrs. Weiss's story is a remarkable contrast to most other Holocaust testimonials in terms of the relative streak of good fortune which she experienced in Auschwitz. It seems unbelievable that so many overseers and officials, both Jewish and German, took such great risks to protect her and her children. One should keep in mind while reading her story that Auschwitz was a huge complex sprawling over many miles and housing thousands of prisoners, as many as 2,500 in a single block. Each block was governed by officials who had independent jurisdiction over it, and prisoners could sometimes fall upon the mercy of an individual, or manage to be overlooked altogether.

The Sealed Letter

In August 1944, when the liquidation of the Lodz ghetto was about to begin, seventy-two thousand Jews were still living there. The ghetto had survived five years of starvation, deportations, disease, and death, and was the longest-lasting ghetto in Europe; but its Jews were not to be spared. People made desperate attempts this time to hide. We too wanted to avoid the deportation, mainly for the sake of our children: our daughter Pesele, who was ten years old, and our son Moyshele, an infant of four months. Pesele had been hidden during the great Sperre of 1942, and the baby was born afterward. Since the Sperre we knew that children were the prime targets of the Nazis, and we were certain that none of them

would survive this last deportation. We also held back because of the heartening news then circulating that the Russian front was advancing and was not far from our city. Like many others, we hoped to hold out long enough to see the liberation.

The final deportation of the Jews of Lodz was different from all the other deportations of the ghetto years. This time each workshop director was required to choose candidates from his own factory or shop, which in essence meant marking his fellow Jews down on a death list. Each day new groups of employees went directly to the Czarnieckiego prison, which was being used as a deportation center, and from there they were transported in cattle cars to Auschwitz.

At that time the Zatler leather factory sheltered a hundred workers and their families on its premises.* The Zatler building was enclosed by a tall wooden fence, and no one was allowed to enter or leave the building. My husband and I both worked in the factory, and we begged Mr. Podlaski, the director, to include us among the people who were quartered there. In the beginning he was very reluctant to accept us, but after thinking it over, he consented for the sake of our baby.

All during that period the Germans hunted Jews for the final deportation, apprehending them in the streets and in their homes. On August 27, 1944, posters appeared on the walls of all the buildings, proclaiming that any Jew found in the ghetto after August 28 would be shot. Jews quartered in the workshops would not be excepted.

The Zatler workers tried to find favor in the eyes of both the German and Jewish officials who were conducting the deportation. We showered them with gifts of our handiwork: leather pocketbooks for their wives, useful leather articles for their children, household items. We also tried to convince the manager of the factory, Israel Miller, to persuade the German commander to let us remain in Lodz.

Miller tried, but he was refused. The German told him that the order for the deportation had come from Berlin and could not be revoked. He promised, however, to give Miller a sealed letter of recommendation

*A number of ghetto inmates managed to last until the liberation by hiding in whatever nooks and crannies they could find. Some, tragically, hid in the reservoirs, where they froze with the water when the weather turned cold.

which might be of help. What the letter contained none of us knew. In any case it seemed to make no difference, for on August 28 the last group of the Zatler resort workers — my family among them — was forced to board a horse-drawn carriage. We were driven to Radogoszcz, the nearby railway intersection, where cattle cars were waiting for us.

In Radogoszcz we saw the German official who had given Miller the sealed letter. I do not know if this German put in a good word for us, but somehow we got the impression that we were treated a bit better than the other ghetto inmates. We were permitted to take along all the belongings we could carry, a privilege denied to the other deportees; and whereas the other wagons were crowded with eighty to a hundred people, ours contained no more than sixty. And yet, though we could have been somewhat comfortable, the people in our group pushed and shoved, each one wanting to stay in the same wagon with Israel Miller, who held the treasured letter. After we had boarded the wagons, the doors were bolted, but the train did not move until dawn of the next morning, August 29.

That same evening we arrived in Birkenau-Auschwitz. Again we spent the night in the wagons, unaware of the place. At daybreak on the 30th we were surrounded by many SS men yelling: "*Alles herunter!* — All come down!" Jewish prisoners in striped, pajama-like suits hustled us down from the wagons, and some advised us bluntly: "If you want to live, throw away the children!"

I would not let go of my children at any price. I held them tightly as we descended the wagon. It was then that we realized where we were, and we understood finally that the rumors that had flown in the ghetto were true; the deportees had all been sent to their deaths. Among the SS men in the square were the two criminal murderers Dr. Mengele and Dr. Fisher, whose names I only learned later on. They were conducting a "selection": children, women with children, the elderly, and the infirm to the left, the others to the right. The two men passed sentence upon the line casually. Mr. Miller, our factory manager, tried to approach one of the German officers to hand over the precious sealed letter. He was struck from all sides by both German and Jewish Kapos, but he finally succeeded in handing the letter to a high-ranking SS officer who was involved in the selection.

This official ordered the one hundred and nine Zatler workers to step aside and wait. One hundred and nine stepped out, but as it turned out, only about half of them were actually from the Zatler group. The initial selection had been conducted with such turbulent speed that many of the Zatler people had been pushed to the left as soon as they got down from the wagons. Their places were filled by others in the line, who sensed that some special attention was being given to these factory people and quickly maneuvered themselves into the group. From the original Zatler contingent, only twenty-five men, twenty-three women, and six children stepped out. Among them were Mr. and Mrs. Zelewski with their two children, Mr. Kleiner with his son, Mr. Herszkowicz with his little daughter Mirele, and my husband and I with our two children.

While we waited, we observed that most of the people from the transport were sent directly to the so-called "showers" and then to the ovens. We had heard many reports and rumors of Auschwitz in the ghetto, and although people in our group did not want to believe their eyes, it was impossible to deny the smell coming from the ovens. Only a very few people were taken to a real bathhouse. After the SS men were finished with the selection, they turned their attention to us.

A young woman prisoner recorded all of our names, including the children's. One of our men reported to the German overseer that we had left our factory tools in the wagon, and we were ordered to retrieve them. After we brought the tools, we were led to a barrack and put through all the Auschwitz "formalities": we were registered, shaved, smeared with some kind of stinking liquid, and given strange clothing to wear. After spending two days and two nights together in a block, we were separated. The men were transferred to Lager A and the women to the F.K.L. — *Frauen Konzentrations Lager,* the main women's concentration camp.

It is almost impossible to describe the astonishment of the women in the F.K.L. when they saw me with the infant in my arms. They could not believe their eyes; they thought they were seeing a mirage. When I told them how it had happened, they burst out crying.

The Shtubenelteste of the barrack was named Roza. She was a woman from Warsaw, about thirty years of age, whose seven-year-old daughter had been killed by the Germans. This young mother did

everything possible to save my baby. Since I was forbidden to approach a stove, she "organized" food and cooked it for me so that the baby would not starve.

I had only been in the F.K.L. lager for two days when I suddenly developed an infection in my foot. I had no choice but to go to the revier and ask for help. On the way I kept an intense watch for Dr. Mengele, who, I had been told, often walked around in the streets of the camp, looking for subjects for his medical experiments. In the revier I was checked by a Jewish Hungarian woman who advised me to stay in the revier until my foot healed. (Normally this was not a very safe gamble, but there were people who did occasionally recover and leave the revier — if they were lucky enough not to be taken away in the frequent selections made there.) I thanked the woman for trying to help but explained that I could not remain here because of my baby. The woman was unusually sympathetic and generous. She expressed frank doubts that I would ever get my baby out of the revier if I brought him here, and suggested instead that I come to her for treatment every day at two-thirty. At that time Dr. Mengele was having his dinner, and there was no danger that he might visit the revier or the barracks. This woman was an angel. She took care of my foot regularly for three full months.

Another person to whom I owed a great deal was our Blockelteste, Giza. She was also a Jewish Hungarian woman, and she did not report my infection. Block chiefs were required to inform their superiors of any sign of illness or infirmity among the prisoners in their charge. Giza knew that if the "oversight" were discovered, she would pay for it with her own life; but she kept quiet out of consideration for my baby.

While I was still undergoing treatment for my foot, the baby developed a serious case of influenza. It was now September and very cold in the barracks at night, and his flu quickly turned into pneumonia. I could not ask for medical help, for if he were discovered, there was a good chance that he would be killed immediately. The baby had initially been allowed into the camp by the SS official who registered the Zatler workers; but in Auschwitz this was something of a fluke and did not guarantee him protection from other overseers or block personnel, who

had free reign to come by and shoot him, G-d forbid, if they felt like it. For three weeks my baby hovered between life and death. He ran a temperature of a hundred and four, and each day I thought would be his last. Yet a miracle happened, and once more we owed thanks to a woman who gave us lifesaving help.

When the baby became critically ill, a Polish Jewish girl, one of our Shtubeneltestes, begged assistance from a Jewish woman doctor who treated children in the block of the *Mischlinge*, the children of mixed Jewish-Aryan marriages. The doctor came, but she could not examine Moyshele well because it was too cold to remove his clothing. All she could do was give him some drops of a therapeutic substance to strengthen his heart. Luckily this medication had some effect, and his fever began to drop, but before he had a chance to fully recover, he developed a boil under his ear which exuded pus. This time the doctor did not come, and I had no idea how to treat the boil; but to my great relief, it began to heal by itself. My baby was out of danger for now, but I knew that he and I were living on borrowed time. A woman with a baby was in particular danger here, where Jewish children were considered as so much garbage. It was only a wonder that the few mothers with children had been overlooked until now.

We had been in Auschwitz for some time when the people from our original transport were tattooed, unlike most prisoners, who received their tattoos upon arrival. My two children were also given numbers. The tattoos gave us a certain amount of reassurance, for we understood that the Germans did not tattoo people they intended to kill. But we soon came to see that in Auschwitz it was useless to look for any correlation between events or to use any sort of ordinary logic that applied in the outside world.

Shortly after we had received our numbers, Giza, our Blockelteste, dashed into the barrack shrieking at the top of her voice: *"Women with children, line up! You're going to the ovens!"*

The women burst into hysterical tears. They moaned and wailed and literally tore the hair from their heads. The order had come from above, and our compassionate Blockelteste could do nothing about it, but she did have one trick up her sleeve. In order to save my ten-year-old daughter

from the ovens, she registered Pesele as sixteen years old and allowed her to remain in the barrack. I took Moyshele in my arms and joined the line of mothers who stood awaiting the selection.

As we progressed toward the selection site, a woman overseer advised us: "If they ask you if you want to go with your children, say no." Without exception we responded: "We know what to do; we will go with our children. Our lives are not worth living without them!" I was sorry, in a strangely morbid way, that I had not taken my daughter with me. At least that way I would have known what happened to her . . . But as I watched the smoke pouring toward the heavens in the distance, carrying upward the souls of our people, I recovered myself and felt some relief at the thought that maybe my daughter would survive.

While we waited in line, my imagination ran wild; I pictured myself inside the building, going up in flames together with my baby. We stood there, waiting and waiting, but the gas chambers weren't ready for us. They were packed with children who had just come in on a new transport.

Two hours passed, and now the selection was about to take place. Dr. Mengele appeared with his assistants and his trained dogs. The four hundred women of our block stood in front of him, stark naked, except the few of us* with children. We stood in our rags, reluctant to undress. The clerk, a young woman who was busy recording our names, ordered us to take off our clothes quickly to avoid a beating, but we did not listen to her. We were going to the ovens anyway; why should we rush to undress?

The selection began, and our murderers must have become blinded for a split second, for they didn't seem to notice [the three of] us standing apart in a huddle. In a flash of instinct, we used this fragment of a second to slip behind the wall of a small barrack. Through a crack in the corner of the wall, we watched the selection. Those motioned to the left were ordered to step out of the line and were led away, and the rest were commanded to remain in place and to dress. Mengele and his assistants finally departed.

[The three of us] burst into spasmodic sobs; our heads were spinning from the miracle that had just occurred to us. At that moment a thought

*Presumably these were the three women from the original Zatler transport.

raced through my mind: "Perhaps my children and I survived in the merit of my father and mother, who perished in this very place . . ."

We stood there holding our children, looking at each other in confusion. We did not know what to do now or where to go. The blocks were still under curfew, as they often were during a selection, and the pathways of the lager were empty except for the guards who patrolled them. After a while I suggested that we take a chance and return to our block; maybe another miracle would happen and no one would catch us on the way back. In any case, standing here was certainly just as dangerous. We were very lucky and got back unnoticed.

When we entered the block with our children, all the other prisoners began to cry again. They could not understand what kind of people we were, people who had managed to stay alive in Hell with their young ones for several months, who had managed to escape selection and come back in the flesh from the world of the dead . . .

Giza, our Blockelteste, listened patiently to our story, but then she informed us that despite her best intentions she could not let us stay in the block, for we were now "illegal subjects." We were officially considered dead and could not be included in the block count.

We were thrown off balance. This was something we had not anticipated. After our extraordinary escape, we had not considered the possibility that another door might be slammed in our faces. We fell to the ground and kissed the Blockelteste's feet, begging her to hide us in the block and not give us over to the murderers. Apparently a small voice of mercy touched her Jewish heart, for she turned to her assistant and said, "I did not hear anything, and I did not see anything. You take over and do for them whatever you can."

Giza proved to be a compassionate Jewish daughter in more ways than one, and she often risked her life to help the prisoners. Unlike most of the Jewish overseers and Kapos, who were quickly demoralized and turned into animals under the pressure of their German masters, she went so far as to help the women in our group hold on to their traditions. For Rosh Hashanah and Yom Kippur she brought candles to the block so that the married women could light and make a blessing over them; she allowed girls who had *siddurim* (prayer books) to pray on their bunks; she

tried to supply bread for those women who did not want to violate the kosher dietary laws by eating the salami rations.

Giza took [the three of us] and our children to the back of the block and gave us bunks in a secluded corner next to the washroom, so that in an emergency we would have a place to hide. It was very cold and windy in this corner, for the windowpanes were broken and the roof leaked. Giza ordered her assistant to bring heavy blankets for all the children. My older daughter was still registered officially in the block as a sixteen-year-old and was not in as much danger.

In that block I stayed in hiding with my baby for several months.

The Liquidation Begins

At the beginning of November 1944, we heard rumors that the F.K.L. lager was about to be liquidated and that all prisoners would be sent to work in other places. We ourselves had been in a non-working block all this time, which was dangerous enough, for the "useless" people were the first to be sent to the left in selections; but we knew from experience that a liquidation was bad news, for worse fates most likely awaited the prisoners in other camps — if indeed they would make it to other camps. We also knew that no rumors were ever literal and that no orders were to be trusted.

However, we found ourselves reacting to the rumors differently than we had in the past. We were resigned to our fate this time. We were grateful that G-d had granted us life until now against all reasonable odds. How many miracles could He possibly grant us? If He decreed now that we were to die together with our children, we would have to accept His judgment . . .

As always, the selection was conducted by Mengele and his henchmen, with one major difference: it was held in the block and not outside in the square. When our Blockelteste learned of this, she advised us to hide under the lowest pritsche and to bind the mouths of the children. The selection lasted for three days in a row; for three days we lay on the floor beneath the pritsche, under a pile of rags. Our children understood the danger and did not let out a cough, a sneeze, or even a sigh.

And again we escaped death.

With the progress of the autumn season, transport after transport of prisoners left Auschwitz for work in Germany, and the F.K.L. lager was slowly emptied as well. Sooner or later we knew we would be discovered, and one day the suspense finally ended. The Blockelteste burst into the barrack, shouting, "*Alles heraus!*" and this time all of the inmates, without exception, were forced to join the transport — including my daughter. Certain that she would not pass selection, I decided to leave my hiding place, and went out with my baby to join her. The Blockelteste saw me preparing to leave, and she swiftly grabbed my arm and pulled me back. "Mothers with children are not to go now! You'll go when you are called!" she said, and pushed me back into the room. In a few moments the barrack was empty, except for we [three] women with our children.

A few hours later the women who had passed the selection returned. They told us of those who had gone to the ovens, among them my daughter Pesele. They told me how it had happened: Dr. Mengele asked her how old she was. She replied, "Sixteen." "You lie! You're not sixteen! You are too small for sixteen!" — and he had pushed her to the left.

What had I been expecting — another miracle? And yet, that's exactly what I had expected: a miracle, on top of all the others we had received. When I heard their words, I began to bang my head against the wall. "I lost my little girl! I lost my little girl!" I repeated over and over again. I felt that I would go insane. All that day and most of the night I sat mourning my daughter, reproaching myself for not being with her during the last moments of her life . . .

The liquidation proceeded at a steady pace. It was clear that those who passed selection had merely obtained a temporary reprieve, that the entire population of the camp would eventually be sent to their deaths.

The last few women who remained in our block were waiting to join the next transport to the gas chambers when a sudden order came to halt the extermination process. The rumor flew that America had threatened to kill three Germans for each murdered Jew. No one knew if the rumor was true or where it had come from. But to me it made no difference. How could I care when I had just lost my daughter?

The next morning a Russian woman prisoner came into the barrack. She told me to hurry outside because my daughter was waiting for me. I

asked her if she had lost her mind. It was already twenty-four hours since Pesele had been taken to the gas chambers! But the woman insisted that she herself had seen my daughter and that I only had to go out and convince myself. I left my infant in the block and ran out.

With a beating heart I crept along the back walls of the barracks, hoping that no one would catch me. Finally I reached the building where the Russian woman had seen my child. I peered through the openings between the slats — and wonder of wonders! There she was, together with all the others who had been selected for the transport. They looked like wild animals, stark naked, frenzied with hunger and thirst. I later learned that this was Block 25 — the Death Block, where prisoners were kept before gassing or left to die a natural death. During the last twenty-four hours these women had not received even a drop of water. I saw my Pesele, naked as the day she was born, shivering from cold and hunger.

I ran back to my block and told our Shtubenelteste what I had seen. Immediately she took a dress, a pair of shoes, and some food, and went straight to the Death Block. She knew that the inmates were to go through three more "health" examinations by Dr. Mengele and Dr. Fisher, and that those who passed had some chance of being discharged from the block. She told my daughter to dress and eat everything she had brought. She also warned her not to lie about her age, because for her true age of ten she was well-developed and would have a better chance of passing selection on her own merit.

When the Shtubenelteste returned, she told me that she would try to have my daughter transferred to the Mischlinge children's block, which was somewhat safer. Her influence must have had some effect. After spending eight days in the Death Block, my daughter was examined three times and sent to the Mischlinge block. She was not alone; several Jewish children from other transports had wound up there as well.

Pesele stayed in the children's block for several weeks. During that time I had great difficulty seeing her, for the prisoners were generally not permitted to venture outside of their own barracks; the Germans did not want them to see the selections that were going on or to witness the huge crowds of people being led to the gas chambers. My daughter and I, however, found an ingenious way to make contact. In the mornings she

and another child volunteered to take the pail of human waste accumulated during the night and carry it to the latrine. My block was on the path to the latrine, and this way I could at least see her as she passed by.

This "idyllic" situation did not last long, for the deportation of the women prisoners was proceeding steadily. Two of the children in our barrack were sent to the children's block, and their mothers were deported to work in Germany. My baby was too small to be accepted into the children's block, and he and I were relocated to a barrack populated by Russian and Ukrainian prisoners. Here a new and unexpected problem arose. Though they themselves were prisoners, these Jew-hating Russians barred me from entering. They demanded that I give up my baby to the children's block and go to work like the others. Our Shtubenelteste, who had protected me and the baby all this time, went to the camp chief, a Jewish woman named Hilda, and asked her to write an order to let me into the block. Only when I presented the note with the order would these barbarians let me in.

It is hard to describe what it felt like to be one Jewish woman with an infant, alone in a block with a hundred and fifty Russian and Ukrainian prisoners. They wouldn't allow me to approach the stove in the center of the room to cook a bit of food or warm some water for my baby. I slept in a hole in the corner of the block, where rats ran around freely. This is how we existed for another three weeks.

Then one day we were transferred yet again, to the Gypsy lager in Birkenau. There were no Gypsies left there; every last one had been exterminated! The inmates who now replaced them, including the children from Auschwitz, were grouped separately according to their nationalities. The Jewish children, who numbered one hundred sixty, were placed together with the Jewish women. The greatest good fortune of all this upheaval was that I was reunited with my daughter!

In this block I also met little four-year-old Mirele Herszkowicz, who had been in our original group from the Zatler Leather Resort. Mirele's aunt had taken care of her after her father was sent to the men's lager, and later, when the aunt was transported out of Auschwitz, Mirele remained alone, an orphan. I immediately took her under my wing, for I knew she had no chance to survive on her own. Now I had three children.

Over the Fence

It was now the end of November. For a period of about a week, we were awakened at five a.m. and chased out, kept outside all day long, and counted numberless times. During that week we did not receive food or water. It was almost as cold inside the block as it was outside, and we slept on hard boards. The little children caught colds easily and became very sick, and those who were taken to the revier never returned. My baby fell ill with pneumonia for the second time, and once again we were fortunate to receive clandestine help. One of the camp clerks was a Jewish girl from Hungary whose aunt, a doctor, worked in the revier. She brought her aunt to the block to see my son, and after examining the baby, the doctor gave him some sort of drops. G-d helped again, and the child recuperated.

I had had a deep intuition for some time that my husband must be in the adjoining men's camp, and for two weeks I ran to the wire fence each day, hoping that he would show up. Talking to other prisoners through the fence was forbidden. Guards were posted in sentry boxes at intervals along the length of the fence, and they had free reign to shoot anyone they pleased, or even to push them against the fence and electrocute them if they felt like it; but I was desperate to see my husband and took the chance. One day when I was standing not far from the fence, I recognized Mirele Herszkowicz's father on the other side. He told me that my husband was in the same block with him. Both fathers were aware that their children were alive and close by. They also knew that they had only a slim chance of seeing us, but they had not given up trying.

Herszkowicz tried to find favor in the eyes of the lager clerk, a Pole who was in charge of choosing men for work crews. With much effort, he maneuvered himself into the position of cleaning this Pole's room. After they became better acquainted, Herszkowicz confessed that he had a child in the women's lager, and that his friend also had a wife and two children, and he begged the Pole to assign them to clean the women's lager so that they could see their children. The Pole promised to help, and indeed, shortly afterward, both men were given jobs in the women's camp.

I began to keep a careful lookout for the block officials. When no one was around, I would grab my children and Mirele and run to the fence

around our barrack, hoping that the men would pass by on their way to work and see the children. They could not talk to us, but at least they could look at the children and see that they were alive. After a time the men's assignment was completed, and they were no longer able to see us.

In December 1944 an order was finally given that any mothers remaining in the camp would be deported to work in Germany and would have to leave their children behind. I became very depressed and despaired of my constant struggle. I had rescued my baby from death so many times already, and now, after all we had been through, I should leave him here to die? I knew and saw with my own eyes what was done with the children in Birkenau. The Shtubenelteste in the F.K.L. lager had had a Jewish heart, but here in Birkenau the overseers treated the children no better than the SS men did, beating them mercilessly and stealing their food. More than half of the one hundred sixty children who had originally been transferred to the Gypsy lager had already died of hunger and cold. I had no doubt that if I left my children here I would never see them again.

The next morning I went out to the wire fence near the men's camp and succeeded in getting a message to my husband. He and Mr. Herszkowicz soon came out to see me. I told them that in a month the mothers would be forced to leave their children behind, even the very young ones, and go to work in Germany. The men became very depressed, but they tried to console me. They told me not to cry but to believe that the Almighty would help us, and they reminded me that before the month was up we might be liberated.

In the meantime we were ordered to go for an *Antlausung*, a delousing. The *Antlausung* was a dreadful ordeal. It was extremely cold in the block, and we sat there naked for a full twenty-four hours before being sent "home." My baby became ill again, and the next day I could tell that his temperature had risen dangerously high. The Jewish Hungarian clerk called in her aunt again from the revier. The woman told me that the baby only had a cold, which was aggravated by his teething. But the next day his temperature had not gone down, and on the third day I noticed red spots all over his body. Measles! I felt as if a thunderbolt had suddenly struck me. It was dangerous enough to develop any kind of sickness in the concentration camp, for it put one at risk of selection, but a contagious

disease like measles was a certain death sentence. If the Blockelteste or the Shtubenelteste found out, they would surely take severe measures or even kill me. But I knew that I would rather be killed than abandon my child.

It was Sunday, and the clerk's aunt had promised to come again and examine the baby. Normally I would have been happy to see her, but this time it was different. I did not think that she would report the baby's measles, but I also knew that if she didn't, her own life would be in jeopardy. I was in a terrible predicament. My thoughts were racing wildly, and I knew that I must act swiftly.

I grabbed the baby and climbed into a pit in the ground outside the block. The Shtubenelteste ran around, searching for me inside and outside, calling: "Weiss! Weiss!" I did not move. I heard her ask my daughter where I was, but Pesele replied that she did not know. When the doctor finally left the block, I climbed out of my hiding place. It was four o'clock in the afternoon, and the appel was about to take place. The Shtubenelteste saw me and asked: "Where have you been? The doctor came especially to examine the baby."

"I was outside, getting a bit of fresh air," I replied.

"When a child is so sick, one does not take him out for fresh air," she said sharply.

"It's all right," I said. "A drop of fresh air wouldn't hurt him."

For three days my baby did not open his eyes because of the high fever, and I was afraid that the measles might cause some kind of permanent damage. I did whatever I possibly could under the circumstances. At night I put compresses on his head and tried other old-wives' remedies that I remembered. After a few days he felt better, and the spots began to fade. I breathed a bit more easily — until I saw that he was still far from well. He could not digest any food and threw up whatever he swallowed. He also developed an infection in his mouth, and his eyes remained closed, which worried me most of all.

There was a Jewish woman from Lodz named Holenderska, who was an eye doctor and worked in the revier. She had come to Auschwitz with her husband, who was also a doctor. I went to the revier and appealed to her: "I'm from Lodz too. Please come and help my baby!" Holenderska

came daily to our block to treat the baby's eyes. At the same time, a Jewish nurse who had converted to Christianity took care of the infection in his mouth, and his vomiting also abated. He was still not a healthy child by any means, but during the next two weeks, at least, he had a reprieve from his constant battle with illness.

During this time we heard that the Russian front was advancing rapidly and that all the prisoners of Auschwitz would be evacuated. We asked each other: "Will they let us live to see the liberation?"

In this period of tension and uncertainty, Mirele Herszkowicz came down with pneumonia, and my baby caught it from her. I did not know how much more sickness his tiny body could stand... The Jewish clerk's aunt came again and declared that his condition was now so serious that the only option was to take him to the revier. But how could I leave him in the revier if we were about to be deported? I pleaded with the doctor to treat him here, as she always had. She explained that he needed injections of a certain serum which was kept in the revier, but she mentioned that it might also be available in the men's lager.

Early the next morning I went to the electric wire fence and asked the first man who approached to call out my husband. With some pull and a few portions of bread, my husband managed to get the serum. I brought it to the doctor, and she began to give the baby injections immediately. He was so sick that she doubted it would do any good, and yet, on the fourth day, he began to improve.

On January 18, 1945, the order to evacuate the entire camp finally materialized. Our division was called to an appel. In the heart of the night I dressed Mirele and my sick baby and went outside to join the column. While one group of Nazis counted us, another searched the barracks for hidden weapons. In the block where the Russian inmates were quartered, the Germans found several guns, and five Russians were shot on the spot. This created a terrible unrest in the ranks. The Germans were dreadfully agitated and kept us standing appel all through the morning.

At noon the situation relaxed somewhat, and the watch over us slackened. The German guards herded all the men out for deportation and then turned their attention to the women. They pushed us to the camp gate and conducted another selection.

When I saw that the children, the older people, and the sick were being sent to the gas chambers, I grabbed my daughter and Mirele and ran back to the block. Others were hiding there too; and even though they were mostly Russian and Ukrainian women, who had so abused me in recent weeks, I decided to take my chances and stay in the block.

In the midnight hours, the sudden and terrifying wail of a siren pierced the darkness. A surprise air-raid attack! Bombs fell on all sides, and we thought we would surely meet our end here, but the night passed and no one in the block was hurt.

Liberation

The next few days were a continuing series of surprises, reversals, and tension. Our situation became completely unpredictable and tottered from one minute to the next between hope and despair. On Friday morning, January 19th, a new lager commandant arrived to take the place of Rudolf Hess. His first announcement was: "We are marching out. Whoever wants to go to work should leave the children and join us! Here no one will survive." I had decided long ago that I would never give up my children. Whatever would be, would be, I told myself, but at least we would stay together.

Late on Friday all the guards disappeared — but not before taking final measures against us. They locked all the gates so that we couldn't run away, shut off the water supply, and torched the storerooms in Birkenau, where all the prisoners' possessions were kept. We were very much afraid that they might set fire to the lager from all sides, so we took our children and left the block. Auschwitz was a huge complex, and perhaps we might find some other place to hide . . .

In the compound we met several Russian men, civilians who had been brought to Auschwitz from the occupied Russian territories. They too were seeking shelter. We also saw male prisoners from other divisions of the camp robbing the kitchen and food cellars, and we heard rumors that the Russian troops were swiftly approaching. Were we free?

Two days later, on January 21, a new SS kommando appeared suddenly and took control of the camp. They chose a Blockelteste and a Shtubenelteste, and the counting of prisoners began anew; but this lasted

for only two days, and then the kommando disappeared. They weren't seen on Tuesday, Wednesday, or Thursday, and all during that time bombs fell unremittingly. The prisoners were consumed with only one thought: "Will we be free again?"

The bombing was haphazard and forceful, and claimed many lives. Every few minutes there were new victims, and there was no place to go to escape the attacks. On Thursday afternoon another woman with a child approached me and said: "The men's blocks are empty — let's go there. I heard that in the Blockelteste's room there is an oven. We could make a fire and keep our children warm!" On the way to the men's lager, we "organized" a few pieces of wood and coal and some scraps of food.

When we had just settled down in one of the vacant blocks, four SS men suddenly entered the room, shouting the familiar order: "*Alle Juden antreten!* (All Jews line up!)" It seemed as though they were going to shoot us. Outside, we saw that the sick people from the revier were also standing in line. As we formed columns, two of the SS men went to search the barracks for people in hiding, and when they emerged they ordered us to begin marching. The sick who fell out of the line were killed on the spot.

We were led to a bridge and were ordered to perform "calisthenics": "Lie down! Get up! Run!" We were sure they wanted to finish us off right here. Suddenly a military vehicle appeared, and a high-ranking officer stepped out and called the four SS men. After talking for a while, all of the officers got into the vehicle and drove off.

We were confused. We didn't know what to do, whether we should wait here any longer or leave — but if we left, where would we go? It was now very dark, and we were afraid to return to the block. We began to straggle forward aimlessly. On the road we passed soldiers, cannons, machine guns; but we kept on walking without any idea where we were headed. We passed a field where men and women prisoners were hiding underneath large piles of wood.

Mrs. Miller, a woman from Lodz who also had a child, turned to me and asked: "Do you think we should hide underneath these piles?"

I answered: "I do not intend to hide here. I'm marching with all the others." Somehow I felt that I did not want to be separated from the group,

and besides, who knew if someone might not come along and set fire to these woodpiles?

There were four hundred people in our group, the majority of them women, along with a few children and a handful of men. We kept marching on blindly, without really understanding anything that was happening to us. As we walked we saw a huge gate in the distance, and behind it many barracks. I wondered if we were still in Auschwitz. At first we were afraid to enter, and we sat down on the snow and rested for a while, but then we ventured inside, hoping to seek shelter and warm up a bit. The building turned out to be a stable. We felt strangely uneasy there, for there was no telling whether German soldiers would show up at any minute. After a while we left the place, shivering from fear and cold, and continued to march.

We saw a man walking, and we stopped and waited for him. When he approached, he told us not to be afraid of him, that he was also a Jew. He spoke such a perfect German, however, that we doubted his words.*

Further along we met a Jew who advised us to keep going straight until we reached the Auschwitz hospital, a barrack-like house. When we reached the barrack, we met with a surprising scene. Many Jews were in the building, but there were no SS officials or overseers. Although there was filth and confusion, the terror had subsided. The Jews here were fending for themselves, taking care of each other as best they could. They gave us clothes and blankets, and when they saw my baby they were completely overwhelmed. A baby who had come out of the camps alive! They couldn't believe their eyes. They brought food and clothing especially for him and helped me make him as comfortable as possible.

The next day, which was Friday, we sat there in the hospital and talked of nothing else but the good news that was passing along all up and down the roads: Help was near!

There were no more Germans around. On Friday night a Jewish Hungarian man who was a doctor entered the barrack with a few other men. They advised us not to go to sleep because the city of Auschwitz had been bombed and was now an inferno. It was possible that we would have

*Many Germans, when they were certain that the Russians were upon them, changed into rags and pretended to be Jews, hoping to escape punishment.

to run on short notice if an air raid hit us. Surprisingly enough, it remained quiet for most of the night and we were not disturbed, except for the walls of the barrack vibrating from the impact of the bombing.

At about five in the morning, the bombs began to fall right around us. The glass collapsed from the windows and shattered on the tables, but no one was injured. At eight o'clock the bombing stopped, and people came running in from the road to tell us that we would be liberated very soon, for the Russians were only five hundred meters from Auschwitz!

At eleven a.m. the children ran out of the building and came back screaming with excitement: "We are free! The Russians are here!" We ran out to convince ourselves and were astonished. It was true! The Russians were here! We embraced and kissed the soldiers in feverish gratitude.

I was free — but I had no idea where my husband was, or even if he was alive.

In March 1945 I arrived with my children in Lodz and began the task that now consumed all the freed inmates of the concentration camps: trying to locate lost relatives. One man I spoke to told me that my husband had been deported to Germany on January 20, 1945, in a group of ten thousand men and women. Later I learned that he had been sent to Dachau and was liberated there on April 30, after I had already been home for a month. He then began to search for me, and we finally met in Lodz in September 1945.

After wandering from place to place for a while, we finally ended up in Stuttgart. Mirele Herszkowicz also found her father, and they now live in Zeeshapend, near Weilheim in Ober-Beharin.

My children and I escaped the Satan's paw, and our story is a miracle that defies description or understanding; for in addition to the survival of the children, we were one of the few families to be reunited intact after the war. It is a mystery to me in what merit we received this great blessing from G-d. I am only concerned now about how the children will be affected in the future by all the sicknesses they suffered in the camp.

Historical Commission of Stuttgart, Germany
Recorded by D. Greisdorf, 1946

GLOSSARY

❖

Aktion (Polish, *akcja*) — a term used by the Germans to indicate an official roundup of Jews for death or deportation, accompanied by a curfew.

Antlausung (G.) — delousing.

appel (G.) — roll call in the concentration camps.

Aryan — This term originally referred to the Indo-European languages and the peoples who spoke them. The Nazis used it to mean "a Caucasian of non-Jewish descent," although the word has no racial connotations. In this book, Aryan means "non-Jewish."

Aryan side — the non-Jewish side of a city, used after the formation of ghettos.

Blitzmaidlech (G.) — Literally, "lightning girls"; overseers who pushed the prisoners to perform their activities at great speed.

block — barracks; a building or unit of buildings in a concentration camp.

Blockelteste (G.) — block supervisor (similar to a Kapo; Jewish or non-Jewish).

Blocksperre (G.) — a block curfew, in which the inmates were not allowed to leave their building under any circumstances for a given period of time.

bunker — a hiding place or hole. Also refers to an air-raid shelter.

Gestapo — common name for the *Geheime Staatspolizei*, the German state police, organized in 1933 under the Nazi regime to monitor and destroy political opposition.

Judenelteste (G.) — head of the Judenrat.

Judenrat (G.) — the Jewish administration in the ghetto. These people were appointed by the Nazis to attend to all civil administrative tasks in the ghetto, including food distribution, housing, medical care, and sanitation. They were also expected to carry out all Nazi orders explicitly, including the roundup of given numbers of people for deportation. The Nazis in effect made the Judenrat agents against their own people.

Judenrein (G.) — literally, "cleansed of Jews." This was the German order for all Jews to evacuate the central portions of major cities by a given date.

Kapo (Italian, "head") — In the camps, a prisoner who was put in charge of a work group or a block. Kapos were male or female, Jewish or non-Jewish.

kommando — work gang.

Kripo — Office of the German criminal police station in some ghettos. Jews who were taken there for interrogation rarely emerged.

lager (G.) — concentration camp. Also refers to subdivisions within the camps.

Lagerelteste (G.) — camp division head.

Lagerfuhrer (G.) — camp chief, German.

Mischlinge (G.) — German term for children of mixed Jewish-Aryan marriages.

mussulman/musslemess — A person whose condition had weakened so much that he or she had lost the will to live. Mussulmen received their nickname because they would shuffle around mindlessly until their strength gave out, and in their collapsed state resembled Moslems at prayer.

Ordnungsdienst (G.) — the Jewish police force in the ghetto, who acted merely as puppets of the Nazis and who were forced to impose German ordinances upon the Jews and to round them up for deportations.

"organize" — to acquire a needed item in the camps (e.g. a piece of bread, an item of clothing, medication) by whatever means possible. The word "steal" was not used by the Jews because all their possessions had been stolen by the Germans in the first place.

partisan — resistance workers during the war who operated from hiding places in the forest. The partisans were both Jewish and non-Jewish, but the Jewish partisans were rarely accepted by their gentile counterparts, who killed many of them.

pritsche (G.) — a plank of wood used as a bunk. Many people often shared one small pritsche.

ratzia (Polish) — rations.

revier (G.) — literally, hospital; in actuality, a building used as a dumping ground in the camps for those who were sick. Most of the sick people were taken to the crematoria during selections.

Shtubenelteste (G.) — room supervisor in the concentration camps.

Shtubowa (G.) — block overseer of lower status.

Sonderkommando (G.) — literally, special. In the ghetto, this referred to the special police staff who also controlled the medical dispensary. In the death camps, it referred to the group of men who worked in the crematoria.

S.S. — *Schutzstaffel* (Defense Corps). This was the special security force drawn from the ranks of the SA, the military arm of the Nazi party. Its main role was to terrorize, murder, and otherwise enforce all Nazi edicts against the Jews. Heinrich Himmler transformed the SS into the primary instrument of the Final Solution.

Stubendeinst (G.) — the Blockelteste's assistant, Jewish or non-Jewish, who was required to carry out all of his or her orders.

Volksdeutsche (G.) — In Poland, the large minority of Polish-born German nationals who had immunity from Nazi law because of their birth.

Wehrmacht (G.) — the regular German army.